OUTSIDE THE FRAME

PERFORMANCE AND THE OBJECT

A SURVEY HISTORY OF PERFORMANCE ART IN THE USA SINCE 1950

CLEVELAND CENTER FOR CONTEMPORARY ART

1994

Publishing and Copyright Information

OUTSIDE THE FRAME
PERFORMANCE AND THE OBJECT
A SURVEY HISTORY OF PERFORMANCE ART IN THE USA FROM 1950 TO THE PRESENT

Catalogue Published by
Cleveland Center for Contemporary Art
8501 Carnegie Avenue, Cleveland, Ohio 44106
September, 1994

Library of Congress Catalogue Card Number: 93-074238
ISBN: I-880353-06-7

Catalogue Coordination
Gary Sangster
Catalogue Design
Stephen Trout

Typeset by Cleveland Center for Contemporary Art
Printed by Sherman & Son, Inc; Printed and bound in Cleveland, Ohio

The presentation of *Outside the Frame*, the catalogue, and the exhibition tour has been made possible through the financial support and assistance of *The Cleveland Foundation, The George Gund Foundation, National Endowment for the Arts, Ohio Arts Council, The Rockefeller Foundation, B&B Appliance,* and *Omni International Hotel.*

The catalogue for *Outside the Frame* is published with financial support from *The Warhol Foundation for the Visual Arts.*

The presentation of *Outside the Frame* at Snug Harbor Cultural Center is sponsored, in part, by *Philip Morris Companies Inc.*

Cover: Detail, *Fluxus Concert*, Concert Master, Larry Miller, 1994
Severance Hall, Reinberger Chamber Hall
Photograph: Cleveland Performance Art Festival

Contents

Exhibition Itinerary

February 11-May 1, 1994

Cleveland Center for Contemporary Art

Cleveland, Ohio

February 26-June 18, 1995

Snug Harbor Cultural Center

Staten Island, New York

Curators

Robyn Brentano

Olivia Georgia

Project Coordinator

David S. Rubin

Performance Coordinator

Thomas Mulready

Artist List

Vito Acconci

Laurie Anderson

Eleanor Antin

Janine Antoni

Jacki Apple

Nayland Blake

Bread and Puppet Theater/Peter Schumann

George Brecht

Chris Burden

James Lee Byers

John Cage

Jimmie Durham

Gretchen Faust and Kevin Warren

Karen Finley

John Fleck

Terry Fox

Coco Fusco and Guillermo Gómez-Peña, with Pepon Osorio

Bill Gordh and John Malpede

Ann Hamilton

Matt Heckert

Geoffrey Hendricks

Anna Homler

Joan Jonas

Alison Knowles

Suzanne Lacy and Carol Kumata

Christian Marclay

ARTISTS

Paul McCarthy

Ana Mendieta

Larry Miller/Fluxus

Meredith Monk

Linda Montano

Bruce Nauman

Lorraine O'Grady

Claes Oldenburg, Coosje van Bruggen, and Frank O. Gehry

Pat Oleszko

Yoko Ono

Raphael Montanez Ortiz

Nam June Paik

Adrian Piper

William Pope.L

Liz Prince

Robert Rauschenburg

Carolee Schneemann

Joyce Scott

Stuart Sherman

Theodora Skipitares

Jack Smith

Rirkrit Tiravanija

John White

Robert Whitman

Hannah Wilke

Robert Wilson

and documentary photographs by Peter Moore

Foreword

Gary Sangster

Outside the Frame: Performance and the Object is a pivotal exhibition for The Center's 25th Anniversary Year. It follows the extensive survey of The Center's work since its founding in 1968, *25 Years: A Retrospective,* organized by Marjorie Talalay, and examines the adventurous and expansive arena of performance art through original research and collaboration with numerous individuals and organizations. Utilizing the experience and expertise of guest curators, Robyn Brentano and Olivia Georgia, the skills and local knowledge of David Rubin, Associate Director/Chief Curator of The Center, and Thomas Mulready, Director of Cleveland Performance Art Festival, and the remarkable enthusiasm and support of the Board of Trustees, The Center has accomplished a project of great breadth and imagination.

Embarking on the largest and most ambitious project in an institution's history is an exciting prospect. Realizing that project successfully can be a precarious journey that entails myriad shifts and reversals, pragmatic advances and retreats, and daring leaps of thinking, as well as a significant development of resources, both intellectual and material. In recent years, I have been privileged to be involved with two outstanding, ground-breaking exhibitions, *The Decade Show: Frameworks of Identity*, in 1990, and now *Outside the Frame*. Although both followed a traditional historical survey format, the underlying proposal of each exhibition was to uncover an extraordinarily original ensemble of material that could open-up debate and stimulate further research, exhibitions, and, importantly, renewed art activity in the field. By adopting an exploratory, almost speculative, attitude, each exhibition provided the possibility of a generative, creative process occurring for audiences, through exposure to such a wide body of related work. The potential to extend the thinking of audiences and to create new possibilities for artists, rather than defining possibilities that occurred in the past, were the primary goals of these exhibitions.

Cleveland Center for Contemporary Art has taken this opportunity to explore the language of exhibitions by examining the historical trajectory of performance art, producing new and existing live performances, and aligning that material with the possibilities of an interactive, installation-based, and documentary-style exhibition. *Outside*

the Frame is a highly selective exhibition, designed to touch on many different forms of performance and to raise critical questions concerning the interrelationship between performance art and all other art forms. It is not presented as an encyclopedic exhibition that embodies an exhaustive history and covers the detailed impact of each radical shift or significant nuance of artists' performance work.

The recent history of performance art in the USA has received less attention in the realm of exhibition research and presentation than many other contemporary art forms. The dynamic range of the theatrical and improvisational strategies of performance art has tended to place it within a marginal or peripheral category of interest and concern to art museums, where static art forms may often enjoy certain advantages of archival simplicity. The absence of an exhibition overview of this field has tended to negate the power and experimental qualities inherent in performance art and has also tended to obscure the level of impact that performance has had on the development of recent art, both modern and post-modern. Performance strategies and issues of theatricality have infiltrated almost every avenue of late-twentieth century art. Elements of performance art stretch from the self-conscious, ironic persona adopted by an artist as influential as Andy Warhol, to the private, shamanistic, and quasi-ritual discourses of Joseph Beuys, or to the irreverent purveyors of humor in everyday objects and experience in the collective work of *Fluxus*. The relationships between performance, the media, and contemporary art is a field of ongoing research and speculation.

It is the vision of *Outside the Frame* to open up space for a renewed discussion of the significance and influence of performance art on all other aspects of the visual arts. Without question, it is a rich and exciting field of exploration that yields new insights into the current focus of contemporary artists and art museums on concerns of communication and audience engagement. Many of the paradigms of experimental performance art, in particular the recognition of the audience as a vital element in both the constitution and realization of the artwork and its various meanings, have been incorporated into other fields of visual art, both actively and subliminally. Articulating these connections is a critical issue in the conceptual strategy and potential extended impact of this exhibition.

The Center has demonstrated a long-standing commitment to the arena of performance art through innovative programs and events that have provided opportunities for performers to explore new performance ideas and methods, and provided

audiences with unusual access to an ongoing arena of experimental thinking in the visual arts. The Founding Director, Marjorie Talalay, possessed a profound vision for The Center to develop an exhibition that could encompass some of the complexities of the relationship between contemporary art, exhibitions, and performance art. The catalyst for initiating *Outside the Frame* came during research discussions among members of The Center's Program Advisory Committee, where Roger Copeland (Professor of Theater and Dance, Oberlin College), Don Harvey (Professor of Art, University of Akron) and Marjorie Talalay first discussed the opportunities and the current relevance of such an exhibition. From that point on, the project gradually evolved to become both the most ambitious and expansive exhibition in The Center's history.

The Center is indebted to the guest curators, Robyn Brentano and Olivia Georgia, who worked in a creative and energetic fashion to develop the vast range of material available into a coherent and cogent exhibition. Through their unique insight and tireless research, this project has established a new benchmark for performance art exhibitions. The Center is also indebted to all consultants and volunteers who contributed to the project in a generous and constructive manner. I would like to pay special tribute to The Center's dynamic staff, who managed all aspects of this ambitious project with incredible ingenuity, patience, good humor, and, importantly, a complete commitment to professional levels of presentation for contemporary performance art. I wish to thank Susan Murray, former Development Director at The Center, for seeking and securing such a wide range of local and national funding for this original project. I also wish to thank David Rubin, the Project Director for *Outside the Frame*, for managing the planning and presentation details of this exhibition with great care and vision.

The live performance program for *Outside the Frame* was a collaborative venture between the Cleveland Center for Contemporary Art and the Cleveland Performance Art Festival (PAF). For 1994, the PAF adopted the name of the exhibition in order to closely identify with and participate in the overall research and historical objectives of the exhibition. By bringing together two organizations committed to presenting the latest examples of experimental contemporary art, the project was enhanced by the varied perspectives and different outlooks each organization represents. Thomas Mulready and his PAF team worked diligently with The Center's staff and volunteers to make this enterprise a valuable addition to the study of performance art. There were many areas of cooperation between the two organizations, including joint planning, coordinated

programming, documentation, publicity, promotion, and, finally, the various live productions at different theater, museum, and cultural venues throughout Cleveland. It was mutually beneficial for both organizations to share resources and to precisely co-ordinate the development and production of performances for both the exhibition and the Performance Art Festival.

The staff and supporters of *Snug Harbor Cultural Center* have provided crucial assistance and valuable support to Cleveland Center for Contemporary Art by gathering work together in preparation for the exhibition, and, perhaps more importantly, by encouraging Olivia Georgia's work on *Outside the Frame* while serving as Visual Arts Director at Snug Harbor. The Center is also indebted to Snug Harbor for enthusiastically presenting this project to the New York region audiences.

The Center is especially grateful to its major local supporters, *The Cleveland Foundation, The George Gund Foundation,* and *Ohio Arts Council,* for their continued recognition of the vital role The Center plays in the Cleveland and northern Ohio communities, and for their special assistance for *Outside the Frame.* The Center is extremely honored to have *Outside the Frame* supported in part through grants from the *National Endowment for the Arts* and *The Rockefeller Foundation,* and from *The Warhol Foundation for the Visual Arts,* who provided additional financial assistance to publish this catalogue. Further sponsorship for the exhibition was generously provided by *B&B Appliance* and *Omni International Hotel.* The presentation of *Outside the Frame* at Snug Harbor Cultural Center is sponsored, in part, by Philip Morris Companies Inc. Research into the field of recent and experimental contemporary art and cultural thinking is only possible through the generosity and foresight of such institutions, agencies, and corporations.

Introduction

Marjorie Talalay and David S. Rubin

Outside the Frame: Performance and the Object is a landmark exhibition for Cleveland Center for Contemporary Art. Opening during the institution's 25th Anniversary Season, *Outside the Frame* is the most ambitious project initiated and presented by The Center. In addition to serving as the first survey of the history of performance art in the United States, the exhibition continues the organization's long-standing involvement with the performance genre. In 1978, The Center presented a performance by Laurie Anderson, who was then a relatively little-known artist. Other performance projects include the 1984 exhibition *Rauschenberg/Performance* and several recent collaborations with Cleveland Performance Art Festival.

Plans for a major exhibition on performance art history began in the fall of 1990, when Marjorie Talalay (Founding Director, Cleveland Center for Contemporary Art) and David Rubin (Associate Director/Chief Curator) invited Thomas Mulready (Director, Cleveland Performance Art Festival) and Roger Copeland (Professor of Theater and Dance, Oberlin College) to join them in preliminary discussions, with the intention of defining the project. Working together, this group determined that the exhibition would be a collaboration between The Center and the Performance Art Festival. They proposed candidates for an advisory planning committee, curators, catalogue essayists, and artists who might be included. Initially, artists were considered in terms of their focus on art objects (which might place them in the exhibition), or their leanings towards theater (hence putting them into the live performance category). From the outset, there was a consensus that the exhibition should focus on the relationship between performance and the visual art object and that the exhibition not be static. Also at this very early stage, Thomas Mulready suggested the appropriate title *Outside the Frame: Performance and the Object*.

In 1991, The Center received a grant from the National Endowment for the Arts to help support the planning stage of *Outside the Frame*. David Rubin was designated Project Director, Thomas Mulready was hired as a consultant to facilitate the planning meetings, and an Advisory Committee was formed. Those serving on the Committee were Jacki Apple (Writer and Performance Artist, Los Angeles), Roger

Copeland, John Killacky (Curator of Performance Art, Walker Art Center, Minneapolis), and Barbara Tsumagari (former Director, The Kitchen, New York).

The Advisory Committee held its first meeting at The Center in January 1992. At this meeting, the Committee engaged in lively discussion about the scope and structure that the exhibition should take. It was recommended that the exhibition should break barriers, be nonlinear in structure, and be divided into four focus areas:

(a) identity/body, self/object, autobiography;

(b) temporality;

(c) site, ritual, spectacle; and

(d) social/political issues, media/popular culture.

The panel agreed that the exhibition should also contain video components, including:

(a) documentation;

(b) performance for video;

(c) video art related to performance; and

(d) live interactive video.

Other suggestions were that live, interactive performances be held in the gallery and that site-specific environments be created by nationally prominent artists; these could then be animated further by local artists. The group was unanimous in its consensus that the exhibition provide audiences with a performative experience in the spirit of contemporary performance art and that it not be merely a reconstructive project. It was determined that it should contain a timeline of performance art history since around 1900 and be available for travel.

At its second meeting, held in March 1992, the Advisory Committee reviewed the applications of candidates for Curator, all of whom had been solicited by the Committee. The Committee recommended that the exhibition be co-curated and proposed a collaboration between Robyn Brentano, an MA candidate in the Department of Performance Studies and the Ethnographic Film Program in the Department of Anthropology at New York University, and Olivia Georgia, Director of Visual Arts, Snug Harbor Cultural Center, Staten Island, New York. It was felt that Brentano's

extensive production experience would complement Georgia's exhibition planning background to yield exciting results. Although the two had never met prior to this undertaking, Robyn Brentano and Olivia Georgia were hired as Curators for *Outside the Frame* in July 1992. Concurrently, Thomas Mulready was appointed Performance Coordinator.

Robyn Brentano and Olivia Georgia are to be congratulated for the extraordinary amount of time and diligent effort that each contributed to the realization of this groundbreaking project. Working at times independently but more often in collaboration, Brentano and Georgia developed a comprehensive list of artists for both the exhibition and its live performance components. Guided by the criteria established by the Advisory Committee, the Curators selected every object and installation. They contacted lenders and institutions to secure loans, initiated contract negotiations with artists and performers, contributed to and facilitated grant proposals, researched and wrote the historical timeline, catalogue essays, and didactic wall text, advised on a multitude of technical requirements, and designed and oversaw the installation. Through their insightful essays, they have placed an enormous body of work into historical and cultural contexts and provided a significant document that should open the doors for much further investigation.

This year, Cleveland Performance Art Festival shifted its focus to serve as co-host for *Outside the Frame*. In addition to its annual program of juried and non-juried performances by established and emerging artists from around the country, the Festival included historical recreations and new performances by artists who were selected by Robyn Brentano and Olivia Georgia. As Performance Coordinator, Thomas Mulready oversaw the implementation of the performances that took place in Cleveland, both at The Center and off premises. Mulready assisted in finalizing contract negotiations, organizing artist travel, coordinating performance workshops, and marketing the project to the local community. We are particularly grateful to him for arranging *Outside the Frame* performance events at the Cleveland International Film Festival, Cleveland Public Theatre, The Cleveland Museum of Art, The Idea Garage, Karamu House, Oberlin College, Severance Hall, and SPACES.

Support for *Outside the Frame: Performance and the Object* was made possible by two grants from the National Endowment for the Arts; the first was for the planning phase, and the second was for the implementation. Funds for the exhibition were also

provided by The Rockefeller Foundation, The Cleveland Foundation, The George Gund Foundation, and Ohio Arts Council. The Andy Warhol Foundation for the Visual Arts contributed to the support of this catalogue, and B & B Appliance assisted with the exhibition's technical equipment requirements. Hotel accommodations for visiting artists were donated by Omni International Hotel.

We are very fortunate to have been assisted in the preparation of this exhibition by several student interns. At The Center, Julie Manke handled numerous administrative details, including documentation of information for the exhibition checklist and securing of photographs for the catalogue and timeline. Scott Cataffa served as chief liaison for Suzanne Lacy's workshop and installation. Jennifer Breckner researched and produced educational materials for use in docent training, and prepared a timeline of cultural history.

We are also indebted to the hardworking staff members of Cleveland Center for Contemporary Art. Anna Spangler compiled the exhibition checklist and Grace Garver produced detailed financial reports for all aspects of the exhibition and performances. Ray Juaire researched equipment needs and solved numerous technical challenges, while Dann Witczak orchestrated a mammoth and complex shipping itinerary. Additional administrative assistance was provided by Heather Mackey and Andrea Cipriani. All members of The Center staff participated in the final stages of the exhibition's installation.

At Snug Harbor Cultural Center, Olivia Georgia was assisted by Michele Bernatz, Eva Capobianco, Stephanie Conforti, Mindy Meinders, Michael Ryncavage, and Margaret Sundell.

The Center is proud to present this catalogue as the first in-depth study of the history of performance art in the United States since the 1950s. Robyn Brentano and Olivia Georgia have synthesized a wide range of information, based on research, interviews, and each of the curator's firsthand experiences with performance. Accompanying their catalogue essays are illustrations of works and performances from the exhibition. An historical timeline, an important ancillary component of the exhibition, is reproduced here as well. This extraordinary document highlights the major performance events of the past one hundred years and is followed by a selection of photographs that were mounted with the timeline. A complete checklist of objects, installations, and performances from *Outside the Frame* is also provided here, along with an

informative bibliography. The catalogue was co-ordinated by The Center's Executive Director, Gary Sangster, and edited in various parts by Pam Esch, Heather Mackey, Katherine Mills, Anna Spangler, and Mark Stupi.

No exhibition of this magnitude could be realized without the diligence of those who have provided us with research materials and photographic documentation. We are most appreciative of assistance from these many individuals, whose names are listed in a separate acknowledgment. In addition, we are grateful to the artists, lenders, and collaborators for their time, generosity, and enthusiastic responses to the unique challenges of *Outside the Frame*.

Plates

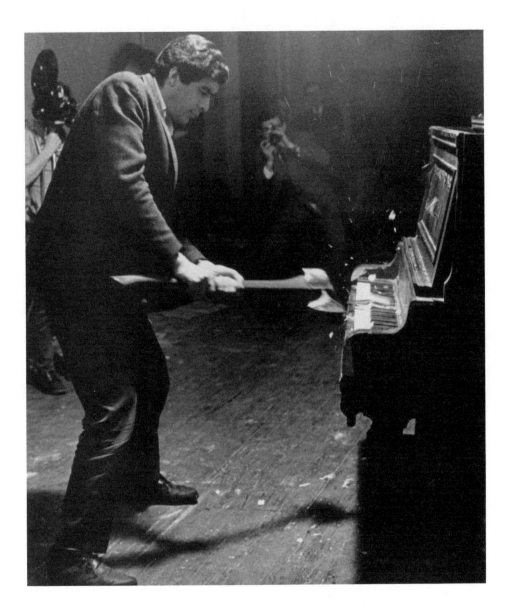

Raphael Montanez Ortiz
Piano Destruction Concert, New York 1967
Photographic documentation of performance
Courtesy of the Artist

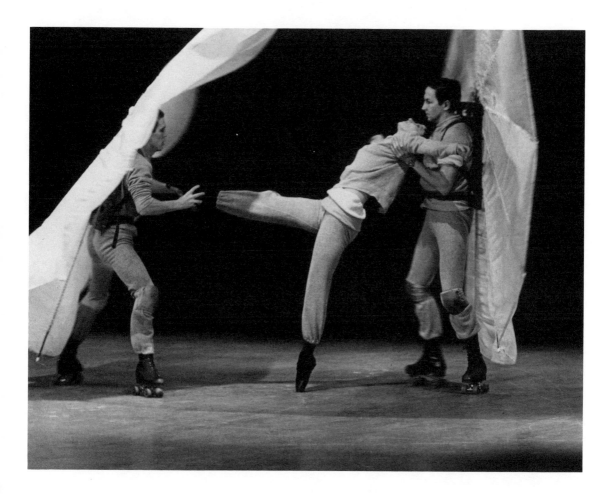

Robert Rauschenberg
Pelican, 1965
Performers left to right: Alex Hay, Carolyn Brown, and Rauschenberg
Photograph: Peter Moore

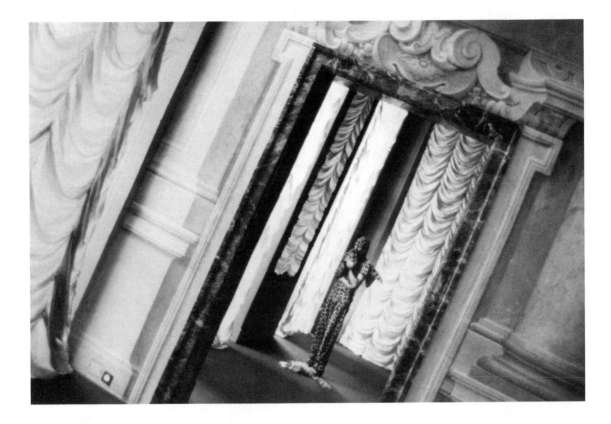

Jack Smith
Untitled, 1981
Photograph of Jack Smith wearing leopard costume
Courtesy of The Institute for Contemporary
Art/P.S. 1 Museum and The Plaster Foundation

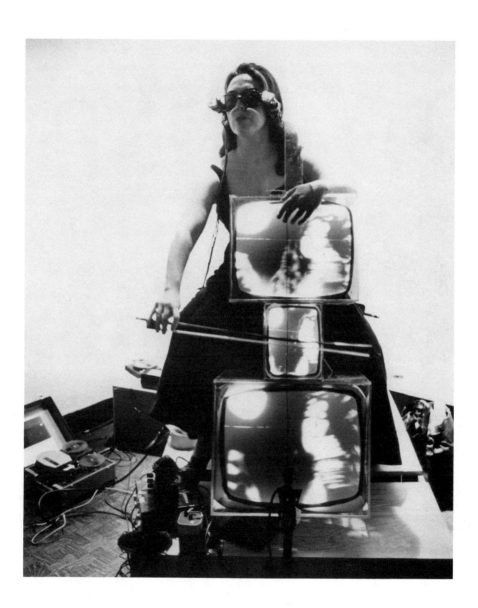

Nam June Paik
TV Cello, 1971
3 video monitors, plexiglass, laser disc and player
Performer: Charlotte Moorman
Photograph: © Peter Moore

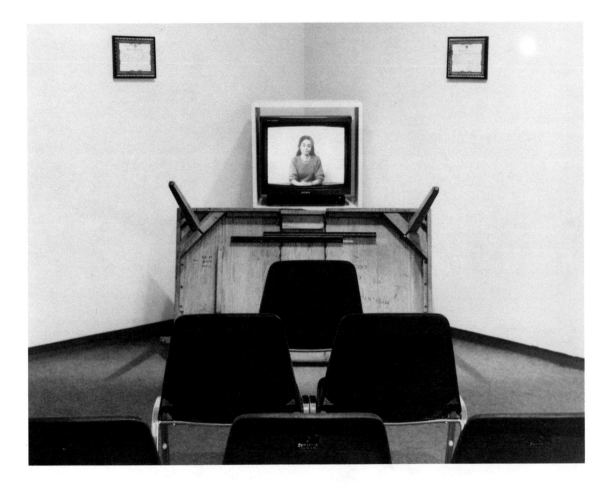

Adrian Piper
Cornered, 1988
Video installation with birth certificates, videotape, monitor, table, and ten chairs
Dimensions variable
Photograph: Courtesy of MCA, Chicago

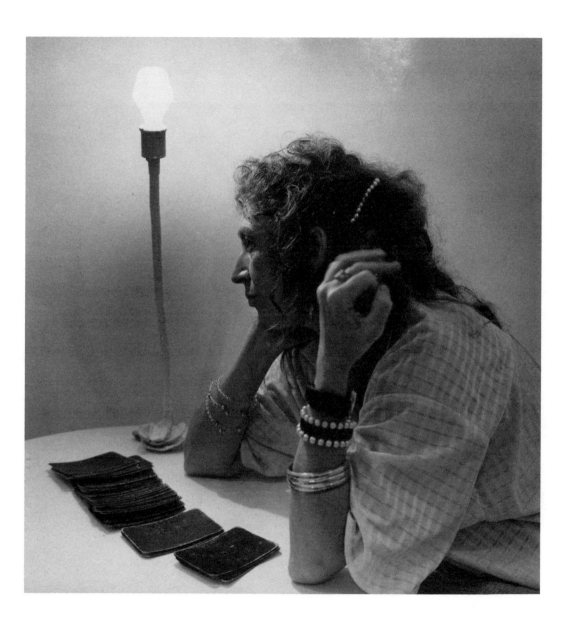

Linda Montano
Tarot Readings, 1991
at The New Museum of Contemporary Art, New York
Photograph: Ellen Jaffe

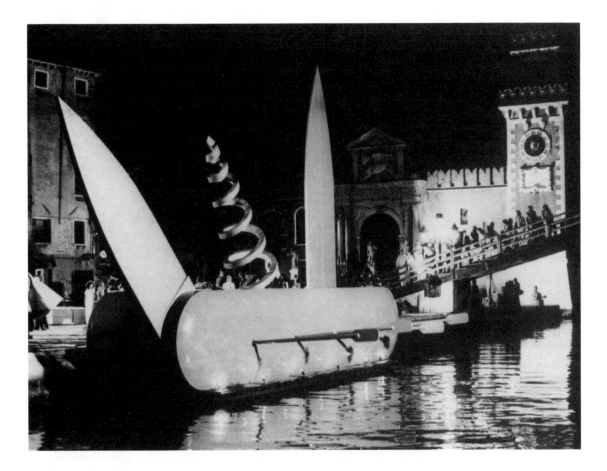

Claes Oldenburg, Frank O. Gehry, and Coosje van Bruggen
The Knife/Ship from Il Corso del Coltello, 1985
Photographic documentation of performance
Courtesy of Claes Oldenburg and Coosje van Bruggen

Robert Whitman
Raincover
Performer: Unidentified
Photograph: Nancy Campbell

Outside the Frame: Performance, Art, and Life

Robyn Brentano

Performance has been a powerful catalyst in the history of twentieth-century art not only because it has subverted the formal conventions and rational premises of modernist art, but also because it has heightened our awareness of the social role of art and, at times, has served as a vehicle for social change. Since the early decades of this century, artists' performances have assumed a confrontational and iconoclastic role in relation to institutional art-world practices, aesthetic traditions, and social norms. Underlying their oppositional stance, however, is a redemptive belief in the capacity of art to transform human life, whether on an individual or collective level, or that of the artist or viewer. The early "public confrontations" of the Futurists, for example, were intentionally irritating and scandalous, designed to gain public attention for the ideas of Marinetti and his followers. While assaulting their audiences with "noise music" (cacophonous sounds of military battle or a modern city), they delivered manifestoes with a grating, mechanistic brio, attacking the academy, museums, libraries, archaeologists—in short, any institution or profession that treated art as a commodity, a dead object to be kept behind walls.

The Futurists envisioned an art of the streets, of technology and speed, of danger and hyperbole. This type of aggressive, antiestablishment attitude has been associated (correctly) with performance art[1] throughout this century, overshadowing at times its more elusive and metaphysical manifestations. In any case, artists have used performance to challenge our assumptions about the relationship between art and life, and, in the discoveries they make at the borders of experience, to find fresh ways to envision the world.

A virtual explosion of performance work since the late 1950s reflects a vitality born of artistic and cultural diversity. What has come to be called performance art in the United States[2] has taken myriad forms, a result of its interdisciplinary nature (drawing from painting, sculpture, dance, theater, music, poetry, cinema, and video) and disparate influences, including the European avant-garde (primarily the Futurists, Dadaists, Constructivists, and Surrealists), Abstract Expressionism, performance and art traditions of Native American and non-European cultures, feminism, new communications

technologies, and popular forms such as cabaret, the music hall, vaudeville, the circus, athletic events, puppetry, parades, and public spectacles.

The term "performance art" first appeared around 1970 to describe the ephemeral, time-based, and process-oriented work of conceptual ("body") and feminist artists[3] that was emerging at the time. It was also applied retrospectively to Happenings, Fluxus events, and other intermedia[4] performances from the 1960s. Over the past thirty-five years, many styles and modes of performance have evolved, from private, introspective investigations to ordinary routines of everyday life, cathartic rituals and trials of endurance, site-specific environmental transformations, technically sophisticated multimedia productions, autobiographically based cabaret-style performance, and large-scale, community-based projects designed to serve as a source of social and political empowerment.

In recent years, the appropriation of the term by the entertainment industry, the commodification of some artists' work in other media such as photography, video, compact discs, film, and television, and a shift to more conventional narrative and theatrical forms have removed performance art from its earlier, radical focus on creating unmarketable work that was meant to undermine the commercial interests of the gallery system. With the politicization of performance in the current struggle over freedom of expression in the United States,[5] and its movement toward popular entertainment forms, the place of performance as a practice within the visual arts is being further attenuated.

In 1990, Kristine Stiles pointed out that despite numerous writings by "American artists who pioneered performative art . . . several historical surveys . . . along with hundreds of articles and dissertations, . . . performance art has remained institutionally marginal, largely absent from the official histories of modern art."[6] One of our goals in organizing *Outside the Frame: Performance and the Object* is to provide a fresh opportunity to examine the practices and concerns of performance art, which is entering a phase of maturity as a genre, and thus stimulate further research in the field.

This essay is not an attempt to provide an overview or survey of the field of performance art. Rather, it focuses on some of those moments or pieces that reveal the dialectical relationship between art and life which artists have encountered through their performances. The work I have chosen to discuss here is meant as exemplary—many more equally important pieces could be cited. Although I consider productions that are concerned with or involve the use of communications media and technology or

that are more theatrical in their mode of production as engaging "real life" issues, I have not included them here for lack of space. Artists such as Laurie Anderson, Eric Bogosian, Ping Chong, Richard Foreman, Spaulding Grey, John Jesurun, Joan Jonas, Meredith Monk, Theodora Skipitares, and Robert Wilson have all made major contributions to the development of performance art; their work deserves extensive discussion, a project far beyond the scope of this essay.

As several scholars have noted,[7] performance has become a marker for the shift between modernism and postmodernism. In his seminal essay, "Pictures," Douglas Crimp (referring to critic Michael Fried's famous 1967 attack on minimalism) argued that the characteristics of performance—of being "between the arts," of temporality, and requiring the informing presence of the spectator—constituted the break with modernism. In effect, performance was replacing the modernist notion of a work of art as a formal, bounded, material object, with its meaning already inscribed, with a more open-ended view of art as a transaction between artist, object, and perceiver.[8] Although the point at which this shift began is open to debate, an examination of the history of performance may show that it was in motion well before the 1960s, the period generally accepted as the hinge between modernism and postmodernism. Indeed, many of the characteristics of performance that scholars have cited to qualify it as a postmodern phenomenon—its interdisciplinary, collaborative, antihierarchical, contingent, and indeterminate qualities—are all aspects of performance that were evident in the modernist setting (in Dada, Futurism, and Surrealism), not to mention "traditional" forms such as ritual.

It is somewhat misleading to describe performance as a single genre because many local factors—audience, space, and the community of artists—as well as broader social and political conditions, and differences in the sensibilities of individual artists, have contributed to the formation of many kinds of performance work. As various groups, communities, and movements have coalesced since the 1960s, distinct styles of performance have emerged, each with its own ideological framework. Admittedly, the aesthetic and cultural diversity of performance art calls for multiple perspectives to discuss it adequately, and in tracing its development, it is important to attend to these differences. At the same time, to begin to delineate the features of performance, it is useful to keep in mind that they are rooted in the inquiry into the relationship between art and life. Some artists working in performance question the validity of mixing art and

life, preferring to treat art as that liminal space outside the ordinary where symbolic action and imagery can mediate the unspeakable and the unknowable. Others are motivated by the desire to blur or dissolve the boundary between art and life. In a literal sense, this means that these artists incorporate materials and behavior from everyday life into their work or that they expand the frame of art to include the activities of their daily lives. It also means that aesthetic developments in performance art have been tied as much to personal and social issues as they have to a rebellion against earlier artistic forms. Certainly a great deal of performance art has been about formal experimentation and visual pleasure, but it has also been driven by other interests, such as the body (and the politics of the body), identity, ritual as a mode of discovery and healing, and the media and technology (both as new imaging sources and as tools of mass culture).

From the turn of the century, the historical avant-garde considered the reintegration of art and life to be essential to the transformation of an ossified and morally corrupt society. Artists sought ways to remove art from its institutional confinement and to open up the creative process itself to influences from beyond the context of art. The Dada artists who gathered in Zurich just after World War I seized on the principle of chance as a mechanism for liberating their paintings and performances from the conventions of art and the restrictions of speculative thought that had been governing Western art for centuries. By giving over rational control of their work to "spontaneous acts," they hoped to gain access to the subconscious and reveal its "primitive coherence." For Hans Arp, who developed a full-blown improvisational method for working on his "automatic drawings," "chance opened up perceptions to me, immediate spiritual insights."[9]

The principle of chance was crucial to the Dada concept of performance. In the manner of collage, it allowed the artists to bring together on the same stage, and sometimes simultaneously, an entire range of heterogeneous elements and media: "music, the dance, theory, manifestoes, poems, pictures, costumes and masks."[10] Chance facilitated an absurdist mode of expression by combining incongruous elements and by heightening the transient, ugly, accidental, humorous, and (in the tumultuous milieu of the Cabaret Voltaire, where the Dada artists convened) the riotous qualities of performance. Spontaneity and laughter were their response to the bourgeois complacency and social chaos of postwar Europe.

In addition to chance and simultaneity, another aspect of Dada acting that was

to have a profound effect on performance art was the rejection of theatrical characterization and settings (in the conventional sense of providing a time and place for a fictional event). For all their use of costumes and masks, Dada actors always retained their offstage identity. The audience always knew very well who they were. In the same way that they attempted to remove their egos from the creative process, they were not interested in displaying the skills of the trained actor, which depend upon rehearsal and the ability to remain hidden behind a role. They were far more interested in the spontaneous eruption of unbidden acts. The stage was always the stage, and if the costumes and décor did anything, they called attention to its artifice by playing up its ramshackle, makeshift qualities. Part of the shock value of these performances lay in their refusal of artistry and permanence. Their attack on the public succeeded in part by frustrating the public's expectations that they would be entertained.

Although the period following World War II was a time of political and social conservatism, profound changes were underway in the arts that led in the late 1950s and early 1960s to the emergence of radically new forms of artistic thought and practice. In the visual arts, a number of developments contributed to the creation of Happenings, the formation of Fluxus, and a host of other interdisciplinary performance activities. Two of the most immediate influences were Jackson Pollock's action painting and John Cage's ideas and work. Each in his own way represented the fusion of art and life.

When Pollock removed his canvas from the stretcher, placed it on the floor, and began to drip and splash paint on it from above, he changed the concept of what a painting is. Movement and the artist's being became integral parts of the work. When Hans Namuth filmed and photographed him at work and these images entered the culture at large, Pollock became an icon of the artist as performer. As critic Harold Rosenberg commented, "What was to go on the canvas was not a picture but an event. A painting that is an act is inseparable from the biography of the artist. . . . The act—painting—is of the same metaphysical substance as the artist's existence. The new painting has broken down every distinction between art and life."[11]

In his class on experimental music at the New School for Social Research from 1958 to 1959, John Cage presented his theories on composition to a group of young musicians, artists, poets, and filmmakers that included George Brecht, Al Hansen, Dick Higgins, Allan Kaprow, Alison Knowles, and Jackson Mac Low—all of whom would go on to pioneer Happenings and Fluxus events. He gave the students performance

assignments to develop solutions to compositional problems. He encouraged them to use unconventional instruments, to work across disciplinary lines, and to discuss the philosophical implications of their solutions. His ideas about the interdependence of art and life introduced new ways of thinking about the creative process and the limitations of working within traditional forms. Combining a pursuit of Zen Buddhism as a way of life and his interests in Duchamp, Dada, Futurism, Surrealism, and Artaud's Theater of the Absurd, Cage developed a seminal approach to composition.[12] To him, writing music was "an affirmation of life—not an attempt to bring order out of chaos or to suggest improvements in creation, but simply a way of waking up to the very life we're living, which is so excellent once one gets one's mind and one's desires out of its way and lets it act of its own accord."[13]

Although Cage's views were criticized in the 1960s for their apparent disregard of political and social realities,[14] they did suggest a revolutionary transformation of life through the removal of the ego. Like the Dada artists, Cage used chance and indeterminacy to remove himself from the creation of the work, but he gave special emphasis to awareness itself as an important component of the work of art. His 1952 composition, *4'33"*, for example, consists of three movements, each signaled by the raising and lowering of the piano keyboard cover. Otherwise, the performer remains silent and at rest for the duration of the piece, allowing whatever sounds that occur by chance to constitute the work. When David Tudor performed it for the first time in Woodstock, New York, the wind in the trees, raindrops on the roof, and mutterings of bemused and disgruntled audience members became the content of the work. The point was not only to accept everyday noise as music (a principle advanced by the Italian Futurist Luigi Russolo in his "noise music"), but also to bring the artist's heightened awareness—the same awareness that arises in a performance situation—to the small details of everyday life. In focusing on attention itself, on the subjective experience of both the performer and the audience member, Cage laid the groundwork for Happenings and Fluxus, where perceptual and bodily experience were a major consideration of the way the performance was structured and perceived.

In 1952, Cage organized an untitled interdisciplinary event at Black Mountain College that was to become the prototype for Happenings. Conceived over lunch and performed the same evening without rehearsal, script, or costumes, Cage, together with Merce Cunningham, Robert Rauschenberg, David Tudor, and the poets M. C. Richards

and Charles Olson, presented simultaneously various unrelated images and activities—poetry, paintings, lectures, dancing, music for prepared piano and gramophone, films, and slides—in a playing space configured to place the audience in the midst of the action. This multifocal mode of presentation denied the conventional theater's organization of privileged dramatic moments and instead required viewers to pay attention to the work as an entire field of action. It also challenged the modernist hierarchical ordering of mediums by positing instead the inherent equality of its separate elements. In the simultaneous juxtapositioning of independent elements, the viewer was free to discover new meanings or to abandon meaning altogether.

The strategies of simultaneity and the restructuring of space to involve the audience more directly with the performance were aspects of a broader philosophical shift that was occurring in the culture at the time. As Sally Banes points out in *Greenwich Village 1963*, her study of the New York avant-garde in the early 1960s, "Cage's embrace, in the Fifties, of Zen Buddhism, led to a non-hierarchical, non-judgmental appreciation of dailiness and the commonplace."[15] He was also influenced by Erik Satie, whose "work accorded with the Zen tenets of renunciation and the acceptance of the world-as-it-is,"[16] and Marcel Duchamp, who introduced found objects into an art context when he exhibited his first "ready-made," *Bicycle Wheel,* in 1913. Robert Rauschenberg, who participated in the 1952 event at Black Mountain and who began to design costumes and sets for the Merce Cunningham Company in 1954, paralleled Cage's interest in the mundane by incorporating everyday objects, often junk from the streets, into egalitarian arrangements he called "combines," for the way they blended painting, collage, and sculpture.

According to Banes, the recuperation of the ordinary took hold as an informing sensibility in the 1960s because, given the political tenor of the period, it came to represent "the populist aims of accessibility and equality—for both artists and audiences."[17] This attitude permeated the avant-garde, bringing sweeping changes in style and subject matter to poetry, dance, theater, film, and music. Banes points out, however, that "for this predominantly white avant-garde of the early Sixties, the notion of equality was a generalized one . . . their aim was the democratization of the avant-garde in terms of class, and sometimes gender, but not race or ethnicity."[18] Because the avant-garde was tied to the larger Euro-American art-world structures (despite its efforts to remove itself both ideologically and in practice from those associations), access

remained closed to African-Americans for the most part. Still, American popular culture had for decades been influenced by African-American performers and performance traditions. The white avant-garde's interest in and appropriation of African-American dance, music, visual art, and literary idioms, styles, and values was motivated by a complex mixture of genuine respect for and appreciation of African-American artistic achievements, a romanticization of blacks that reinforced certain racial stereotypes, and a sense of a shared antibourgeois stance.

In the emerging intermedia genres of Happenings, Fluxus, and the Judson Dance Theater, the desire to level differences—between "high" and "low" culture, between media, and between artist/performer and spectator—contributed to the development of new temporal and spatial structures, the use of ordinary materials and settings, and a movement vocabulary from daily life, including games and sports. Collaborations among artists, dancers, musicians, and poets (which occurred in part by virtue of the close social and personal relationships in the community) helped to blur the boundaries between disciplines and to break down the notion of specialization. New ideas about the body, the nature of movement, and performance attitudes were being developed by the members of the Judson Dance Theater, some of whom—Trisha Brown, Simone Forti, Robert Morris, Yvonne Rainer, and La Monte Young—had studied or collaborated with Anna Halprin, a San Francisco-based choreographer who, in the 1950s, used natural movement and tasks as a basis for choreography.

Productions took on a deliberately rough-hewn, homemade quality as the artists improvised with whatever materials they had at hand in whatever spaces they could commandeer: storefronts, garages, church basements, rooftops, homes, and lofts. The early Happenings and environments of Jim Dine, Red Grooms, Al Hansen, Allan Kaprow, Claes Oldenburg, and Robert Whitman were cobbled together from cardboard, rags, paper, plastic, and refuse from the streets, giving their work a cluttered, unruly feeling. Oldenburg's tableau, *The Street*, and Dine's environment, *The House*, were identified by the artists as being "derived from American popular art, street art and other informal sources."[19] Performances were often intimate (usually the spaces were small and the audiences comprised friends and family), and a casual, unpolished performance style encouraged either a committed audience-participation, or a level of engagement uncommon in the theater and missing from gallery viewing altogether.

It was the desire to create a situation in which viewers could physically engage

with his environments that led Allan Kaprow to produce *18 Happenings in 6 Parts* at the Reuben Gallery in October 1959.[20] For a while, for both practical and theoretical reasons, Kaprow sought out nonactors for his Happenings. Most were friends—artists, poets, and musicians—who were readily available and who, because they were untrained in conventional theatrical techniques, did not project a self-conscious sense that they were performing. Eventually, he completely did away with the division between performer and spectator, turning everyone who attended his Happenings into participants.

Robert Whitman did not encourage his audiences to participate in his "theater pieces" (a term he preferred to Happenings), but he did envelope them in three-dimensional environments in which projected slide or film images and live activities created a dreamlike flow of images. In *American Moon* (1960), one of his earliest pieces, the audience watched the performance from six tunnels that radiated out from a central playing space. The action happened above and around them, and at one point, plastic sheets partially covered with paper rectangles dropped over each opening and films were projected onto the sheets from the rear of each of the tunnels. The audience could also see the film that was being projected onto the opposite tunnel's screen. Even though Whitman's pieces tended to use evocative, sometimes shocking images that suggested primordial scenes or bodily processes with potent psychological associations, he undermined the sense of total theatrical illusion by combining mysterious technical effects with homemade objects and a deadpan style and timing.

While most of the performance events took place in lofts and spaces like the basement of the Judson Memorial Church in Greenwich Village, some of the artists looked for alternative settings to stage their pieces. Allan Kaprow and Claes Oldenburg were particularly resourceful in finding unusual locations for their performances. Kaprow made use of the cavelike interior of the Ebling Brewery in the Bronx (*Eat*, 1963), the courtyard of an abandoned hotel in the Village (*Courtyard*, 1962), various sites around the City of New York (*Calling*, 1965), rural settings such as George Segal's farm, and a Long Island beach (*Gas*, 1966).

Oldenburg presented a series of performances at his storefront, the Raygun Mfg. Co. on East Second Street, in some empty suburban houses near the Dallas Museum of Contemporary Art (*Injun*, 1962), at a downtown parking lot in Los Angeles where the audience sat in cars and used their headlights to illuminate the event (*Autobodies*,

1963), and in the swimming pool of Al Roon's Health Club (*Washes*, 1965). His last performance work, *Il Corso del Coltello* (*The Course of the Knife*, 1986), which he created with architect Frank Gehry and art historian Coosje van Bruggen, was designed for the Arsenale, the ancient shipyard of Venice. His signature large-scale sculptures, the central image of a Swiss army knife (which was realized as a full-scale ship that passed through the canal bisecting the Arsenale), and the activities, characters, and objects that gathered around the central plaza were all conceived to activate the architectural qualities of the space.

Not all of the artists who were involved with Fluxus[21] shared George Maciunas's socialist aspirations for the group as a viable economic and politically engaged collective, but all were drawn to the group's Dada-inspired sensibility, which held that art should not be separate from life and that it should embody the principles of change, fluidity, and indeterminacy that characterize daily life. As an artistic discipline, Fluxus explored the interstices between the media of music, painting, sculpture, poetry, dance, and theater, producing hybrid forms that were governed by the logic of incongruity and an intentional (con)fusion of sensory modes. Chieko Shiomi's *Disappearing Music for Face* (1964), for example, was an entirely "visual music" that consisted of a full smile slowly fading to no smile (over five minutes in performance and twelve minutes in its film form).

In contrast to the exuberant gesturality of Abstract Expressionism (which lent Happenings their textural richness and expansive flavor), Fluxus was concerned with the reduction of gesture, with discovering the essence of artistic practice. The aim was to employ the minimum amount of energy to produce the maximum meaning. This was a notion that George Brecht excelled at demonstrating in his objects and scores, such as the one for *Word Event*, in which the word 'exit' is simply written or posted in the performing space, or

> Three Aqueous Events
> - ice
> - water
> - steam

which points to the world as process and to performance as an energy field that can take any form. Trained as a chemist, Brecht liked to use scientific paradigms such as "space-time, inseparability of observer-observed, indeterminacy, physical and conceptual multi-dimensionality, relativity, field theory, etc." to conceive of his art.

With a predilection for indeterminacy and the minimal, Fluxus events were usually deadpan, literal-minded, and dryly humorous executions of simple activities that anyone with an interest in observing thought in action could perform. As Dick Higgins has noted, the tendency in Fluxus is weighted toward the conceptual, with many artists proposing work that could only possibly exist as mental events. Many of Yoko Ono's "instruction pieces" (which were composed in the 1950s and early 1960s) anticipated conceptual art later in the decade for the way that they focus on perception or the idea itself. In works such as:

> CLOCK PIECE: make all the clocks in the world fast by
> two seconds without letting anyone know about it
> TAPE PIECE I: Stone piece take the sound of the stone aging
> WIND PIECE: make a way for the wind[22]

Ono was asserting a model of art in which awareness and imagination are primary, and the artist is no longer a specialist but can be an ordinary person.

This view of art was widely shared by other Fluxus artists. As Ken Friedman put it, "Fluxus invites each human, every human to come forward, to work or to play. The ritual is interactive, the audience can address, transform, change."[23] Thus, the audience could participate with the artist in communal activities such as Alison Knowles's *Proposition*, in which the artist made a salad for everyone in the audience, or they could be the performers themselves, as in Knowles's *Shoes of Your Choice*. Here, "a member of the audience is invited to come forward to a microphone if one is available and describe a pair of shoes, the ones he is wearing or another pair. He is encouraged to tell where he got them, the size, color, why he likes them, etc."[24] Knowles transposed the concept of participatory performance to the gallery setting for pieces such as *Little Winter Moon's Younger Brother*, in which the viewer is invited to make sounds with all sorts of found objects that the artist has placed in a white circle on the floor. The mood of the piece is playful and contemplative, calling for the viewer to attend to his or her own thoughts along with the physical activity.

While audience participation in performance enacted the egalitarian ideals on the rise in the early 1960s, it also helped to undermine the inherently voyeuristic nature of the theatrical situation by reducing or eliminating the gap between viewer and

performer. In *Cut Piece* (1964), Ono directly confronted the problematic aspects of the performer-spectator relationship by placing herself in a position of extreme vulnerability. She invited members of the audience to cut away pieces of her clothing until everything was gone, while she sat motionless on the stage. The piece challenged participants (and viewers) to contemplate their own potential for violence against others and, on another level, to take responsibility for their aesthetic experience. In light of the civil rights movement and the ongoing Vietnam war, Ono's performance had a strong political message, even though it remained implicit.

The relationship of avant-garde performance to the political realities of the 1960s is a complex subject, and impossible to characterize in a few short sentences, in part because it continued to change throughout the decade. While many individual artists were committed activists who participated in grass-roots activities, performances in the early sixties generally were focused on aesthetic innovation and lacked explicitly political content. There was a sense in the air then that art would contribute to social change by changing consciousness and by operating outside the institutional confines of the art establishment where it could reach a non-art public. It was not until the mid-1960s that artists began to address specific political issues in their work or to place their work in a political context; for example, Carolee Schneemann's anti-Vietnam war theater piece *Snows* (1967), and *12 Evenings of Manipulations* (1967), organized by Jon Hendricks at the Judson Memorial Church, with performances by Raphael Montanez Ortiz, Bici Forbes, Allan Kaprow, Lil Picard, Jean Toche, Geoffrey Hendricks, Kate Millett, Al Hansen, Nam June Paik, Charlotte Moorman, Schneemann, and others, which were concerned with a host of issues—from the war and racism to social inequities rooted in class differences.

The German-born sculptor and dancer Peter Schumann took a decidedly political stance in his work when he founded the Bread and Puppet Theater in 1962 and began producing social protest plays in the Lower East Side community where the Theater was located. Transposing the traditional forms and humble means of German folk theater, Sicilian and Balinese puppetry, and Japanese bunraku to a modern context, Schumann worked with ordinary people in the streets and parks to create an expressionistic, nonverbal theater of images directed at the high rents, bad housing, rats, and police problems in the community. A core group formed, the puppets grew in size, and the Bread and Puppet Theater began to create Christmas, Easter, and Thanksgiving

pageants. In 1964, when President Johnson ordered the bombing of Vietnam, the group began its lifelong struggle against the loss of innocent lives in the name of patriotism. Throughout the 1960s and until the end of the war, the Bread and Puppet Theater staged processions and vigils as part of every major antiwar demonstration in the eastern United States.

In 1970, when it lost its New York City rehearsal space, the Theater moved to Vermont, where it initiated the *Domestic Resurrection Circus*, an annual two-day event combining medieval pageantry, vaudeville variety shows, and a larger-than-life circus that focuses on a particular theme, such as nuclear annihilation or US imperialism in Central America. The Theater's current project, *Fly or Die*, grew out of Schumann's concern for the tragic circumstances in Bosnia. It portrays the moral bankruptcy of all those who sit idly by, allowing the suffering to continue. (Schumann's installation in *Outside the Frame—Ex Voto for Bosnia*—is derived from this project.)

When Yves Klein used his models as "living brushes" to apply paint to large canvases in *Anthropometries of the Blue Period* (1960), he formed a link between Pollock's gestural approach to painting and body art of the late 1960s. Actually, in 1955 and 1956, Kazuo Shiraga, a member of the Japanese Gutai group (which had seen the Namuth film of Pollock at work), used his own body to create two paintings: in one, he entered a shallow pool of mud and moved about, making various patterns in its surface (*Challenging Mud*), and, in the other, he soaked his feet in paint and hopped down a long piece of rice paper (*Untitled*). Together with the rags and newspapers, cardboard and castoffs of the urban environment, the body—both the artist's and the spectator's—was emerging as a medium and material for art in the early 1960s.

Whether it was the visceral, sloppy, unbounded body of early Oldenburg and Dine,[25] or the psychologically charged bodily images of Whitman's performance environments, or the personal contact between artist and spectator in Yoko Ono's *Painting to Shake Hands* (1962), or Nam June Paik's and Charlotte Moorman's irreverent and eroticized concert performances, artists were pushing at all the material, psychological, and sexual boundaries of bodily experience as a resource for their art.[26]

The Judson Dance Theater group was quite naturally involved in exploring a wide range of issues related to the body, from the limits of physicality to the representation of gender in classical and popular dance. In an effort to eliminate (or at least reduce) the fixation on gender that inhibits the perception of the body as an object in motion,

Steve Paxton and Yvonne Rainer collaborated on *Word Words* (January 1963), a ten-minute work which they performed in near-total nudity and in complete silence.[27] They each executed the same movement sequence solo and then together. Rather than call attention to their sexual difference, the dancers' affectless style, the repetitive structure, and the fact that they both performed the same movements forced the spectator to focus on the body in motion, stripped of gender codes. In a similar refusal of sexual encoding, Yvonne Rainer and Robert Morris performed *Waterman Switch*, a piece in which they slowly circled the dance floor face to face, totally nude, accompanied by Lucinda Childs, completely dressed. One reviewer described it as "chaste as a handshake. . . . Unsensational and unsuggestive, its attempt to shock seemed, oddly enough, only touching."[28]

These dances, by refusing the spectator's objectifying gaze, presented an image of the body at its most essential, as a site of consciousness and a source of knowledge. At a time when the body was at the center of cultural and political debates about personal freedoms (from institutional and governmental control, from racist and sexist prohibitions and violence, and from bourgeois attitudes about drugs and sexuality), performances that engaged the body as a primary image or that plumbed the connections between bodily impulses and taboo behavior were regarded as threatening or strange. When artists placed themselves at the center of their work, they did so at considerable physical and psychological risk, and their motivations were frequently misinterpreted as narcissistic or neurotic.

Artists such as Carolee Schneemann, Raphael Montanez Ortiz, Barry LeVa, Vito Acconci, Bruce Nauman, Chris Burden, Hannah Wilke, Paul McCarthy, Terry Fox, Linda Montano, Barbara Smith, and others used their own bodies to explore the outer limits of physical and psychic experience, expanding the parameters of art to include therapeutic, obsessive, and transgressive acts. In focusing on the body, their work not only forced a reconsideration of formal issues, it also foregrounded emotional, psychological, and social concerns, anticipating the autobiographical and identity-based work that emerged in the 1970s and 1980s.

Carolee Schneemann, who was active in the overlapping arenas of Happenings, Fluxus, and the Judson Dance Theater, physically entered her work in 1963 when she integrated her body into an environment composed of large painted panels, broken mirrors, glass, and moving umbrellas. She covered herself in paint, grease, ropes, and plastic and performed a "series of physical transformations" that called up the earth

goddess images that would become central to feminist art in the 1970s. The piece, which she called *Eye Body*, crystallized her thinking as a female artist. In it, she not only reclaimed her body, transforming it from object to subject, but also asserted her "creative female will" in a calculated challenge to "the psychic territorial power lines by which women were admitted to the Art Stud Club, so long as they . . . did work clearly in the traditions and pathways hacked out by the men."[29] Acting in a milieu in which the creative act was considered male, Schneemann redefined imagemaking and the use of the nude female body in her own terms. For her, the nude was "a primal, archaic force which could unify energies [she] discovered as visual information."[30] Six months later, Schneemann orchestrated these energies in *Meat Joy*, an ecstatic "celebration of flesh as material"—a ritualized commingling of bodies, raw fish, plucked chickens, sausage, wet paint, plastic, rope, and paper. Years later, Jerome Rothenberg remembered the vividness and intensity of the work as springing from a carefully choreographed juxtaposition of the full range of sensory and kinetic experiences. The combination of living bodies and animal flesh in an erotic ritual brought it, in Rothenberg's words, "down to the very reverence and terror of the enactment of our dreams. . . . It was an art that was no longer art but the precision born of art directed now towards life."[31]

For Raphael Montanez Ortiz, the value of ritual in art is as a symbolic action that enables participants to unearth and consciously experience the repressed, destructive forces of the psyche, forces that would be inaccessible or too dangerous to encounter under the conditions of everyday life. During a long period of research in the 1950s and 1960s, Ortiz studied the traditional rituals of non-Western societies, the sacrificial practices of Mezoamericans, ancient Greek and Etruscan divination rituals, and Western philosophy and depth psychology (Nietzsche, Kierkegaard, Heidegger, Sartre, Freud, and Norman O. Brown) in an effort to understand the close relationship between creativity and destruction. As Kristine Stiles points out, however, growing up as a Puerto Rican in New York City, where Ortiz was exposed to gang violence and racism, may have been the most compelling influence in his work. "Perhaps more important than the intellectual work he had undertaken, his experience in American society had prepared him best to understand the complex, damaging, and enlightening physical and psychological ritual dimensions hidden in culture."[32]

In 1966, Ortiz performed his first public "destruction rituals" in London at the Destruction in Art Symposium (organized by Gustav Metzger, John Sharkey, Bob

Cobbing, Wolf Vostell, and others). Of the several rituals he created during the Symposium, his *Self-Destruction* caused the greatest disturbance because it entailed a hysterical and violent enactment of childhood oedipal experiences. In it, Ortiz regressed to an infantile condition of dependency and rage in which he tore off his suit and then proceeded to diaper himself and act out the primal experience of loss of the mother. At the time, many found the performance too crude and raw, but as Stiles notes, "It remains today among the most daring and precocious events."[33] In its breach of rational behavior and full embodiment of extreme emotion, it helped to set the stage for much of the transgressive performance work that evolved in the 1970s and 1980s.

After returning to the United States, Ortiz created a series of "destruction realizations" that involved the ritual destruction of chickens (and/or mice) and musical instruments such as a piano or guitar. His decision to destroy the lives of animals was motivated by "his search for a profound means by which to communicate the physical and psychological brutality of destruction and for a 'more visceral way to relate to art.'"[34] In 1970, however, he stopped using the literal destruction of animals in his rituals, mainly because it contradicted his ideas about the therapeutic value of art.

By the late 1960s, in a climate of political unrest and counterculture ferment, artists were once again challenging the institution of art and the economic system that supports it. In keeping with the prevailing anti-establishment attitudes, artists sought ways to remove themselves and their work from the art market, which rested on the circulation of objects that could be bought and sold. They also began to create alternatives, both in their work and in the artist-run spaces that cropped up in the early 1970s.

With conceptual art's rejection of the art object, and building on the performative work of Happenings and Fluxus earlier in the decade,[35] artists turned to action and process as ways of investigating temporal and spatial structures, the body's kinetic and iconographic qualities, and their own psychological and psychic states of being. In some of these experiments, artists placed themselves (and, at times, their audiences) at considerable risk, creating dangerous situations or performing disturbing acts of self-mutilation, physical endurance, and self-denial in order to confront fears and inhibitions and to plumb the physical, sexual, and psychological taboos of our society.

The performances of Chris Burden and Paul McCarthy in very different ways pushed the boundaries of self-knowledge and contemporary debates about narcissism,

power, and the responsibility of the artist to his or her audience. Burden's *Shoot* (1971) is perhaps his best-known piece—a work in which he asked a friend to shoot at him at close range with a .22 caliber rifle (he was hit in the arm)—but his *Prelude to 220*, a public piece in which he lay strapped to the floor by copper bands next to two buckets of water with two live 110-volt electrical wires in them, brings out the aspects of control and trust that underlie his work. While Burden tested the limits of physical risk, Paul McCarthy indulged in monstrous behavior, exposing his audiences to disgusting and obscene acts many found impossible to watch. His performances involved ingesting, vomiting, and smearing his body with catsup, raw meat, mayonnaise, or cold cream, emulating rape and masturbation, and throwing himself around with such violence that members of the audience were forced to catch him. Barbara Smith described one of his performances as "a display of inner power, as well as a prayer coming from great need—by putting himself in such a position, he may effect the harmony and energy of wholeness. There is a sort of rapture to his display."[36] McCarthy explains, "It is my belief that our culture has lost a true perception of existence. It is veiled. We are only fumbling in what we perceive to be reality. For the most part we do not know we are alive."[37]

Sometimes performances of a highly personal nature were done without an audience in the privacy of the studio or some non-art space and later presented to the public in the form of photographic, film, or video documentation. In the mid-1960s, Bruce Nauman carried out a series of experiments in which he performed various repetitive actions, such as walking around the perimeter of a square, throwing balls, applying makeup, etc., for long periods of time—activities that required substantial physical exertion and mental concentration. These experiments were filmed or videotaped and subsequently shown, contributing to the emergence of performance video several years later.

Nauman's interest in the body was twofold: he used it as a medium or tool in creating his sculptural pieces to produce evidence of the work process or bodily gestalt in the objects themselves, and he wanted to experience the sensations generated by movement and the range of sounds that could be produced by the body. In a 1970 interview with Willoughby Sharp,[38] Nauman explained, "The first time I really talked to anybody about body awareness was in the summer of 1968. Meredith Monk was in San Francisco. She had thought about or seen some of my work and recognized it. . . . An awareness of yourself comes from a certain amount of activity and you can't get it from

just thinking about yourself. . . . The films and some of the pieces I did after that for videotapes were specifically about doing exercises in balance. I thought of them as dance problems without being a dancer. . . ."[39]

The San Francisco Bay area throughout the 1960s and early 1970s was a vital center of political and countercultural activity in which violent protest and ebullient celebration met in a highly theatrical street life. The Berkeley teach-ins, the massive Golden Gate Park be-ins, rock concerts, the 1967 Peace March, the Native American occupation of Alcatraz, and the Haight-Ashbury scene provided a rich milieu for the growth of performance. As Moira Roth observed, "Political and social protests merged and in the process, produced visually and theatrically vivid, often potent symbols, images and events that fired the imaginations and activated the ethical convictions among artists."[40]

She lists as the main influences on performance work in the Bay area "political activism and political 'theater' of the 1960s; meditative ritual and mysticism; and models of synaesthesia in poetry, dance, music and mime."[41] Several overlapping networks of artists constituted an informal support system in which performances tended to be casually organized events, often taking place in the streets, studios, and private homes. While some artists such as Mel Henderson, Bonnie Sherk, and Anna Halprin were doing large-scale public works, others created pieces that took the form of social encounters and meditative rituals. Tom Marioni, the founder of the Museum of Conceptual Art, an important center for performance work, was interested in dissolving the boundary between art and life by organizing social gatherings, either in Breen's Bar (downstairs from MOCA) or in a museum setting, and presenting them as art. Cafe Society, a weekly "saloon/salon," became the main activity of MOCA. Marioni saw it as a place "where ideas are born. . . . What I'm trying to do is make art that's as close to real life as I can without its being real life."[42]

Terry Fox took performance in a hermetic direction with his early body works. After two years of organizing street theater events, such as *Buying and Selling*, in which he invited a large group of people to watch a Woolworth's pen salesman deliver an impressive sales pitch, Fox began a series of private rituals to explore interactions between matter and energy, and consciousness and the body. Using ordinary materials and simple actions, he created symbolically charged "situations" that elicited a heightened sense of awareness in the viewer. In *Levitation* (1970), he covered the floor of a large room at the

Richmond Art Center with white paper, spread a ton and a half of dirt in the form of a square and then lay down in the middle of a circle drawn in the dirt with his own blood. While holding four polyethylene tubes filled with blood, urine, milk, and water, he "lay there for six hours . . . trying to levitate. . . . Nobody saw me. I didn't move a muscle. I was trying to think about leaving the ground, until I realized I should be thinking about trying to enter the air. For me that changed everything, made it work. I mean, I levitated. . . . The feeling of being out of my body persisted for about two hours."[43] Afterward, when the public entered the space, they could see the imprint of Fox's body on the earth and read a description of his action. Fox considered *Levitation* to be his "strongest piece of sculpture because the whole room was energized." This and his other pieces from this period were inspired by Joseph Beuys's work, which was concerned with "energy transfer through the artist's ritual interaction with materials. [Fox] learned from Beuys that the residue of a ritual action could retain the aura of the event."[44] His work was also profoundly conditioned by his eleven-year struggle with Hodgkin's disease, a painful and debilitating illness. Through his personal experience of suffering, Fox found ways to give symbolic shape to the transience of human existence and the strength of the human spirit.

In the early 1960s, performance works that aimed to break the boundary between art and life succeeded in removing art from its institutional settings and introducing the materials and behavior of everyday life into the context of art, but for the most part, these works were emblematic in nature and only rarely incorporated intensely personal material in a way that revealed the private life of the performer. At the end of the decade, with the emergence of feminist performance, a shift occurred in which artists began to present themselves as the subject matter of their art, further eroding or problematizing the art/life dichotomy. While much of the work remained grounded in visual and symbolic practices, new forms evolved that were based on self-revelation and interpersonal exchange. These works relied on language, movement, sound, and image to unearth repressed histories (both personal and collective) and to deconstruct the sexist myths that ruled the art world and society at large. The feminist axiom, "the personal is political," was realized in myriad ways, from straight-forward presentations of difficult and painful experiences to highly ironic or comedic assaults on the representation of women in all areas of culture and society (by the media, in the workplace, on the streets, etc.). As many performers confronted the gaps and

differences between their subjective perceptions, dreams, and fantasies and the realities of a gender-biased world, they began to develop fictional personae and to work in quasi-narrative forms to negotiate the divide and challenge stereotypes of women. Concern with showing the contingencies of identity and representation of women led to a kind of doubly-aspected performance in which the artist was both herself and other. In many works, the performer conveyed both an air of authenticity and the falseness of an inscribed identity. Performances used disruptive strategies to reveal the multiplicity of selves required of women in daily life.

Linda Montano's performance work has been about eliminating the distinction between art and life altogether. Her early performances, such as *Handcuffed to Tom Marioni for Three Days* (1973), provided opportunities for her to investigate aspects of her life and work on her relationship with others that she did not have in her "real" life. Some of her performances involved trance and meditation, while others consisted of narratives of autobiographical events. In a 1974 performance, she lay in a crib for three hours listening to a tape of her mother talking about her as a child, and, in 1978, over the course of months, she did three "versions of mourning" on the death of her ex-husband, Mitchell Payne. In a performance described as "devastating" and "one of the most brilliant and moving art events I have experienced,"[45] Montano appeared wearing white makeup and acupuncture needles in her face. She chanted the story of Mitchell's death and her visit to the crematorium as Al Rossi played a sruti box and Pauline Oliveros played a Japanese gong. Nearby, a TV monitor showed her applying the needles to her face. The presentation and visual elements of the piece had mystical significance, reflecting Montano's background as a Catholic nun and her interest in Eastern mysticism.

In 1975, Montano did a series of works in which she lived with various people. (Nina Wise and Pauline Oliveros, among others) for periods of time, designating everything they did as art. Since then she has done similar pieces, such as her one-year performance with Teh Ching Hsieh from July 4, 1984, to July 4, 1985. The two were tied together by an eight-foot rope and never touched, but problems that arose during the year brought to light their two very different visions of what the piece was about. In treating her life as art, Montano has designated two domains as the focus of her work: cultivating "attention" to the details of daily living and applying that awareness in relationships. Her *Art/Life* counseling and palm and tarot readings are intense one-on-one encounters shaped by her compassion and an anarchic sense of humor.

In New York, Adrian Piper carried out a series of "self-transformations" (*Catalysis Series,* 1970) in which she intentionally disfigured herself in order to provoke responses from people in the streets, the subway, the Metropolitan Museum of Art, and the library. These experiments in xenophobia eventually led her to create a single art persona, the *Mythic Being*—a young, angry Third World male. Piper dressed anonymously, wore dark glasses, and sported a pencil-thin moustache—a disguise that allowed her "to investigate the male 'other' in her own personality, as well as to experience society's indifferent or fearful reactions to this type of individual, and act out the resulting feelings of alienation and hostility."[46] As an African-American who could pass for white, Piper has pursued strategies to expose racism and examine the relationship of self and other. Many of her performances were created to force "a consciousness in the audience of their own social roles as spectators . . . one reason why I am interested in working with a neutralized, objectified, de-personalized image: what's interesting to me is not my own personal history as art, but what my actual presence itself tells the audience, independently of any background knowledge. People interact with that object, project thoughts and relationships onto me that transcend our anonymity. Instead of hearing about me, they find out about themselves, and so do I."[47]

Both Jacki Apple and Martha Wilson had been exploring issues of women's identity and the power of society and the media to shape a woman's self-image when, in 1973, they decided to collaborate on *Transformance: Claudia,* a piece that focused specifically on the subject of power and money—women's fantasies about it and the reality of their place in a male-dominated system. Sharing the persona of *Claudia,* the two artists dressed up in glamorous clothes, rented a limousine, ate at the elegant Plaza Hotel, and toured the galleries in SoHo, where they improvised dialogue that "typified the role-model of the 'powerful woman' as she has been culturally stereotyped by fashion magazines, TV and movies."[48]

Of all the artists working with invented personae to probe the limits of the self, try out fantasized alternatives, and question the roles of women in the world, Eleanor Antin has produced the most extensive and sustained body of work. Working over a period of years in photography, video, writing, painting, and live performance, Antin evolved four alter egos—*the King, the Ballerina, the Black Movie Star,* and *the Nurse*—whose lives she inhabited to experience the vicissitudes of fame (the Ballerina), fortune (the King), and romance (the Nurse). Some of her manifestations have appeared in "real

life," such as the King, who hung out in beard and cape on the streets of Solana Beach (where she lived) discoursing with her subjects (surfer bums and old folks). As one writer put it, ". . . by putting the King into the world, [she was] not a symbol but herself as himself, swilling beer with surfers . . . another displaced person plagued with conscientious objections to being in the wrong century with wrong feelings about most everything."[49] In other performances, she used sets, costumes, and casts of cut-out characters to enact historical or romantic melodramas. In *The Angel of Mercy* (1977), Antin portrayed *Eleanor Nightingale,* after the founder of nursing. To create the cast, she photographed herself and her friends costumed as hussars, lancers, generals, common soldiers, and Victorian figures, and then drew from these images forty four-and-a-half foot tall masonite figures, which she animated by speaking for and with them as they played their roles. The adventures of her personae constitute an extended narrative in which her "fictive roles contend with and modify her identity as Eleanor Antin. . . . A kind of congruence emerges between this narration of her fantasies, the detailing of these imaginative portraits, and her own autobiography."[50]

While many factors contributed to the shifts in performance toward autobiography, ritual, and social action, it was the feminist movement that galvanized some of the most innovative and radical work in the 1970s. As Moira Roth has observed, women were engaged in both public political battles and more private struggles to explore and validate the substance of their lives, and to "redefine the models on which they had based their self-images. . . . It was this fresh and passionate investigation of self and of identification with other women that created the fervent supportive alliance between the first women performers and their audience. And it was this bonding with the often all-women audiences as much as the new personal content in the art, that accounted for the power of the early work."[51]

The strength and vitality of feminist performance was also due to the symbiosis of theory and practice in the women's communities. This was especially the case in southern California, where, in 1970, Judy Chicago launched the Feminist Art Program at Fresno State College using performance as a vehicle for confronting major issues and concerns of women. As she later explained, "Performance can be fueled by rage in a way painting and sculpture can't. The women at Fresno did performances with almost no skills, but they were powerful performances because they came out of authentic feelings."[52] In 1971, Chicago, together with six of her students, moved to California Institute

of the Arts, where she set up another Feminist Art Program jointly with Miriam Shapiro. Performance was already being taught at Cal Arts by Allan Kaprow, who brought with him well-developed ideas about performance from his years in the New York art world in the 1950s and 1960s.

Over the next two years, the Feminist Art Program group did scores of performances, created Womanhouse (an old house in Los Angeles that the women transformed with installations and performances), and joined with others to form the Women's Building, which became the main center for the feminist art movement in the Los Angeles area.

Although the emphasis in much feminist performance work was on personal transformation through narrative and ritual, performance also became a powerful vehicle for addressing social and political issues, and for bringing together disparate communities of women outside the art-world setting. Of all the artists who were active in the Feminist Art Program and the Women's Building, Suzanne Lacy has emerged to create a new genre of performance aimed at changing the consciousness of participants and performers alike. Starting in 1977, Lacy began a series of large-scale participatory projects that were a combination of community organizing, consciousness raising, and a highly visual form of performance art. Passionately committed to feminist ideals, she has focused on the themes of violence against women, discrimination, and aging. Her deep sense of spiritual kinship with other women has fueled her efforts to bring together women of all races, classes, and ages. As a result, women with very different backgrounds have collaborated on projects that enabled them to open to new and different perspectives while affirming their own life experiences.

Lacy's success rests on sharp organizing skills, a thorough and sophisticated grasp of feminist theory, and a firm belief in collaboration as a social model. Her first two public events, *Three Weeks in May* and *In Mourning and in Rage* (organized with Leslie Labowitz-Starus), protested the high incidence of rape in Los Angeles in 1977, the Hillside Strangler murders, and the sensational and irresponsible media coverage of the slayings. These events established the pattern for Lacy's future work of combining dramatic, clearly structured performances (to serve as visual statements easily utilized by the press and accessible to non-art audiences) and ancillary activities designed to empower and later feed back into the community. For *Three Weeks in May,* feminist groups and artists joined in a series of public meetings and self-defense classes, while

Lacy charted the daily rape occurrences on a huge map of the city installed in the L.A. City Mall. In an article on *In Mourning and in Rage*, Lacy and Labowitz-Starus explained that they were "concerned with the changing images and conditions of women in our culture.... [We are] consciously working on models of collective action which combine the collaborative activities of artists and non-artists alike. We see the political artist in present-day society as a model-maker as well as image maker."[53]

Lacy's subsequent productions—*Freeze Frame: Room for Living Room* (1982, with Julie London), *Whisper - The Waves, The Wind* (1984), and *The Crystal Quilt* (1987), among many others—have involved months, even years, of working with community groups and individuals. For *Freeze Frame,* Lacy brought together more than one hundred women: groups of elderly black churchwomen, old Jewish women, prostitutes, Chicana artists, nuns, ex-psychiatric inmates, teenagers, and others in a large elegant furniture show-room in San Francisco. A diverse audience circulated among the women to listen as the women talked about survival. In the end, the women mixed among themselves and then turned as one to face the audience and speak in unison.

While performances such as this may appear to be utopian gestures of social wholeness, Lacy continues to seek ways that have a more direct and immediate impact on the communities in which she works. Her latest project, *Auto: On the Edge of Time,* brings battered women together in a workshop process to create installations of wrecked cars that give form to their memories and feelings. An integral part of the project is the production of public service announcements for television on domestic violence, a measure that transforms the workshop process into a collective performance of self-empowerment and calls attention to the need for change at the broadest level.

From the mid-1970s to early 1980s, with the entry of large numbers of women artists, artists of color, and gay and lesbian artists into the field, and with the proliferation of cabaret and media-based productions, performance art became a term of convenience to cover a very wide range of disparate projects. As a generation of artists schooled in art and cultural theory emerged, performance became a multiplex form, shot through with the discourses of cultural criticism and reflecting the pluralism of the period. Multiple voices and histories have been surfacing in works that simultaneously resist or reject unifying notions of culture and affirm "alternative" cultural formations that are themselves in a state of flux. In very different ways, Jimmie Durham, James Luna, Guillermo Gómez-Peña, Coco Fusco, Robbie McCauley, Lorraine O'Grady, and

William Pope.L expose the notion of identity as a cultural construct and interrogate the structures of representation and history in a country whose popular myths are predicated on denial and homogeneity.

In his installations and performances, Jimmie Durham disrupts the master narrative of the US that traffics in myths and stereotypes of racial "otherness" by infiltrating the domains in which it thrives: official histories, ethnographies, and their institutional expressions as museums and art galleries. Durham's art slyly alludes to his Cherokee heritage, but it is more concerned with the ways in which American Indian identity is misrepresented and "how whites identify themselves and the world."[54] Adopting the performative mode of the Trickster, a mythic figure common to many Native American societies, Durham continually shifts identities in textually complex, satirical assaults on white cultural constructs.

Although Durham's assumption of multiple identities is a deconstructive strategy, it also reflects the reality of being an artist who must negotiate the encounter between disparate cultures. For Guillermo Gómez-Peña, this encounter is enacted on "the border," a conceptual space in which hybridity is a response to the "multiple crises and continuous fragmentation" of contemporary social and political life. As a Mexican-born artist who inhabits multiple cultural realities on both sides of the Mexico/United States border, Gómez-Peña has developed an entire mode of expression that disintegrates cultural, social, and linguistic boundaries in order to explore North-South relations and embody an intercultural future. In the introduction to his performance piece *Border Brujo*, he explains that "*Border Brujo* unfolds into fifteen different personae, each speaking a different border language.... [He] exorcises with the word the demons of the dominant cultures of both countries ... creates a sacred space to reflect on the painful relationship between self and other ... is a performance artist, but he is also a cultural prisoner, a migrant poet, a homeless shaman, and the village fool."[55]

In 1992, Gómez-Peña and the writer, curator, and media artist Coco Fusco collaborated on an elaborate, interdisciplinary arts project called *The Year of the White Bear*, which was a response to the "government-sponsored celebrations of the Quincentenary and the ongoing ideological and political battle in the United States over how to define national identity and culture."

Over the year-long period, the artists gave a series of performances in Irvine, London, Minneapolis, Washington, DC, Chicago, and Sydney in which they "presented

themselves as inhabitants of an island called Guatinau that was overlooked by Columbus. [They] lived in a 10'-12' cage for three days during which [they] conducted [their] 'traditional' aboriginal activities, such as watching TV, working on a laptop computer, lifting weights, sewing voodoo dolls, listening to bilingual rap music, and so on."[56] Despite the obvious confabulation of primitive and modern, many visitors thought they were real aborigines and were upset by the sight of humans in a cage. Others were cognizant of the ruse and played along, without stopping to consider the performance's historical precedents in the European and American practice of displaying human beings in all sorts of venues—from the Spanish court to zoos, parks, museums, and circuses. The project interpolated these practices as being the real roots of performance art and called attention to the ways in which Western fascination with otherness continues to produce misconceptions and inequalities.

Although the world and art-historical conditions faced by contemporary performers are very different from those faced by the Futurists and the Dadaists, there is a common impulse that seems to drive them both: the desire to disrupt or change the status quo, to transform conventional attitudes and perceptions, and to introduce a more fluid, open, and creative outlook to social life. Because of its indeterminate and immediate nature, performance has lent itself well to both aesthetic experimentation and social and cultural criticism. It is an open form that can accommodate a wide range of sensibilities and adapt to almost any setting—physical, conceptual, or virtual. As an interactive medium, performance has contributed to a shift from artists' adversarial posture toward the public in the early decades of the century to a more inclusive, more democratic stance, so that today whole communities embrace performance as a vehicle for confronting the most painful realities and celebrating the strengths of the human spirit.

Notes

1. For lack of a solution to a terminological problem, I will use the term "performance art" in the general sense, to refer to all live performative activities and events by artists in this century, rather than restrict it to work from the late 1960s and early 1970s, when the term first appeared.

2. The decision by the steering committee to limit this exhibition to performance art in the United States was not meant to exclude the very significant contributions of artists in other countries to the field, or to ignore the international exchange that has nurtured the growth of performance work here. Given the large number of artists in the United States who do performance work, it was decided for logistical reasons to concentrate on this country. We were also interested in seeing what affinities and concerns would emerge from a survey of artists who, in a very general sense, occupy a common cultural framework but whose personal histories and experiences are quite different from one another.

3. Performance was first established as a separate academic discipline in 1970 by Allan Kaprow at the California Institute of the Arts. It was also taught in Judy Chicago's and Miriam Shapiro's Feminist Art Program at Cal Arts beginning in the fall of 1971.

4. Fluxus artist and theorist Dick Higgins borrowed the term 'intermedia' from Samuel Taylor Coleridge to describe the conceptual fusions of different artistic disciplines such as "visual poetry" and "action music." See his "Fluxus: Theory and Reception," *Fluxus Research* (Lund, Sweden: Lund Art Press, vol. 2, no. 2). The conception of performance as being between media can also be traced to Kandinsky's theory of synaesthesia.

5. Performance art became a target in the "culture wars" of the late 1980s, as conservative congressmen attempted to censor and defund art that expressed sexual and cultural differences by controlling appropriations for the National Endowment for the Arts. In 1990, NEA chair John Frohnmayer rescinded grants awarded to Karen Finley, John Fleck, Holly Hughes, and Tim Miller under pressure from Senator Jesse Helms and others.

6. Kristine Stiles, "Performance and Its Objects," *Arts Magazine 65* (November 1990): 3. We are indebted to numerous artists, scholars, critics, and curators for the substantial work that has been done to date and have included some of their books and articles in the catalogue's bibliography.

7. See Philip Auslander, *Presence and Resistance: Postmodernism and Cultural Politics in Contemporary American Performance* (Ann Arbor, MI: University of Michigan Press, 1992); Johannes H. Birringer, *Theater, Theory and Postmodernism* (Bloomington, IN: Indiana University Press, 1991);

and Henry Sayre, *The Object of Performance: The American Avant-Garde Since 1970* (Chicago: University of Chicago Press, 1989).

8. This conception of art was anticipated by the Russian literary and cultural theorist Mikhail Bakhtin, who developed the concept of dialogism, in which meaning emerges from the complex interaction of vernacular sources and frameworks, and does not preexist in the text.

9. Quoted in Annabelle Henkin Meltzer, "The Dada Actor and Performance Theory," *The Art of Performance*, ed. Gregory Battcock and Robert Nicklas (New York: E. P. Dutton, 1984): 46.

10. Ibid., 39.

11. Harold Rosenberg, "The American Action Painter," *Art News 51* (December 1952): 22-23.

12. Cage provided his students with historical antecedents for the kind of work he was doing by reading to them from Robert Motherwell's anthology, *Dada Painters and Poets*. Published in 1951, this book became a seminal influence on the younger avant-garde, stimulating an interest in performance as a viable medium in the visual arts.

13. Quoted in *Blam! The Explosion of Pop, Minimalism, and Performance, 1858-1964*, ed. Barbara Haskell (New York: Whitney Museum of American Art, 1984): 31.

14. Yvonne Rainer comments, "What is John Cage's gift to some of us who make art? This: the relaying of conceptual precedents for methods of nonhierarchical, indeterminate organization which can be used with a critical intelligence, that is, selectively and productively, not, however, so we may awaken to this excellent life; on the contrary, so we may the more readily awaken to the ways in which we have been led to believe that this life is so excellent, just, and right." From "Looking Myself in the Mouth," *October 17* (Summer 1981): 67-68.

15. Sally Banes, *Greenwich Village 1963: Avant-Garde Performance and the Effervescent Body* (Durham, NC and London: Duke University Press, 1993): 119.

16. Ibid., 119.

17. Ibid., 122.

18. Ibid., 111.

19. op.cit., *Blam!* (Haskell, ed.), 27.

20. This was the first time the word "Happening" appeared publicly in connection with this type of

work. It immediately caught on and was used indiscriminately by the media to describe performances and events by other artists, many of whom rejected the term.

21. The term "Fluxus" was coined by its chief organizer, George Maciunas, in 1961 and was applied to various public events starting in 1962. Some historians date the end of Fluxus at 1978, the year of Maciunas's death, but many of the artists who were involved with the group continue their work, which is no less related to the spirit of Fluxus now than it was then.

22. According to Ono's book, *Grapefruit,* "This piece was first performed in 1962 Sogetsu Art Center, Tokyo, with a huge electric fan on stage. In 1966 Wesleyan University, Conn., audience was asked to move their chairs a little and make a narrow aisle for the wind to pass through. No wind was created with special means."

23. Ken Friedman, "Explaining Fluxus," *White Walls 16* (Spring 1987): 16-17.

24. Alison Knowles, *By Alison Knowles* (New York: Something Else Press, a *Great Bear Pamphlet,* 1965): 5.

25. In *The Smiling Workman*, a manic thirty-second performance, Dine enacted his gleeful obsession with paint and painting. With his hands and face painted red and his mouth black, wearing a red, paint-splattered smock, Dine rapidly painted "I love what I'm doing" on a large canvas that was already embellished with his handprints around the edges. When he finished, he drank some paint, poured the rest over his head, and dove through the canvas.

26. op. cit., *Greenwich Village 1963,* Sally Banes's discussion of the "Effervescent Body."

27. Rainer noted, "At that time it was illegal to dance totally nude. We obeyed the law: I wore pasties and we both wore g-strings." See Sally Banes, *Democracy's Body: Judson Dance Theater 1962-1964* (Ann Arbor, MI: UMI Research Press, 1983).

28. Jacqueline Maskey, "Yvonne Rainer and Robert Morris," *Dance Magazine* (May 1965): 39-64.

29. Carolee Schneemann, *More Than Meat Joy: Complete Performance Works and Selected Writings* (New Paltz, NY: Documentext, 1979): 52.

30. Ibid., 53.

31. Ibid., 281.

32. Kristine Stiles, *Raphael Montanez Ortiz, Years of the Warrior 1960/Years of the Psyche 1988* (New York: El Museo del Barrio, 1988): 18.

33. Ibid., 15.

34. Ibid., 22.

35. The activities and events of European artists such as Herman Nitsch, Wolf Vostell, Otto Muhl, Gunter Brus, Arnulf Rainer, Valie Export, Jean Toche, Rudolph Schwartzkogler, and Gustav Metzger, among others, were also profoundly influential in the emergence of new performance in the United States at this time.

36. Quoted in Linda Frye Burnham, "performance art in Southern California: An Overview," *Performance Anthology: Source Book for a Decade of California performance art*, ed. Carl E. Loeffler and Darlene Tong (San Francisco: Last Gasp Press and Contemporary Arts Press, 1989): 419.

37. Ibid.

38. From 1970 to 1976, Willoughby Sharp and Liza Bear published *Avalanche* magazine, the first artist-produced periodical to report on postobject and performance art.

39. Willoughby Sharp, "Bruce Nauman," *Avalanche* (Winter 1971): 27.

40. Moira Roth, "Toward a History of California Performance: Part One," *Arts* (February 1978): 94.

41. Ibid.

42. op.cit., Carl E. Loeffler, "From the Body into Space: Post-Notes on performance art in Northern California," *Performance Anthology* (Loeffler and Tong, eds.): 378.

43. Ibid., 374.

44. Constance Lewallen, "Terry Fox," *Terry Fox: Articulations* (Philadelphia: Goldie Paley Gallery, 1992): 12.

45. Moira Roth, "Autobiography, Theater, Mysticism and Politics: Women's performance art in Southern California," *Performance Anthology* (Loeffler and Tong, eds.): 485.

46. Jane Farver, *Adrian Piper: Reflections 1967-1987*, a retrospective catalogue, 3.

47. Quoted in RoseLee Goldberg, "Public Performance: Private Memory," *Studio International*, 192 (July 1976): 23.

48. Quoted in RoseLee Goldberg, *performance art: From Futurism to the Present* (New York: Harry N. Abrams, 1988): 176.

49. John R. Clarke, quoted in *Performance Anthology* (Loeffler and Tong, eds.): 408.

50. Jonathan Crary, quoted in *Performance Anthology* (Loeffler and Tong, eds.): 188.

51. Moira Roth, *The Amazing Decade: Women and performance art in America 1970-1980* (Los Angeles: Astro Artz, 1983): 16.

52. Moira Roth, "Toward a History of California Performance: Part Two," *Arts* (May 1978): 117.

53. op.cit., Roth, *The Amazing Decade*: 32.

54. Durham, quoted in Richard Shiff, "The Necessity of Jimmie Durham's Jokes," *Art Journal* (Fall 1992): 51-53, 75; and Jackson Rushing, "Jimmie Durham: Trickster as Intervention," *Artspace* (January-April 1992).

55. Guillermo Gómez-Peña, *Warrior for Gringostroika* (St. Paul, MN: Graywolf Press, 1993): 75.

56. Coco Fusco, quoted in Kim Sawchuck, "Unleashing the Demons of History," *Parachute*, 67:22.

Plates

John Cage

Excerpt from score for *Concert for Piano and Orchestra*, 1958

Dimensions variable

© 1960 by Henmar Press Inc.

Reproduced by permission of C.F. Peters Corporation

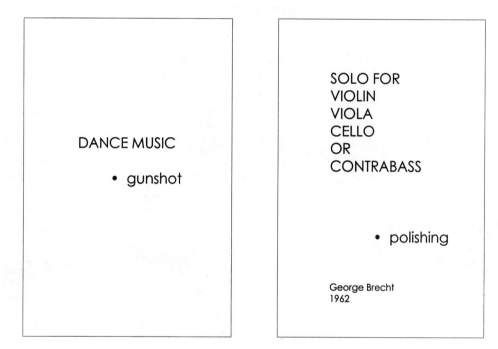

DANCE MUSIC

• gunshot

SOLO FOR
VIOLIN
VIOLA
CELLO
OR
CONTRABASS

• polishing

George Brecht
1962

George Brecht
Scores for Events
2 facsimiles of original scores
Dimensions variable
Collection of Gilbert and Lila Silverman/Fluxus Collection Foundation

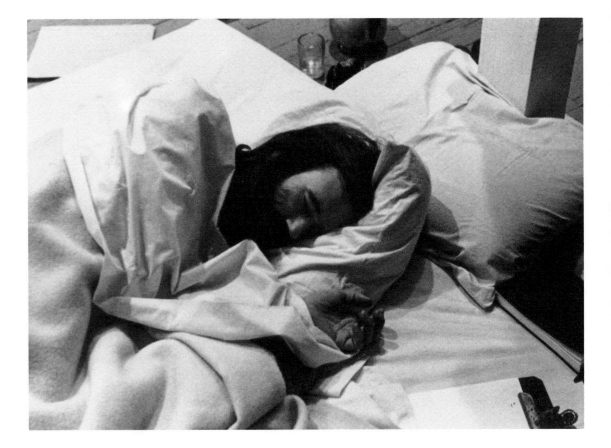

Geoffrey Hendricks
Dream Event, 1971
Photographic documentation of performance
Photograph: Valerie Herouvis

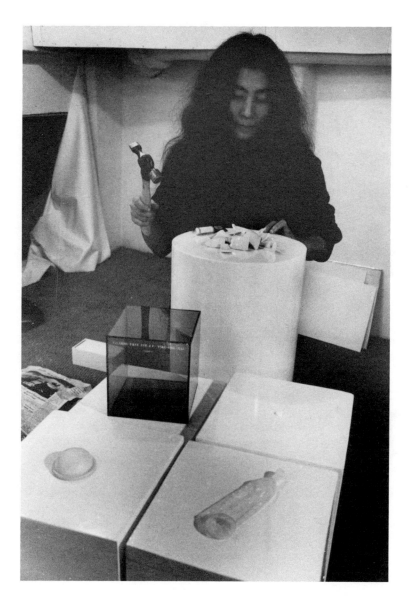

Yoko Ono
Mending Piece I, 1966
Preparing broken crockery for audience participation
Collection of Gilbert and Lila Silverman/Fluxus Collection Foundation

Alison Knowles
Creek Indians March, 1990
White floor with artifacts
Diameter 72 ins.
Courtesy of the Artist and Emily Harvey Gallery

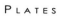

Larry Miller/Fluxus
Fluxus Concert, 1994
Wrapping an opera singer
Performers left to right: Larry Miller, Kay Raplenovich, and Dennis Barrie
Photograph: Cleveland Performance Art Festival

Robert Wilson
Danton's Death, Watermill, NY 1992
Charcoal on paper
24½ x 34¾ ins.
Photograph: Geoffrey Clements

Joan Jonas
Mirage, 1981
Mixed media
Dimensions variable
Courtesy of the Artist

Terry Fox
Experiment in Autosuggestion, 1973/1993
Paper, string, lead weight, and text
12¼ x 12¼ ins.
Photograph: Ray Juaire

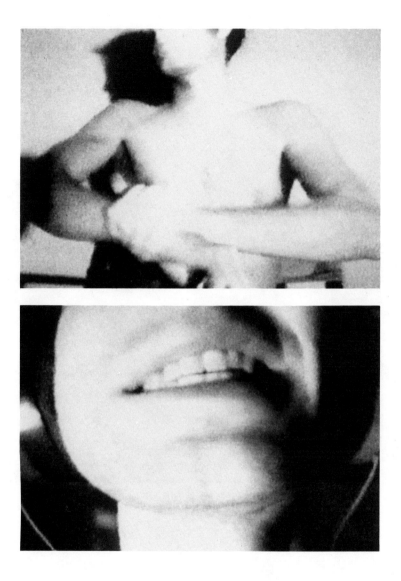

Bruce Nauman
Flesh to White to Black to Flesh, top, 1968
Lip Sync, bottom, 1968
Videotape documentation of performances
Video stills
Courtesy of the Artist and Video Data Bank

Carolee Schneemann
Venus Vectors, 1987-88
Acrylic panels. Kodaliths, paint, and video monitors
35 x 72 x 72 ins.
Photograph: Elijah Cobb

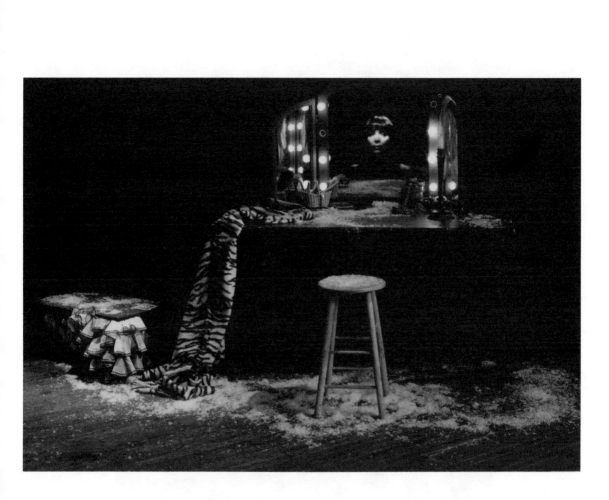

Eleanor Antin
Portrait of Antinova, 1986
Installation with 16mm color film on a continuous loop
Dimensions variable
Photograph: D. James Dee

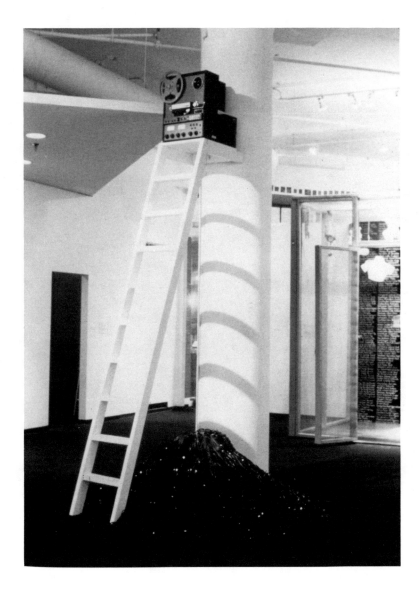

Christian Marclay
Tape Fall, 1989
Wooden ladder, reel-to-reel tapedeck, and magnetic recording tape
Dimensions variable
Photograph: Doug Cox

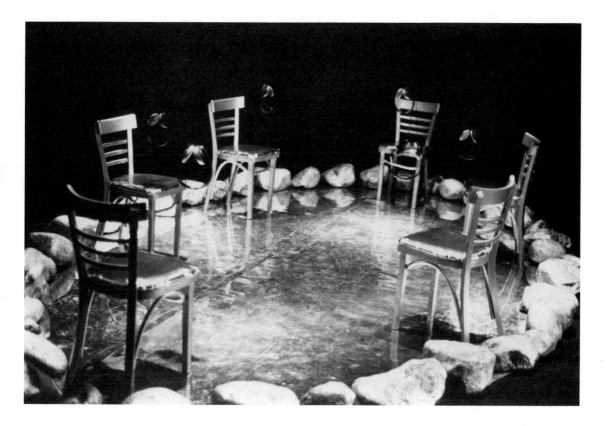

Meredith Monk
Silver Lake with Dolmen Music, 1980
Sound installation, with mylar, stones, chairs, tape recorder, headsets, and audio tape
28 x 236¼ x 157½ ins.
Photograph: Ray Juaire

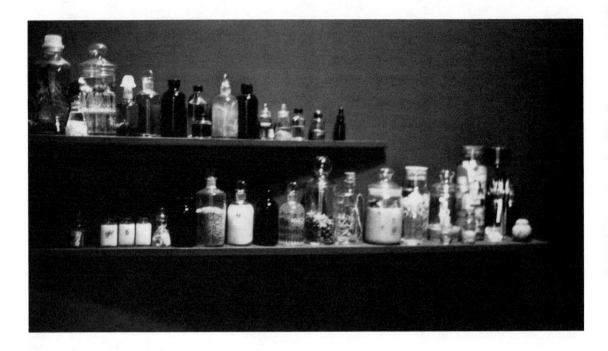

Anna Homler
Pharmacia Poetica, 1987–94
Glass bottles with mixed media contents, and shelves
Dimensions variable
Photograph: Doug Cox

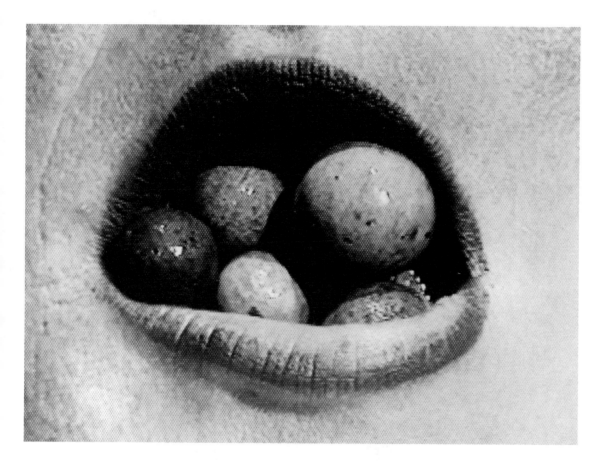

Ann Hamilton
Untitled, 1993
Video still from installation consisting of video disc,
LCD screen and video disc player, and color toned image
Courtesy of Sean Kelly, Inc., New York

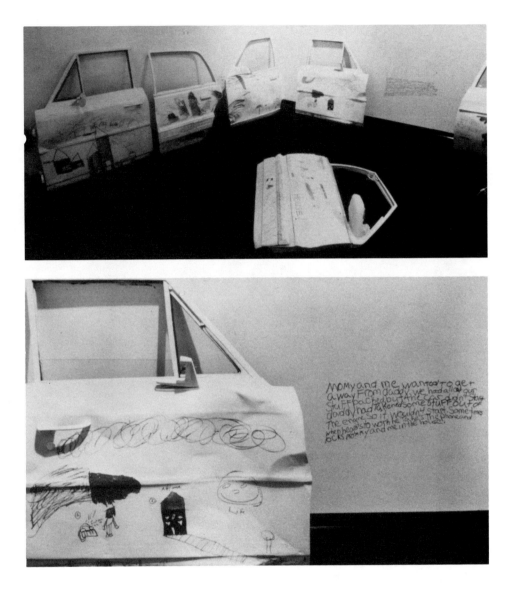

Suzanne Lacy and Carol Kumata
Auto: On the Edge of Time — Children and Domestic Violence, two views, 1994
Wall text, video, and car parts
Dimensions variable
Photographs: Doug Cox

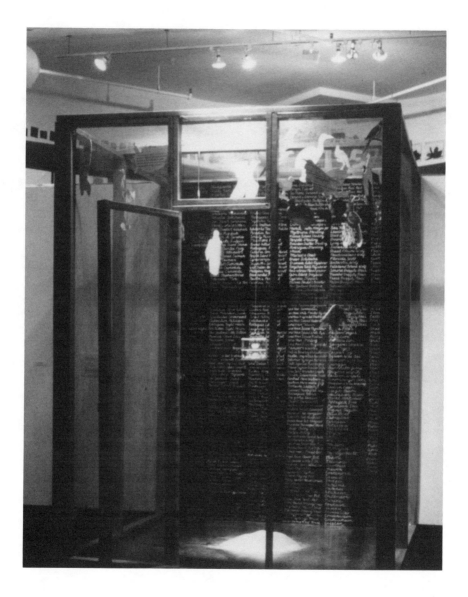

Jacki Apple
The Culture of Disappearance, 1994
Mixed media with audio
Dimensions variable
Photograph: Doug Cox

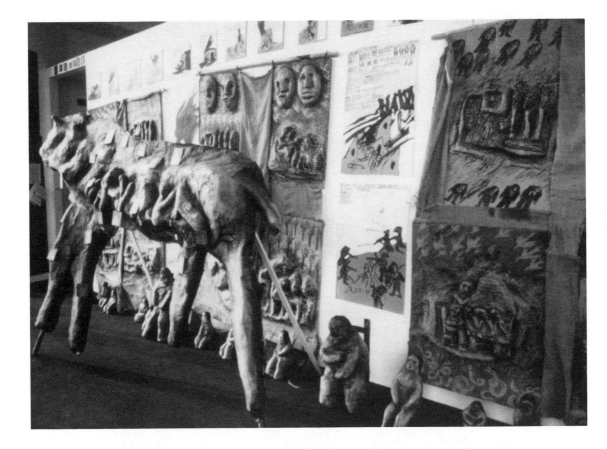

Bread and Puppet Theater/Peter Schumann
Ex Voto for Bosnia, 1993
Cardboard, papier-mache, burlap, and acrylic paint
Dimensions variable
Photograph: Doug Cox

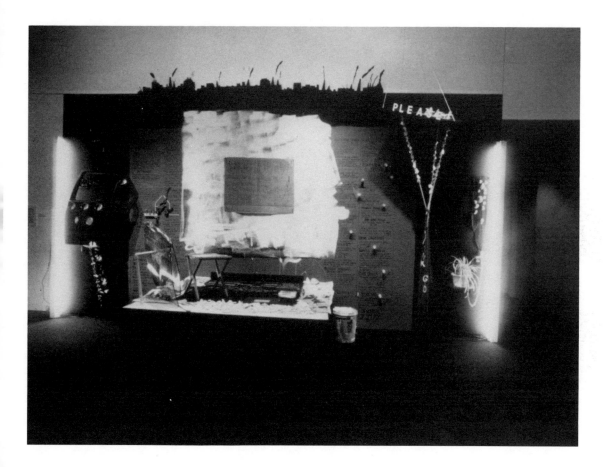

John White
Despertly Seeking, 1994
Mixed media
Dimensions variable
Photograph: Doug Cox

Framing Out

Olivia Georgia

Outside the Frame: Performance and the Object can be read as an ironic title for an exhibition which essentially is an attempt to draw a frame around a realm of work that concertedly defies circumscription. Admittedly, the exhibition consists of tangible sculptures, installations, relics, costumes, photographs, audio, video, and written text (primarily) confined within the walls of a contemporary art gallery. Most of its contents, however, have been selected to convey what is not there—the live presence of the artist. While the show itself stands in sympathetic contradiction to the nature of performance art, the title, *Outside the Frame*, imparts one of the most consequential impulses of the field: to challenge the parameters of artistic expression, its methods and milieu of presentation, and its perception. This relentlessly challenging nature of performance embodies its own irony, in that by challenging the "frame," performance art makes the frame more visible and thereby affirms its complicity with art and its participation in the construction of the art and culture which it presses against and beyond.

Understanding and acknowledging the significance of performance art thus depends on seeing, understanding, and acknowledging its "frame." The frame, however, is as elusive as the temporal nature of performance, being constructed of many interlacing subframes or contexts of media, of time, of place, of venue, of milieu, of artistic, political, and cultural associations and communities—all of which are inextricable from the work. The diverse, multiple, and transitory natures of these contexts account for why much performance of the recent and historical past has been misunderstood, misrepresented, dismissed, or lost. On the other hand, because the context is difficult to grasp, performance is open to interpretations that can take on a life of their own and can, for better or worse, go far beyond the original intent and impact of the work itself.

The task of thoroughly exploring and understanding this ephemeral field cannot be tackled in the few pages of this exhibition catalogue. Nevertheless, with the exhibition, associated performances, the timeline, and these two introductory essays, we have set out to affirm the importance of its territory to other artists and art forms and to the culture at large.

The term "performance art" has been in use since the 1970s and has been

applied retroactively to shifting spheres of work that have evolved from the visual arts, theater, dance, music, and film. It has referenced vastly dissimilar works—from those presented on traditional proscenium stages; to the intimate settings of clubs, cabarets, or black-box theaters; to public-scale events that involve thousands of performers and tens of thousands of viewers (or millions of viewers when transmitted through electronic media); to actions that take place in complete privacy and are brought to the public only in the form of a relic or documentation of the creation of a situation, such as a list of instructions, in which the viewer becomes the performer. The art-historical frame, or timeline, that accompanies the exhibition begins in the late nineteenth century. This starting point, which of course has its own history and antecedents, is in keeping with the assumption that the roots of performance art are located in the European avant-garde. We recognize that this is only one branch of its history; many other cultural and media-specific histories could be drawn that are relevant to work presented in this exhibition and the field at large.

The oppositional nature of the European avant-garde characterizes its fundamental relationship to performance art. This adversarial bearing, among other things, contributed to the rise of the Dada, Futurist, Constructivist, and Surrealist movements and the advancement of modernism. Artists associated with these movements were reacting against the restrictions of conventional media and forums of presentation while simultaneously responding to the dynamic and traumatic social and political realities occurring from the late nineteenth century until World War II. The history of the avant-garde reflects an incessant impulse to break with conformity and a continuous process of questioning and doubt. This impulse has helped expand the parameters of specific disciplines and has fostered the combination of different art forms to effect new concepts or to create new interdisciplinary applications. It has also been manifest in forms of protest along with anti-social, anti-establishment, or extreme types of actions or behavior that raise moral as well as artistic questions. On a broad social level, these doubts have concerned the political and cultural landscape of the moment and, in many cases, have resisted a traditional and/or hierarchical view of art that characterizes the artist as "creator," the object as precious and intransigent, and the viewer as passive receiver.

The evolution and conferral of these doubts and challenges have frequently been aided by a coalescing of like-minded individuals into short-lived and casual

groups or sustained and institutionalized associations. The importance, if not urgency, of forming alliances, collectives, organizations, or unions has helped support a critical mass of energies that has furthered new ideas and approaches. These frameworks have constituted hothouse environments, frequently self-contained and self-reflexive. However solipsistic they may be, the concerns addressed within these "hothouses" resonate beyond the immediate group on broader artistic and social levels.

The exhibition timeline begins with one such environment that helped to foment artistic experimentation and exchange across Europe at the turn of the century: the artist cabaret. The performances presented in such cabarets from the late nineteenth century through the first few decades of the twentieth century fostered a range of explorations and were a barometer for the political and cultural conscience of progressive intellectuals wherever they emerged. Fittingly, they were artist-run, but most often short-lived—briefest, a few nights; the most sustained, less than two decades. The cabarets presented poetry, music, song, puppetry, dance, and visual art. Their diverse programs were strongly influenced by the philosophies of Richard Wagner, who had encouraged new art forms from the synthesis of many art forms.

This Wagnerian approach was coupled with a pervasive interest in folk, primitive, and popular idioms in song, visual art, literature, and dance, along with variety theater (burlesque and vaudeville) and circus techniques such as exaggerated clowning and acrobatics. These interests were grounded in a general disillusionment with Western civilization. In the years prior to and following World War I, "high art" and "high culture" were considered moribund and morally bankrupt by progressive artists and intellectuals as the gulf between the upper classes and the poor became magnified. Cabaret performances were based on social and political matters, especially regarding the condition of the underclass (whores, criminals, street urchins/the homeless), and human sexuality, in addition to critical satire of more traditional art, theater, and literature (or simply colleagues with whom the performers had differences). Another element that distinguished the artist cabarets was a disdain of artifice; artists performed their own works and were concerned with their own immediate lives. They did not, as in conventional theater, attempt to portray a synthetic reality.

Cabarets in each region were imbued with their own local character while serving as nexuses of international exchange. The successes of individual cabarets were not based on their importation of a style or preoccupation from one country to the next,

but on their ability to reinvent the form and content of performances by local artists. In Paris, Le Chat Noir (The Black Cat), considered one of the most influential cabarets, became famous for its cinematic shadow theater—borrowed from Javanese puppetry techniques. More than forty shadow plays were produced at Le Chat Noir from 1886 to 1896. Many were involved productions that incorporated music, poetry, and moving figures and sets (in varying scales to create a sense of perspective) that cast black shadows on a white screen, punctuated with projected color.[1] The shadow shows were so successful that Rodolphe Salis, proprietor of Le Chat Noir, took them on tour around France.

In Germany, strict Prussian censorship forced artists to create literary parodies which were shills for social satires. At the *Eleven Executioners*, opened in 1901 in Munich, a collaborative group of artists, writers, a composer, a musician, an architect, and a lawyer greeted their guests at the door in masks and hooded, blood-red robes, in keeping with the gallows humor that exemplified the pulse of the times.[2] The Germans incorporated indigenous forms such as bench singers, who sang on the streets and in the markets about sensational events, accompanied by signboards. The bench singers were war veterans, licensed by the state. They synthesized song and image, pointing to illustrations as they sang of horrid crimes, especially murders.[3]

In contrast to the Germans, Viennese cabarets like The Bat Theater and Cabaret (opened in 1906), which involved artists such as Gustav Klimt and Oskar Kokoschka, had an affected air of style and elegance. Despite the turbulence of the times in Vienna, even within the art community, the awareness of the decline and dissolution of society was suppressed and varnished over by "courtly manners and verbal polish."[4]

The cabaret that would leave the most indelible mark on the arts was unique in its lack of a regional identity. The famous Cabaret Voltaire, open in Zurich for less than six months (February to June 1916), was founded by disaffected expatriates from eastern, central, and western Europe. Its core adherents included Hugo Ball, Richard Huelsenbeck, Tristan Tzara, Georges Janco, and Jean Arp. As aliens in a country surrounded by war, their experiments took on a cast of moralistic pedagogy that paralleled the proselytizing Futurists, but without the broad public engagement the Futurists were able to achieve. The explorations of the Cabaret Voltaire contingent, by virtue of the detached status of its adherents, were both more deeply inward and more universal in their protest of the grievous social and political dilemma of the times. The

Cabaret Voltaire later became known as the progenitor of Dada. At his final performance at the Cabaret Voltaire on June 23, 1916, Hugo Ball recited his legendary sound poems that have come to typify the Dada anti-art, anti-logic stance—a repudiation of traditional European values brought on, or at least exacerbated, by the brutality of World War I. Ball's rejection of intelligible content in his sound poems was not simply meant as an absurdist slap in the face of convention, but was conceived as a transcendental declamation. The poems were part of the Dada search for new forms and meaning in art that could purify the culture.[5]

The collective and interdisciplinary nature of the cabarets was an excellent vehicle for creating and transmitting new ideas across the continent; it also nurtured and supported individual talents that surpassed the hermetic environs of the clubs. Pablo Picasso, for instance, had his first exhibition at El Quatre Gats (The Four Cats) in Barcelona. El Quatre Gats was a direct descendant of Le Chat Noir and was open from 1897 until 1903. Erik Satie, the exceptionally influential composer and performer, eked out a living as a pianist in the Parisian cabarets. Outside the cabarets, Satie produced several landmark performance works, including *Parade* (1917)—a collaborative effort with Diaghilev's Ballet Russe, with book by Jean Cocteau and costumes by Pablo Picasso. *Parade* portrayed a circus road show, with several performers in giant ten-foot-high cubist costumes integrated as moving elements of the set. The music was embellished with Futurist-inspired sounds, such as typewriters, sirens, airplane propellers, Morse tickers, and lottery wheels. This production, on the program with two other conventional ballets, scandalized Parisian critics. One critic's accusation that the revolutionary new work was "in reality a German-engineered attempt to undermine the solidarity of French culture" enraged Satie so much that his obscene retaliation resulted in his being sentenced to a week in jail and a stiff fine.[6]

Frank Wedekind, the radical poet and dramatist, survived by his wits writing songs and performing in several renowned German cabarets. Wedekind's lurid humor typified the frustration and cynicism of the German aesthetic at the time. In the 1890s, Wedekind wrote plays and songs dealing with human sexuality and the hypocrisy of the preponderant moral codes. In 1889, Wedekind had befriended circus clown and painter Willi Morgenstern, who accompanied him on a tour of popular Parisian entertainment venues the following year. This association, along with other influences (such as Nietzsche's view on dance), led Wedekind to an interest in mime, the body's power of expression,

and the primacy of the physical in performance. In subsequent years Wedekind wrote wordless plays—notably *The Empress of New Foundland*, about the destructive power of sexual obsession.[7] Wedekind's raw and contemptuous performances, in a high-pitched nasal voice, were electric. His admirers and imitators included Bertolt Brecht, who wrote of Wedekind in a 1918 obituary, "A few weeks ago at the Bonbonnière he sang his songs to a guitar accompaniment in a brittle voice, slightly monotonous and quite untrained. No singer ever gave me such a shock, such a thrill. It was the man's intense aliveness, the energy which allowed him to defy sniggering ridicule and proclaim his brazen hymn to humanity, that also gave him this personal magic."[8]

The artist cabaret created a certain chemistry that nurtured new ideas, but the cabaret format was not an invention of the time nor did it disappear with the advent of World War II. Nevertheless, the vanguard role of the artist cabaret diminished over time. In recent decades, however, the café/cabaret forum reappeared as a conducive proving ground for new ideas and fresh invention. In the 1950s and 1960s, the coffeehouse became the meeting place of the Beat Generation. Later artists also benefited from the informality and interaction between performer and audience that the café offered. For instance, Vito Acconci first investigated performance that depends on the actions of others in his poetry experiments at the Orient Coffee House in 1968. In these poetry works, Acconci would distribute pieces of paper to the audience, on which they were invited to write a letter; the letter would serve as a cue for an improvised adverbial or prepositional phrase.

Over the past two decades, cabaret-style performance has been simultaneously rediscovered and condemned as retrogressive. The early 1980s saw the resurgence of the nightclub as a principal setting for formulating work that synthesized popular forms and progressive ideas. Yet the accessible, text-based cabaret forms were widely reproached by art-world critics, who viewed the use of traditional stand-up comedy within the realm of the avant-garde as lowbrow and retrograde. To these critics, the form, format, and venue for performance was as important to its transformative potential as its content.

Despite this response, cabaret has persisted robustly, exploring subject matter that is frequently beyond the range of more traditional performance arenas while reaching new audiences who are less concerned with the avant-garde than with performances that address their contemporary experience.

Eric Bogosian and Ann Magnuson have been particularly successful in this mi-

lieu. In the early 1980s, Magnuson managed Club 57, located in the basement of the Holy Cross Polish National Church on St. Marks Place in New York City. Magnuson's performances consisted of a panoply of characters, from heavy-metal rock singers to Gala Dali to religious evangelists. She frequently collaborated with other East Village regulars, including Bogosian, John Sex, and Joey Arias. In the spirit of her insightful character studies, she has written:

> They came from the outermost regions of America, suburban
> refugees drawn to the big city in search of fame, fortune and fun.
> Self-exiled from the comforts of American 9-to-5, two car family
> living, they migrated to the uncertainties of the nocturnal bohemian
> world of Manhattan's misfitted East Village. At a time when the Bee
> Gees were at the top of the charts, these young pioneers ventured
> into the dangerous tenement wilds of urban space—the Final
> Frontier. . . . Weaned on television and rock'n'roll, these exponents
> of the 15-minute attention span generation turned the club into a
> center for personal Exorcism. Nightly services of bloodletting rituals
> released spirits buried deep within their collective subconscious.
> Media heathens, re-enacting scenes from the communal memory
> grooved in a group mind with a one-way ticket to Nirvana. . . .
> And from 007 came forth much exoticism, beginning with The
> Happening, son of dada, mother to disco, opening the doors to an
> exploding mind dimension of ultra glowing grooviness where all
> brought their sleeping bags and created a truly beautiful experience.[9]

The text-based work of other artists, such as Jack Smith, Spalding Gray, Holly Hunter, John Fleck, and John O'Keefe, has offered candid self-relevatory or self-exploratory presentations of intensely personal subject matter. These confessional and expository modes are employed by many current performance artists to address a broad range of concerns, such as racial or gender identity and conflict, historical, political, and economic issues, or other essential aspects of the human condition. Eric Bogosian, Karen Finley, Joyce Scott, Judith Jackson, Robby McCauley, and John O'Neal, to name a few, give voice to a variety of palpable characters. These artists and others,

including Rachael Rosenthal, Laurie Anderson, John Malpede, and the Los Angeles Poverty Department (LAPD), tell stories—personal accounts as well as fictions—to challenge the senses as well as social and cultural mores in the same spirit that Hugo Ball did through the abandonment of narrative and embracing of the unintelligible.

Referring back again to early twentieth-century work, parallels can also be drawn between the performances of contemporary artists such as Pat Oleszko, Liz Prince, Stuart Sherman, and Laurie Anderson and their forerunners. They are connected by an interest in wordplay and in vernacular forms like popular music, magic tricks, and circus-like antics. For more than ten years, Oleszko has constructed parade-scale costumes and inflatables that are, in her words, "pedestrian sculpture . . . in the popular art forums of the street, party, restaurant, burlesque house, beauty contest, sporting event. . . ." Similarly humorous, Liz Prince has designed costumes and performance environments that are verbal and visual puns with decidedly consumerist themes. Prince frequently creates costumes to illustrate hackneyed torch songs, such as her cigarette-fringed dress to accompany "Smoke Gets in Your Eyes." The connections to popular entertainment and cabaret forms are more abstruse in the work of Stuart Sherman, yet in his guileless manner he presents himself as a magician and a consummate punster of words and mundane objects. Using sleight-of-hand techniques, he explores all manner of associative thinking that shifts the vernacular into a metaphysical query. Laurie Anderson's performances are basically one-woman variety shows. Although on the opposite end of the spectrum from Sherman in terms of scale and polish, the essence of Anderson's performances is the non sequitur and irrational juxtapositioning that somehow creates an illogical yet universal meaning.

The cabaret setting can be viewed as a domain in which proximity and empathy form a bridge between performer and audience. This type of setting or "frame" has hastened informal and organic artistic exchange. Tangible or institutional environments along with intangible or ideological environments have fostered similar conduits for exchange and innovation.

In 1919, Walter Gropius founded the Bauhaus, an idealistic school that spearheaded innovations in fine arts, design, architecture, performance, and stage design. It was here that Oscar Schlemmer explored his mechanistic visions and philosophies, which were imbued with an optimistic fascination with technology. In Schlemmer's work, the performers were dressed in geometric costumes that cast them as dehumanized or

robotic objects performing everyday or abstract actions.

In 1932, the Bauhaus was closed and, with the rising repression of the Nazis, most of its faculty fled Germany over the next several years. One of the Bauhaus's most lauded professors, Joseph Albers, immigrated to the United States to teach at Black Mountain College, where he became a major influence and indirectly influenced the course of performance art in this country.

Albers encouraged a rejection of Eurocentrism and, after arriving in the United States, became immersed in the study of the pre-Columbian art of the Indians of the southwestern US, Mexico, and Central America. While in Germany, Albers had been influenced by Kandinsky, who affirmed the role of art as a physical manifestation of the spiritual in life. In Albers's own words, ". . . art does not exist on a material, but on a spiritual level. It rests within us instead of upon a canvas or marble."[10]

The communal environment and the emphasis on process and problem solving rather than on product distinguished the arts at Black Mountain and attracted to its campus leading artists of the 1940s and 1950s—among them, John Cage, Merce Cunningham, David Tudor, Robert Rauschenberg, M. C. Richards, and Charles Olson, who in 1952 created *Theater Piece No. 1*, which would come to be recognized as the first "Happening." The composer John Cage, a devotee of Erik Satie, emphasized the use of chance procedures; multifocused organization; non-narrative, simultaneous, unrelated actions; and the self-determination of performers.

Other pedagogical environments provided the catalyst for further interactions and experiments. To note just a few: From 1956 to 1960 John Cage taught an influential class at the New School for Social Research in New York. Robert Dunn's experimental workshops at the Cunningham studio in New York and Anna Halprin's workshops in San Francisco precipitated the formation of the Judson Dance Theater in 1961. Subsequently, the Judson Dance Theater became the nexus for choreographers, dancers, artists, writers, and musicians and placed dance in the forefront of experimental performance, emphasizing movement and the body while transfiguring essential notions of what is considered dance.

By the late 1960s and early 1970s a swell of interest in new performance modes compelled the formation of artist organizations or "alternative spaces" on the East and West Coasts, including Gain Ground, Apple, 98 Greene Street, 112 Greene Street Workshop, 10 Bleeker Street, the Idea Warehouse, and 3 Mercer Street in New York, and

the Museum of Conceptual Art and the Floating Museum in San Francisco. Other spaces also emerged in the 1970s, such as Galerie de la Raza, established by Chicano artists in San Francisco; the Basement Workshop, an Asian-American artists' organization in New York; and the Women's Building in Los Angeles. The formation of these organizations was commensurate with important new dimensions in performance—specifically, exploration of issues concerning cultural identity and gender.

Performance artists have helped convey and extend the insights gained in response to feminism and a growing awareness of non-Western European cultures. In many instances, they have done so by challenging the tenets and charges of the "politically correct." In other words, the inquisitive disposition of performance artists has put them outside the frame of tradition; it has also placed them outside the frame of progressive ideologies. Hannah Wilke, who often appeared naked save for her spike-heel shoes, was frequently chastised by feminists for her pin-up affectations. This was perhaps a predictable response to her intention, which was a sardonic look at both the male-dominant culture and the reserved cast of feminism at the time. Younger artists such as Janine Antoni have also engaged in actions, materials, and forms that were subordinated by an earlier generation of feminists. Antoni has soaked her hair in dye and used it to mop the floor, has repeatedly applied mascara to her eyelashes and made drawings by blinking her eyes and stroking the paper with her lashes, and has coated her lips with colors that "correspond" to specific actions, such as washing dishes or talking on the telephone. In the early 1970s, Ana Mendieta staged her first performances. Her work expanded the boundaries of feminism, earthworks, and the culturally specific ritual forms of her Cuban heritage. Many of her performances took the form of ephemeral installations—as simple as the impression of her body in mud or sand or its silhouette in flowers. In her hands, the earthwork conveyed the fragility of human existence, in contrast to male counterparts such as Michael Heizer and James Turrell who worked on a monumental scale. While her work concerned gender, class, and ethnicity, Mendieta sought a spiritual role for art that transcended ideology.

Lorraine O'Grady's character, *Mlle. Bourgeois Noire*, was created to prod and provoke other African-American artists to take more risks. In 1980, at the opening of the relocated Just Above Midtown (JAM) Downtown, O'Grady arrived in a dress and cape sewn from one hundred and eighty pairs of white gloves. She moved through the crowd with a male escort in black tie, distributing flowers until the inside of her bouquet

revealed a cat-o'-nine-tails whip. While lashing herself with the whip she admonished the attendees: "THAT'S ENOUGH! No more bootlicking, . . . No more ass-kissing,. . . No more buttering-up, . . . No more pos . . . turing, or super-ass . . . imilating . . . BLACK ART MUST TAKE MORE RISKS!!!"

O'Grady's act of intervention as a performance art piece has an exuberant and abundant lineage. The Futurists proposed and performed a great variety of works calculated to provoke a response, especially an aggressively negative response, from the audience. This zeal emanated from their furor against the barren bourgeoisie that was mired in nostalgia, which in their eyes prevented Italy from reemerging as a leader of civilization. As remedy, they devised their own versions of shock therapy. Some of Marinetti's suggestions to provoke and involve the audience are found in his 1913 *Variety Theatre* manifesto:

> Spread a powerful glue on some of the seats, so that the male or
> female spectator will stay glued down and make everyone laugh
> (the damaged frock coat or toilette will naturally be paid for at the
> door.)—Sell the same ticket to ten people: traffic jam, bickering
> and wrangling—Offer free tickets to gentlemen or ladies who are
> notoriously unbalanced, irritable, or eccentric and likely to
> provoke uproars with obscene gestures, pinching women, or other
> freakishness. Sprinkle the seats with dust to make people itch and
> sneeze, etc. . . .

These pranks and puckish devices did little to change the course of Italian history—as the Futurists themselves were soon to realize. The Futurists did, however, excel in upsetting the normative relationship between the audience and performer by employing diverse approaches and philosophies. They advocated the accessible forms found in circus, puppetry, and variety theater, directly involving the audience, frequently under the guise of antiaudience attitudes.

They pioneered innovations in staging by introducing theater as image/ concept, using extremely shortened forms, and by eliminating artifice through the presentation of concrete actions, simultaneous characterization, the portrayal of the subconscious, and the entire elimination of actors. They employed abstract language

along with sound and silence as music, sometimes synthesized on mechanical instruments.

An example of the Futurists' attempt to break down the performer/spectator barrier was *Grey + Red +Violet + Orange*, performed during a 1921 Brazilian tour. In this play, written by Bruno Corra and Emilio Settimelli and produced by Ettore Petrolini, an actor accused a spectator in the front row of murder.[11] The confrontational and arrogant posture (in both form and content) of the Futurist performances regularly precipitated vocal and physical (if not violent) audience reactions. Many spectators knew what to expect and came well prepared with all manner of fruits and vegetables to lob at the performers. After a performance in 1921, a *London Times* reporter submitted this account:

> Few [of the scenes] could be understood because the showers of
> beans, potatoes, and apples often drove the actors off the stage. . . .
> The audience grew so furious towards the end the actors could
> hardly be persuaded to come on stage at all. Marinetti himself, who
> fought well for Italy during the war, supported the bombardments
> almost without flinching, although he was hit on the head several
> times by apples and tomatoes, and his dress shirt was spotted with
> tomato juice, but the company was not quite so brave. When the
> Futurist artists came on the stage carrying paintings they had
> achieved they used their masterpieces quite frankly as shields.
> At one time, when the curtain was down, a member of the audience
> dashed on to the stage to fill his pockets with ammunition that was
> lying there, but one of the younger Futurists saw him and pursued
> him, giving him a mighty kick as he jumped into the nearest box,
> and thereafter the audience was definitely hostile. A vase, several
> saucers, and five and ten centesimi pieces were hurled at the actors,
> and the leading lady received a severe blow over the eye from an
> unripe tomato. The occupants of the orchestra stalls suffered considerably from tomato juice and beans. And the performance came to a
> premature end when the actors themselves began to hurl vegetables
> and fruit back at the audience.[12]

Accounts of similar reactions and counterreactions of the performers are numerous,

to the point where one wonders whether the Futurists themselves might have considered their work less of a success without an exhibition of effrontery.

The Futurists' innovations in staging spanned the gamut from actual theater design to abstract concepts. In 1933, Marinetti's *Total Theatre* proposed a large round central stage, eleven small circular stages throughout the seating area, and a perimeter stage that was to span its circumference. It also provided optional revolving chairs for audience members who would view film, television, poetry, and painting projected on the walls of the theater while experiencing music, simultaneous actions, and smells exhausted and removed with special vacuum cleaners.[13] In works like *Feet* (*Le Basi*) by Marinetti and *Hands* (*Le Mani*) by Marinetti and Bruno Corra (both from 1915), the audience sees only the feet and hands of the performers. In *Feet*, the performers, seated in chairs, are screened from the knees up; their voices can be heard as they act out seven separate vignettes. In *Hands*, twenty unrelated gestures are depicted between blackouts, such as two hands shaking, two hands writing at different speeds, a fist punching, a hand holding a revolver, and so on.[14]

Another important concern of the Futurists was the expansion of written and spoken language. In *Printing Press* (*Macchina Tipografica*, 1914) by Balla, twelve performers move in mechanical coordination, reciting percussive sounds that imitate a printing press. In another work by Balla, *To Understand Weeping* (*Per Comprendere il Pianto*), two characters on a minimal stage, half red and half green, speak to each other in meaningless sounds and numbers peppered with recognizable phrases. The Futurists' expansion of the limitations on written and spoken language were analogous to experiments being performed in music. The radical manifesto *The Art of Noise* and the original mechanical instruments of painter Luigi Russolo anticipated aspects of the philosophies and compositions of John Cage. Russolo's theory was profoundly simple: all sound can be considered music. The instruments that he created for his new orchestra *intonarumori* were boxes that contained motors and mechanisms that replicated various noises: exploding, crackling, humming, rubbing. Silence, too, was employed as a device to create compositional tensions within a work and manipulate the sense of time.

As the Futurists in Italy were advocating a rejection of the past, artists in Russia were reaching back into their own folkloric roots as a source for new and progressive art. Although these two attitudes are in contrast to each other, both were a reaction against established and accepted forms. Despite direct interaction and influence on the Russian

avant-garde from French Cubism, Italian Futurism, and German Expressionism, the sources, motivation, and composition of the multidiscipline works produced in Russia between 1910 and 1930 are significant in their differences from other Western European innovations. This contrast can be traced from a fundamental variant: the economy and cultures of Western Europe were driven by industrialization, while Russia remained profoundly agrarian.

During the ten years prior to the public emergence of the avant-garde, Russian artists were interested in creating "art in harmony with and expressive of the natural universe." Many painted folk scenes and the mythical lore of the peasants.[15] One of the central figures in the Russian avant-garde, Kazimir Malevich, a contentious and paranoid mystic, expressed in his writings that the highest role for art is not as a means of 'thing-making' but as a speculative and mental activity—a primal action.[16] He believed in the spiritual and transcendental potential of artmaking, and asserted that making art was the "most valuable" activity of humankind.[17] Malevich's Suprematist theories and thoroughly nonobjective paintings were prophetic, anticipating the extreme terminus of modernism in minimalism and conceptual art of a half century later.

Despite the highly cerebral and conceptual leanings of Malevich, he and his Suprematist adherents, along with the Constructivists and many other artists of diverse media and persuasions, were swept up in the utopian fervor of creating work that was pragmatically purposeful, work that aided and abetted social transformation in Russia. Until the 1930s, when the totalitarian government reversed its support of the progressive artists in favor of social realism, the avant-garde enjoyed unparalleled state sanction and support.

The pivotal Russian avant-garde work, *Victory Over the Sun*, a radical opera of 1913, created by Malevich, poet and theoretician Alexei Kruchenykh, and painter and musician Mikhail Matiushin, dwelt on artistic rather than political revolution. It infused the performance, literary, music, and visual arts circles with a sense of dynamic new possibilities. In *Victory Over the Sun*, a band of "futuremen" eclipse the sun, which represents the superficial or figurative world of the past, "full of melancholy errors, of affectations, and of genuflections" (Scene V of Kruchenykh's libretto). The choir chants, "We are free. The sun is broken. . . . Hail darkness!" (Scene IV).[18] Performed by nonprofessional actors, much of the script was nonsensical, the music was atonal, and the sets and costumes were abstract, almost thoroughly nonobjective.

The leading figure of Russian theater, Vsevolod Meierkhold, was very much present during the production of *Victory Over the Sun*. The harsh and anti-illusionistic design of *Victory* launched Meierkhold and others into a completely new direction in the styles and modes of production, developing sensibilities that persist today. They were inspired by the propagandistic potential of these new forms and collaborations. In support of the Bolshevik regime, Meierkhold staged *Mystery-Bouffe* in 1918, with sets designed by Malevich. *Mystery-Bouffe* was an adaptation of Vladimir Maiakovsky's parody of a medieval morality play in which the international proletariat is led to a mechanized utopia. In 1920, Meierkhold staged *The Dawn*, an epic drama that told of world revolution. The Constructivist sets, by Vladimir Dmitriev, reflected the influence of Vladimir Tatlin's "counter reliefs." "The set consisted of a number of stationary red, gold, and silver cubes, cylinders, and planes with intersecting ropes attached to the flies. Stationary cubes to either side served as platforms for the actors, and steps spiraling from the orchestra pit lined the auditorium to the stage."[19] Tatlin's Constructivist theories and assemblages, in their respect for and employment of unadulterated industrial materials, were also crucial to Liubov Popova's setting for *The Magnanimous Cuckold* (1922). Built for a humble two hundred rubles, its "object formulation" (as opposed to scenery) and "requisitions" or ready-made purchases (as opposed to props) was the contemporary terminology that reflected a total reorientation of content and aesthetics. The stage was a grouping of platforms, stairs, ramps, and planar backdrops, that had the syncopated graphic virtues of a Constructivist drawing. Experimental theater, spectacles, and agit-prop became the vehicles for artists to take their work out of the studios and produce them on grand public scale.

By the early 1920s, every excuse was contrived to create huge mass spectacles. The most notorious took place on November 7, 1920, with a cast of ten thousand performers watched by an audience of one hundred thousand. The performance, which reenacted the storming of the Winter Palace, was staged in Urisky Square (directed by Nikolai Evreinov) with sets by Yurii Annenkov. The spectacle commenced at ten o'clock in the evening with a gunshot, followed by an orchestra of five hundred playing a symphony by Varlich and ending with the *Marseillaise*. A chant of "Lenin! Lenin!" was repeated until truckloads of workers rolled into the square to enact the storming. As the revolutionaries converged on the building, it was illuminated and a dramatic display of fireworks was set off accompanied by a parade of armed forces.[20]

The language and forms that were utilized in the public processionals and street theater produced for agitprop also exhibited deep roots in folkloric and religious aspects of Old Russian culture, along with other international prototypes provided by workers' organizations in Germany, England, France, and the United States before the turn of the century.[21] The icons, relics, and church banners were replaced with red flags and contemporary shrines, such as those in the 1919 agit procession for the second anniversary of the October Revolution, which sported a replica of Vladimir Tatlin's famous *Monument to the Third International*.

Agitprop examined all forms of popular entertainment and media as potential vehicles to reach a mass public: the printed press, postcards, posters, the sides of trains and boats, tableware, fabric design, monumental sculpture (monuments, commemorative sites, necropolises, townscape décor), street and square decorations, circuses, festivals, carnivals, puppet shows for adults, "living newspapers," "film-truth," and music of industrial sounds, such as blasts of factory sirens and rhythmic machine noises. The agitprop theater that reached out to educate and motivate the long-indentured peasants of rural areas was primarily based on simplified truths and strict categorizations.[22] Nevertheless, agitprop became a catalyst for artists in the pursuit of work that reached beyond the didactic realm of propaganda.

Again and again throughout this century, performance has been used as an instrument aimed at targets that extend from collective efforts to effect social change to introspective artistic pursuit. However divergent these polar concerns may be, artists who operate against and within these frames rarely lose sight of both at any given time; they are, in a sense, inextricable counterpart concerns that balance or circle back on themselves. The impulse behind Dada is most often characterized as thoroughly anti-art, yet, as was noted earlier in reference to Hugo Ball, its adherents were concerned with the curative capacity of their diametric means. The rapid spread of Dada activities throughout Europe following the disbursement of it core adherents from Zurich testifies to the widespread relevance of its posture and attitudes. Dada aligned with the pervasive disillusionment with "culture" as the representation of a civilization then epitomized by greed and war.

Dadaists renounced authorship and the primacy of the art object and declared the 'readymade' to be a significant art form, which opened up the possibility of assigning artistic import to all things and forms of human production. Their expansion of the

frame also extended to the intangible aspects of action and behavior. A quintessentially Dada character, Arthur Cravan, became infamous, widely reviled and admired, through the publication of his magazine *Maintenant* in Paris from 1912 to 1915. Yet, his significance within artistic circles in Europe and New York was as an individual of bold persona who challenged convention not only through his writings but also through his manner of living and his actions. Cravan, an amateur boxer, challenged the world heavyweight champion Jack Johnson to a fight. Hardly a match for Johnson, Cravan went barely six rounds with the champion before being put away.[23] Cravan's "bad attitude," so cherished by the Dada artists of the time, was best exemplified by his appearance at the invitation of Marcel Duchamp to lecture at the Grand Center Gallery, American Independents Exhibition, in March of 1917. As recounted by Gabrielle Buffet-Picabia, Cravan arrived very late and plainly drunk, pushing his way through the crowd to the podium. He gesticulated wildly and began to undress.

Obviously, the police had been primed, for at the moment he began to lean over the speaker's table to hurl insults at the audience, he was promptly arrested. Cravan was bailed out by Walter Arensberg and championed by Duchamp for a "wonderful lecture."[24] Because of its purposeful intent, provocation within an art context by means of abject behavior has the capacity to resonate beyond the moment. The performances of Paul McCarthy are a recent example of this methodology and its particular domain. Since 1972, Paul McCarthy has been performing deliberately repulsive visceral bodily actions like spitting and sucking. Using materials such as ketchup, mayonnaise, hand lotion, hot dogs, and raw hamburger, along with props such as dolls, stuffed animals, kitchen utensils, and car parts, McCarthy has performed dressed in a variety of costumes—ranging from women's underwear to sailor suits to Jimmy Carter masks. The impetus for McCarthy's unsacramental, self-debasing work is to confront the viewer with primal and fundamental aspects of the human condition that lay beneath the surface of accepted behavior. The street works of William Pope.L are also potent acts that challenge habitual conduct that is patently disrespectful of human life. In his 1992 work *The White Baby (or How Much Is That Nigger in the Window?)* Pope.L crawled through the streets of Cleveland for four days, acting like a beggar but handing out dollar bills.

Back in the early 1910s and 1920s in New York, another artist revered by the Dada contingent was Baroness Elsa von Freytag-Loringhoven. Sometimes called the "first Surrealist" or the "mother of Dada," she carried anomalous behavior-as-art into

every aspect of her life. A pioneer of the use of found objects for art and bodywear, she shellacked her shaven skull, colored it vermilion, wore an inverted coal bucket for a cap, and applied to her body decorative contraptions such as bird cages, food tins, and teaballs. As recalled by the artist Louis Bouché, "She wore at times a black dress with a bustle on which rested an electric battery tail light." For such challenging apparel, matched only by her provocative demeanor, she was repeatedly arrested.[25]

Contemporary artists continue to engage the public through unconventional attire. Since the mid-1970s, Kim Jones as *Mud Man* has wandered around or posed in public settings smeared with mud and covered with sticks like jungle camouflage. This visage relates to his experiences in the Vietnam war and to destructive images found in everyday life. James Lee Byars's monochrome garments, especially his gold suit, are worn to announce his "presence as that of an artwork ... [and as] an interrogative presence."[26]

In the early decades of this century, the Dada enthusiasm for aberrant behavior as an end in and of itself was rejected by some artists. The Surrealists in particular took exception with the Dadaists' anti-art and nihilistic tendencies. The Surrealists probed new methodologies for the therapeutic role of art. They enacted to create new artistic processes which they believed would put humanity in touch with its deepest needs and desires and release it from the negative forces of social convention.

Equally important, during the height of Dada and Surrealism, was artists' participation in the social activism movements of the 1920s and 1930s. This trend, which extended beyond the aforementioned Russian avant-garde throughout Europe and the United States, adhered to a hopefulness for art created for the public good—in the worst sense as propaganda, and in the best sense as inspiration. After World War II, the optimistic flame of socialist art was extinguished by the exigencies of the war and the reactionary chill of the 1940s and 1950s. A political solution to elevate the human condition seemed even more remote and, in this country especially, drove artists further from representation and social activism, but not from the notion that art was for the greater good of enriching, if not bettering, the human condition.[27] One result of these currents was Abstract Expressionism. To some extent, Abstract Expressionism can be seen as the culmination of Dada's shift in emphasis from object to process, the Surrealists' mining of the collective unconscious in a pursuit of universal meaning in art, and Marxist tendencies that advocated a unity of art with everyday experience.

Artists of the generation to follow the Abstract Expressionists, such as Allan

Kaprow, Claes Oldenburg, and Jim Dine, became increasingly concerned with the primacy of action, which precipitated the environmental-scale performances called Happenings. The term "Happenings" was applied by the media and by artists to greatly diverse performances and events throughout the 1960s that were loosely tied together by certain characteristics. These includes emphasis on random improvisational collaging techniques; concepts and settings that were site-specific; a propensity to use recycled materials and/or trash, frequently found on site; the use of nonprofessional performers and participation of the originating artist; brief or limited rehearsal time; nonhierarchical, simultaneous, and fragmented actions, frequently a combination of the iconic and the pedestrian; a nonnarrative yet somewhat logical progression or cycle of events; the use of noise as an abstract material rather than as background accompaniment; a limited use of text; and the manipulation or actual incorporation of the audience into the performance itself. Like much performance art that preceded and followed, the notoriety of Happenings far exceeded the small audiences that actually saw or were engaged in their proceedings. Attendance numbered from a handful to several hundred over the course of a week or two. Many Happenings were created only for the actual participants.

Although the emphasis in Happenings was on artistic breakthroughs rather than social change, they were not entirely dissimilar to earlier events where the motivation was to tear apart artistic values in order to retool society. Sally Banes argues in her book, *Greenwich Village 1963*,

> ... these alternative modes of cultural production were crucial
> elements of social change. They were not just "reflections" of society;
> they helped shape the very form and style of political and cultural
> protest in the later Sixties. For one thing, however garbled its
> meaning, the concept of "the Happening," as spread through the
> mass media, was a ubiquitous figure for the expression of freedom,
> spontaneity, and an appreciation of art in life.[28]

Happenings existed within a specific time frame and cannot be recreated; nevertheless, many of their concerns persist. Perhaps one of the most sensational examples of more recent work which resembles Happenings is that of Survival Research Laboratories (SRL), a collaborative group including Mark Pauline, Matt Heckert, and

Eric Werner. In the 1980s, SRL created large-scale techno-punk spectacles performed by machines created from salvaged mechanical parts and exploding devices that engaged in combat and threatens the audience.

Fluxus, minimalism, conceptual art, environmental installations, earthworks, and body art have, to varying degrees, responded to and resisted the basic tenets of Abstract Expressionism in a dematerializing continuum. Raphael Montanez Ortiz's destruction performances evolved from his earlier Abstract Expressionist sculptures, which were made from mutilated pieces of furniture. Ortiz translated action painting into destruction as an artistic process to permit the expression of primal psychic states, fundamental aspects of life-affirming sacred rituals, and an acknowledgment of violence as a precondition of humanity.

On the opposite end of the spectrum, conceptual art reacted against the tendency of Abstract Expressionism to treat painting and sculpture as mythic and heroic endeavors. Vito Acconci's performances from the late 1960s and early 1970s were intended as physical manifestations of conceptual art. Chris Burden's risk-taking performances were also activated by his interest in the materialization of an idea. Like Acconci, he focused on completing a task that lay outside the realm of accepted behavior. Yet unlike the aggressively confrontational actions of earlier twentieth-century artists, Burden's potentially life-threatening actions were performed in a markedly dispassionate manner. They were frequently completed in complete privacy or for a limited audience.

Ann Hamilton, Gretchen Faust, and Rirkrit Tiravanija are also extending the evocative dimension of performance as physical task. In her 1991 piece *Indigo Blue*, Hamilton created an installation with a 14,000-pound pile of men's blue workshirts that had been laundered and neatly folded under her supervision. Throughout the piece, she or another person sat at a desk behind the mountain of shirts silently erasing the contents of old history books. The work was, in essence, a monument to the men who wore the shirts, the women who laundered them, and suggested a rewriting of the history of working-class peoples on the cleared pages.

During a 1990 exhibition at the Pat Hearn Gallery in New York, Gretchen Faust periodically performed a piece that consisted of standing on a stool under a white cloth and pushing its rim outward with a pole in an interminable attempt to lay out a complete circle. Faust's use of spare, beautiful, and symbolic materials that are "ultimately disposable" counteracts the identification of art as a commodity. For *Outside*

the Frame, Rirkrit Tiravanija cooked a Thai curry for gallery attendees. This everyday chore symbolized the nurturing capacity of art. As he has done in similar performances, Tiravanija left behind the cooking equipment, dirty plates, and organic waste as a relic of his proceedings, a somewhat unpleasant reminder that one must look beneath and beyond the immediate frame of an artwork or activity in order to know it more fully.

Over the past century, the entire notion of art has dramatically shifted. A simple indicator can be found in the dictionary. In 1880, Webster's defined "art" as a "creative effort in the production of works that have form or beauty, aesthetic expression of feeling, especially painting, drawing, etc." The current definition of "art" in a 1990 edition of Funk & Wagnall's reads: "The skillful, systematic arrangement or adaptation of means for the attainment of some end, especially by human endeavor."[29] It is evident that the history of performance art has played a significant role in this shift in our making, viewing, and thinking about art. It has come into its own as a frame in a state of constant remaking.

Notes

1. Phillip Dennis Cate and Patricia Boyer, *The Circle of Toulouse-Lautrec: An Exhibition of the Work of the Artist and of His Close Associates*, exhibition catalogue, The Jane Voorhees Zimmerli Art Museum (Rutgers, NJ: The State University of New Jersey, 1986): 19.

2. Harold B. Segel, *Turn-of-the-Century Cabaret: Paris, Barcelona, Berlin, Munich, Vienna, Cracow, Moscow, St. Petersburg, Zurich* (New York: Columbia University Press, 1987): 147.

3. Ibid., 171-177.

4. Ibid., 147.

5. Ibid., 330.

6. Roger Shattuck, *The Banquet Years: The Origins of the Avant-Garde in France 1885 to World War I* (New York: Random House, 1968): 153.

7. Segel, *Turn-of-the-Century Cabaret*, 170.

8. Lisa Appignanesi, *The Cabaret* (New York: Universe Books, 1976): 45.

9. Alan Moore and Marc Miller, eds., *ABC No Rio Dinero: The Story of a Lower East Side Art Gallery* (New York: ABC No Rio with Collaborative Project, 1985): 38-39.

10. Mary Emma Harris, *The Arts at Black Mountain College* (Cambridge, MA: The MIT Press, 1987): 10-16.

11. Michael Kirby, *Futurist Performance* (New York: E. P. Dutton, 1971): 47-48.

12. Ibid., 15-16. *The Times* article was quoted in "Making a Target of the Audience," *The Literary Digest* (3 December 1921): 27.

13. Ibid., 89-90.

14. Ibid., 57-58.

15. *The Avant-Garde in Russia, 1890-1930: New Perspectives*, exhibition catalogue, organized and edited by Stephanie Barron and Maurice Tuchman (Los Angeles: Los Angeles County Museum of Art, 1980): 38.

16. Ibid., 25.

17. Robert L. Herbert, ed., *Modern Artists on Art: Ten Unabridged Essays* (Englewood Cliffs, NJ: Prentice-Hall, 1964): 93-94.

18. Jean-Claude Marcadé, in *The Avant-Garde in Russia* (Barron and Tuchman, eds. op.cit.): 21.

19. Alma H. Law, in *The Avant-Garde in Russia* (Barron and Tuchman, eds. op.cit.): 64-67.

20. RoseLee Goldberg, *Performance Art: From Futurism to the Present* (New York: Harry N. Abrams, 1988): 41-42.

21. Szymon Bojko, in *The Avant-Garde in Russia* (Barron and Tuchman, eds. op.cit.): 73-74.

22. Ibid., 72.

23. Rudolf E. Kuenzli, *New York Dada* (New York: Willis, Locker & Owens, 1986): 103.

24. Robert Motherwell, ed., *The Dada Painters and Poets: An Anthology,* with critical bibliography by Bernard Karpel (Cambridge, MA: Belknap Press of Harvard University Press, 1981): 16.

25. op.cit., Kuenzli, *New York Dada*, 86-87.

26. James Elliot, *The Perfect Thought: An Exhibition of Works by James Lee Byars* (Berkeley, CA: University Art Museum, 1990): 57.

27. Stephen Polcari, *Abstract Expressionism and the Modern Experience* (Cambridge and New York: Press Syndicate of the University of Cambridge, 1991).

28. Sally Banes, *Greenwich Village 1963: Avant-Garde Performance and the Effervescent Body* (Durham, NC and London: Duke University Press, 1993): 9.

29. Deborah J. Johnson, "Is Art Central to Art History?," *Museum Management and Curatorship 12* (March 1993): 93.

Plates

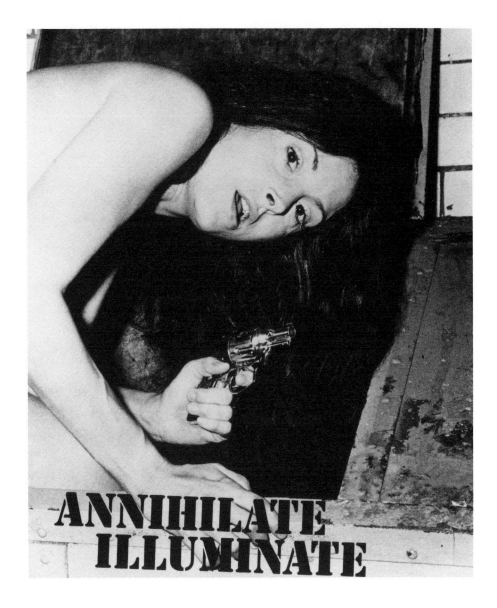

Hannah Wilke

Annihilate Illuminate (Oldenburg), from the series *So Help Me Hannah*, 1978-84

Black and white photograph

60 x 40 ins.

Courtesy of Ronald Feldman Fine Arts, Inc., New York

Chris Burden
The Hard Push, 1983
Photographic documentation of performance with plywood wheel
48 x 112 ins.
Photograph: Matthew Kocsis

Vito Acconci
Fitting Rooms (Revised), 1972/1987
Wood, chalk, steel, mirror, masks, hardware, and balls
84 x 96 x 96 ins.
Photograph: Ray Juaire

Stuart Sherman
Bowling, 1993
Bowling pins, oak flooring, and bowling balls
16¼ x 30½ x 85¾ ins.
Photograph: Shari Jackson

James Lee Byers
IS, 1989
Marble sphere, gilded
Diameter23¼ ins.
Photograph: Doug Cox

Janine Antoni
Eureka, 1993
Bathtub, lard, and soap
Soap: 22 x 26 x 26 ins.; tub 30 x 70 x 25 ins.
Photograph: Scot Cohen

Gretchen Faust and Kevin Warren
Instrument for Listening and Talking, 1993-94
Cushion and tube
Dimensions variable
Photograph: Ray Juaire

Laurie Anderson
Handphone Table, 1978
Table: 34 x 23 x 37 ins.; Photograph: 41 x 31 ins.
Courtesy of the Artist

Ana Mendieta
Untitled from *Silueta Works in Mexico*, 1973-77
Color photograph - C-print (posthumous print)
20 x 13¼ ins,
Courtesy of Galerie Lelong, New York, and the Estate of Ana Mendiata

Nayland Blake
Untitled, 1993
Nylon and steel
78½ x 25 x 14 ins.
Photograph: courtesy Matthew Marks Gallery, New York.

Liz Prince

Fit the Bill, 1989

Dollar bills, pennies, tulle, feathers, wire, beads, and talking "Teddy Ruxpin" doll

Headdress: 19 x 21 x 10 ins.; Gown: 60 x 16 x 10 ins.

Photograph: Valerie Shaff

Pat Oleszko
Udder De Light from *Bluebeard's Hassle: The Writhes of the Wives,* 1990
Costume, blower, and time delay unit
Costume: 7 x 48 x x48 ins.
Photograph: Neil Selkirk

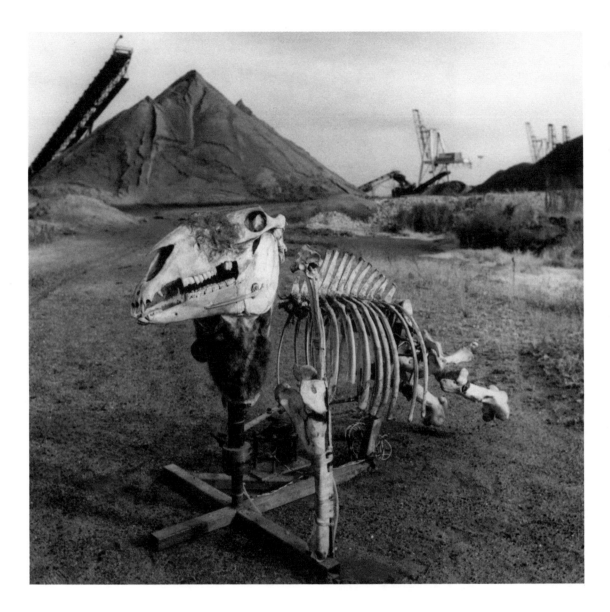

Matt Heckert
No Head, 1987
Machine sculpture
48 x 36 x 36 ins.
Photograph: Bobby Neel Adams

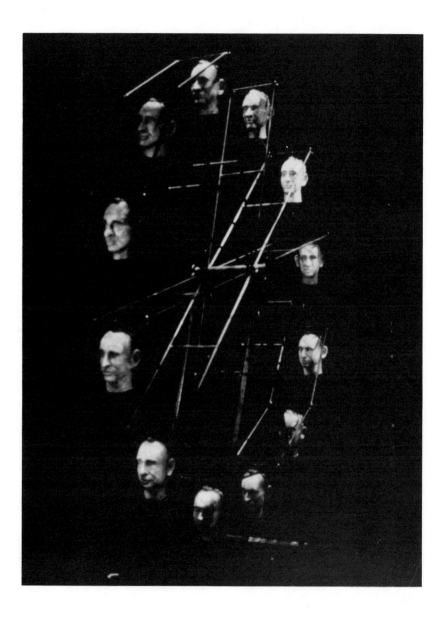

Theodora Skipitares
Wheel of Power from *The Radiant City*, 1991
Steel, latex, and oil paint
144 x 132 x 36 ins.
Courtesy of Nirlilach

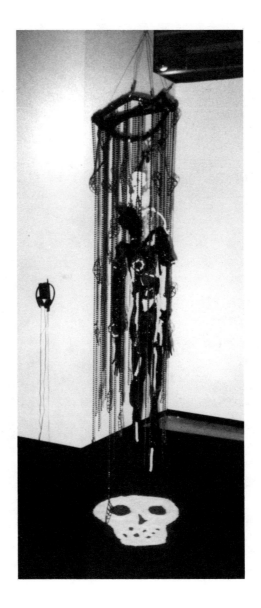

Joyce Scott
Somebody's Baby, 1993
Beads, thread, wire, and audio tape
Approx. 40 x 20 x 22 ins.
Photograph: Doug Cox

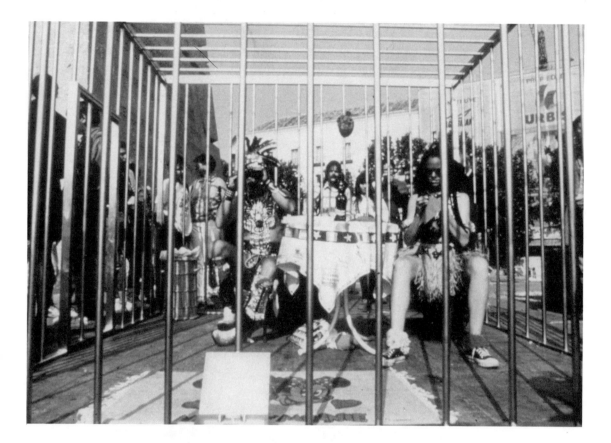

Coco Fusco and Guillermo Gómez-Peña
Two Undiscovered Aboriginals Visit Madrid, 1992
Cage, costumes, and utilitarian objects
Dimensions variable
Courtesy of the Artists

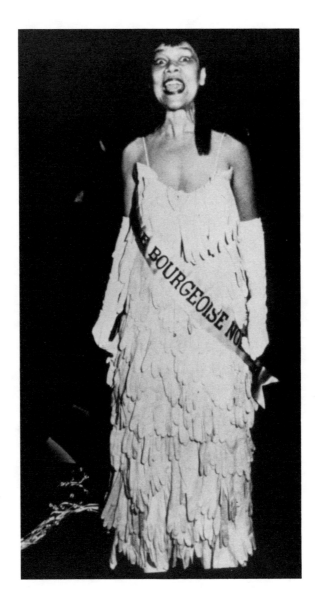

Lorraine O'Grady
Mlle. Bourgeoise Noire Goes to The New Museum, 1981
Costume: dress made from white gloves and sash
40 x 30 ins.
Photograph: Coreen Simpson

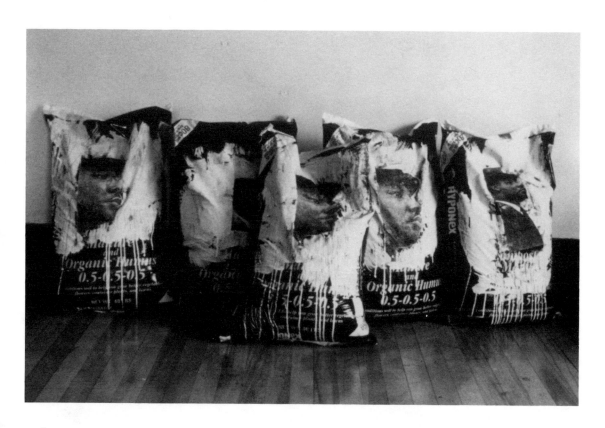

William Pope.L
Rebuilding:..., 1993
Collage, paint, and ink on bags of manure
Dimensions variable
Courtesy of the Artist and Horodner Romley Gallery, New York

Rirkrit Tiravanija
Untitled (Raw), 1994
Thai spices, vegetables, and cooking utensils
Dimensions variable
Photograph: Doug Cox

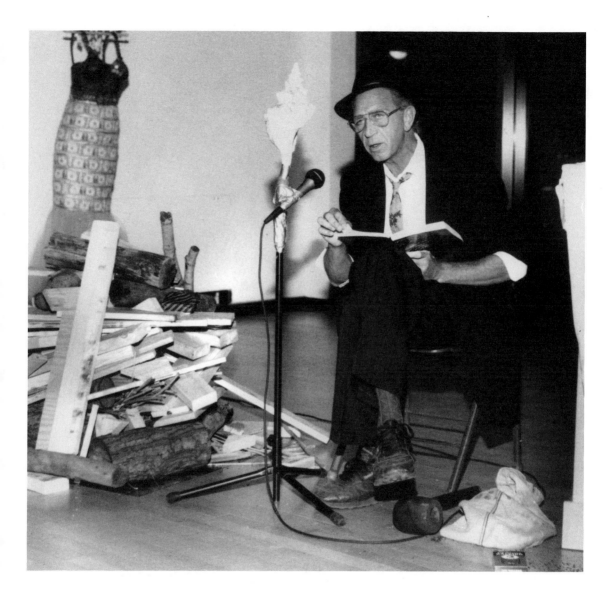

Jimmie Durham
Fire! or Imperialism!, 1994
Mixed media
Dimensions variable
Photograph: Doug Cox

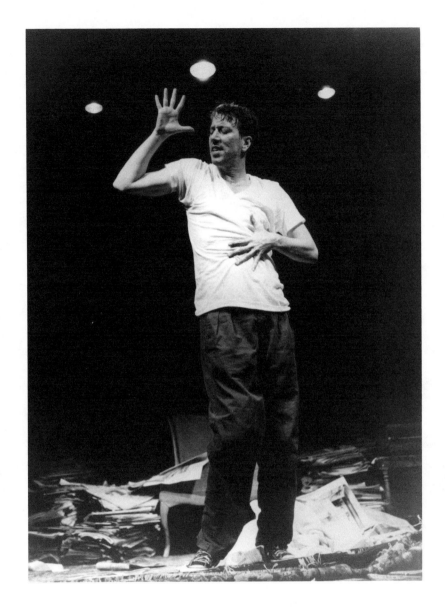

John Fleck
A Snowball's Chance in Hell, 1992
Photographic documentation of performance
Photograph: Greg Cloud

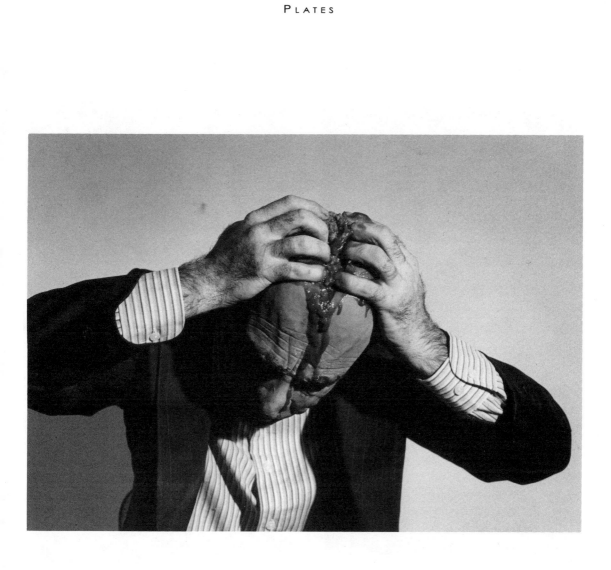

Paul McCarthy
Hollywood Halloween, detail 1978/1993
Black and white photograph
16 x 20 ins.
Courtesy of the Artist and Luhring Augustine, New York

THE BLACK SHEEP

After a funeral someone said to me
You know I only see you at funerals
it's been 3 since June
been 5 since June for me
He said I've made a vow
I only go to death parties if I knew someone before they were sick
Why?
cause-cause-cause- I feel I feel so
sad cause I never knew their life
and now I only know their death
And because we are members of the
Black Sheep family

We are sheep with no shepherd
We are sheep with no straight and narrow
We are sheep with no meadow
We are sheep who take the dangerous
pathway thru the mountain range
to get to the other side of our soul
We are the black sheep of the family called Black Sheep folk
We always speak our mind
 appreciate differences in culture
 believe in sexual preferences
 believe in no racism, no sexism, no religiosim
and we'll fight for what we believe
but usually we're pagans
There's always one in every family
Even when we're surrounded by bodies
we're always alone
You're born alone and you die alone
written by a black sheep.
You can't take it with you-
written by a former black sheep.

Black Sheep folk look different from their family-
it's the way they look at the world
We're a quirk of nature- We're a quirk of fate-
Usually our family, our city, our country
never understand us
We knew this from when we were very young
that we were not meant to be understood.
That's right. That's our job.
Usually we're not appreciated until the next generation.
That's our life. That's our story.
Usually we're outcasts, outsiders in our own family.
Don't worry - get used to it.
My sister says I don't understand you!
But I have hundreds of sisters with me tonight.
My brother says I don't want you!
But I have hundreds of brothers with me here tonight!
My mother says I don't know how to love someone like you!
You're so different from the rest!
But I have hundreds of mamas with me here tonight!
My father says I don't know how to hold you!
But I have hundreds of daddies with me here tonight!

We're related to people we love who can't say
I love you Black Sheep daughter
I love you Black Sheep son
I love you outcast, I love you outsider
But tonight we love each other
That's why we're here
to be around others like ourselves
So it doesn't hurt quite so much
In our world our temple of difference
I am at my loneliest when I have something to celebrate
and try to share it with those I love but
who don't love me back
There's always silence at the end of the phone
There's always silence at the end of the phone

Sister-Congratulate me!
NO I CAN'T YOU'RE TOO LOUD
GRANDMA LOVE ME
NO I DON'T KNOW HOW TO LOVE SOMEONE LIKE YOU
Sometimes the Black Sheep is a soothsayer,
a psychic, a magician of sorts
Black Sheep see the invisible
We know each other's thoughts
We feel fear and hatred

Sometimes, some sheep are chosen to be sick
to finally have average, flat, boring
people say I love you
Sometimes Black Sheep are chosen to be sick
so families can finally come together
and say I love you
Sometimes, some Black Sheep are chosen to die
so loved ones, families, countries and cultures can finally say
Your life was worth living
Your life meant something to me!
I loved you all along
Black Sheep's destinies are not in
necessarily having families,
having prescribed existences-
like the American Dream
Black Sheep Destinies are to give
meaning in life - to be angels,
to be conscience, to be nightmares
to be actors in dreams

Black Sheep can be family to strangers
We can love each other like MOTHER
FATHER SISTER BROTHER CHILD
We understand universal love
We understand unconditional love
We feel a unique responsibility
a human responsibility for feelings for others
We can be all things to all people-
We are there at 3:30 AM when you call!
We are here tonight cause I just can't go to sleep.
I have nowhere else to go
I'm a creature of the night, I travel in your dreams
I feel your nightmares
We are your holding hand
We are your pillow, your receiver, your cuddly toy
I feel your pain
I wish I could relieve you of your suffering
I wish I could relieve you of your pain
I wish I could relieve you of your death
Silence at the end of the phone
Silence at the end of the phone
Silence at the end of the phone

Karen Finlay
Black Sheep, 2 panels, 1990
Cast bronze
2 pieces each 40 x 24 ins.
Photographs: Ray Juaire

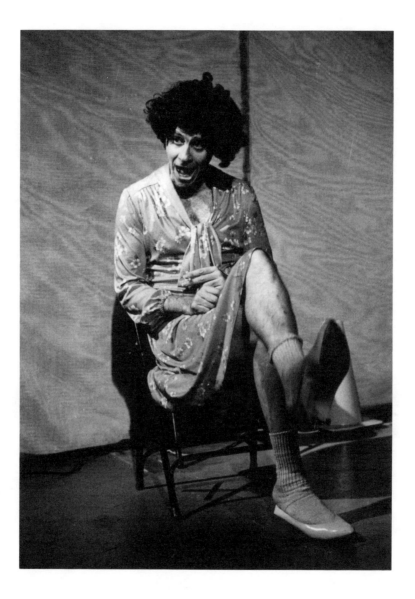

John Malpede
LAPD - The Robert Chapter, 1985
Photographic documentation of Los Angeles Poverty Department performance
Dimensions variable
Photograph: Lukas Felzmann

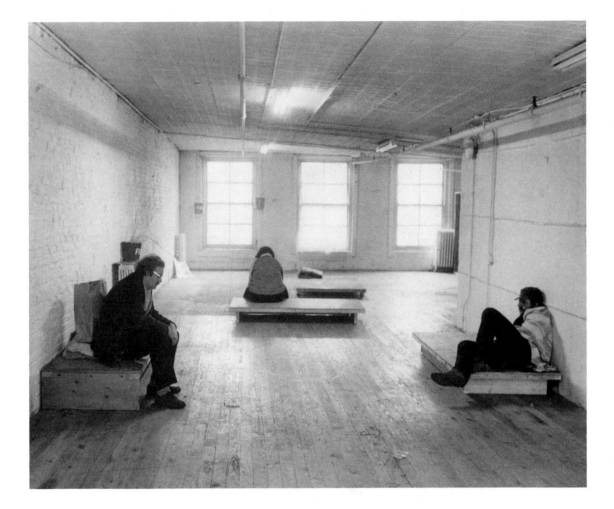

Peter Moore
Untitled, 1969
Performance documentation
16 x 20 ins.
Photograph: © Peter Moore

Performance Art Timeline

A Survey History of Performance Art from 1881 to 1994
Compiled by Robyn Brentano and Olivia Georgia

1881

Le Chat Noir (The Black Cat) cabaret opens in Montmartre, Paris. Attracted by its lively and unpretentious milieu, artists, poets, and musicians give mixed-media performances using a shadow theater technique derived from Javanese puppetry. For a while, **Erik Satie** is the cabaret's regular accompanist. The vitality and success of Le Chat Noir inspires a cafe mania across Europe.

1885

The popular chansonier **Aristide Bruant** opens his own cabaret, **Le Mirliton** (The Reed Pipe), where he performs songs about the lives of society's outcasts—street urchins, pimps, prostitutes, petty criminals, and the homeless.

1896

The poet **Alfred Jarry** presents *Ubu Roi* at the **Théâtre de L'Oeuvre**. The absurdist play, portraying a repulsive king who murders his way to the throne, scandalizes the public with its opening line, a single word: 'merdre' ('shit'). The play's set (created by Jarry, with the assistance of **Pierre Bonnard, Edouard Vuillard, Henri de Toulouse-Lautrec**, and **Paul Sérusier**) and its costumes are blatantly sordid.

1887

Miquel Utrillo, one of Le Chat Noir's inner circle, opens **Els Quatre Gats** (The Four Cats) in Barcelona. A young **Pablo Picasso** has his first exhibition there in 1900.

1901

Artists from the literary society **Die Brill** (The Spectacles) found the Berlin cabaret **Schall & Rauch** (Sound & Smoke). **Max Reinhardt** uses Schall & Rauch as a testing ground for theatrical productions and ultimately becomes its full-time director.

An eclectic group of writers, critics, painters, a composer, a musician, a lawyer, and an architect found **The Eleven Executioners** in Munich. The notorious author, playwright, and song writer **Frank Wedekind** joins, bringing a dark gallows humor typical of the German cabaret sensibility.

1905

Polish dramatist **Jan August Kisielewski** returns to Krakow from Paris and opens the **Zielony Balonik** (The Green Balloons). The cabaret closes in 1910, by which time cabarets have opened in every major city of Poland.

1906

In Vienna, the **Theater Kabarett Fledermaus** (The Bat Theater & Cabaret) opens, with decor by **Gustav Klimt, Emil Orlik, Oskar Kokoschka,** and **Carl Hollitzen**. The Fledermaus closes in 1910.

1908

A.R. Kugel and **Zinaida Kholmskaya** establish a 700-seat theater, **The Crooked Mirror**, in St. Petersburg. Its director, **Nikolai Evreinov,** produces performances using a variety of theatrical styles. This includes *Theater of the Soul* (1912), which is based on his theory of monodrama—an approach that breaks down the barriers between stage and audience.

Nikita Baliev opens **The Bat** in Moscow.

1909

Diaghilev, the Russian ballet impresario, begins to use easel painters for stage design.

Vsevolod Meierkhold opens the cabaret **Lukomore** (The Strand) in St. Petersburg. His hapless venture closes within one week.

The Futurist **Filippo Tommaso Marinetti** publishes the first *Futurist Manifesto* in the French newspaper *Le Figaro*.

Marinetti presents *Roi Bombance*, a parody of *Ubu Roi*, in the same theater in Paris in which **Jarry's** production was presented.

1911

The performance of **Raymond Roussell's** *Impressions d'Afrique*, from a fiction of the same title, includes the *Earthworm Zither Player*—a trained earthworm whose drops of mercury-like perspiration slide down the strings of an instrument to produce music. (This event is highly regarded by **Marcel Duchamp** and **Francis Picabia**.)

Vsevolod Meierkhold makes his third attempt at establishing a cabaret in St. Petersburg, **The Stray Dog** with **Boris Pronin**.

1912

Due to political changes in Western and Eastern Europe, important Russian artists like **Vasily Kandinsky** return home from Berlin and Paris.

1913

Marcel Duchamp creates *Bicycle Wheel*, his first "ready-made." His use of found objects in the creation of art work becomes an important influence in the development of performance art later in the twentieth century

Marinetti publishes the *Variety Theater Manifesto*, a proposal for the formation of a Futurist Theater. Modeled after popular forms of entertainment, such as the circus, burlesque, vaudeville and athletic events, Variety Theater is to be "A THEATER OF AMAZEMENT, RECORD-SETTING, AND BODY-MADNESS," an 'illogical theater' that disrupts audience expectations and stimulates an intuitive approach to art. "Naturally anti-academic, primitive, and naive...the Variety Theater destroys all conceptions of perspective, proportion, time, and space...exalts action, heroism, life in the open air...," calling for an end to all the conventions and psychologies of established theater. Futurist evenings, staged in rented halls in city after city, are calculated attacks on bourgeois mediocrity; audiences retaliate with "showers of potatoes, oranges, and bunches of fennel."

A performance of **Luigi Russolo's** *intonarumori* (noise instruments), at **Teatro Stocci** in Modena, demonstrates his *Art of Noise* manifesto, which argues that machine sounds are a viable form of music.

Victory Over the Sun, an abstract opera by **Kazimir Malevich**, poet and theoretician

Alexi Kruchenyk, and painter and musician **Mikhail Matiushin,** is presented in St. Petersburg, Russia. An allegory about men of the future surpassing the world of the past, *Victory* uses non-professional actors, a nonsensical text, atonal music, and abstract sets and costumes.

1914

Futurist **Giacomo Balla** creates *Macchina Tipografica* (Printing Press), in which 12 performers move in mechanical coordination, reciting percussive sounds that imitate a printing press.

Marinetti visits Moscow and St. Petersburg. In St. Petersburg, he reads at **The Stray Dog** and participates in one of **Vsevolod Meierkhold's** theater classes.

1915

Futurist **Francesco Cangiullo** publishes *Detonazione* (Detonation), in which the curtain rises on a nocturnal scene of a deserted road, a shot is fired, and the curtain falls.

In **Marinetti's** Futurist performances of *Le Basi* (The Feet) and *Le Mani* (The Hands), only the feet and hands of the performers are shown. For example, *Le Mani* consists of 20 unrelated gestures, such as two hands shaking, two hands writing at different speeds, a fist punching, and a hand holding a revolver.

Marinetti publishes *Simultaneità* (Simultaneity) which depicts coincidental, unrelated narratives. Portrayed on one-half of the stage is the life of a beautiful prostitute; on the other is the life of a bourgeois family.

1916

Marinetti's *The Communicating Vases* adds a third scene which is performed simultaneously with two others. At the end, the partitions that divide the scenes are broken through by soldiers, thereby fusing the lives of the prostitute, the bourgeois family, and the soldiers.

Hugo Ball opens the **Cabaret Voltaire** in Zurich, and it quickly becomes a lively center where French, Italian, German, and Russian artists and writers present their work. Within four months, Ball is exhausted by the nightly revels. In his final perfor-

mance, wearing a rigid Cubist costume, he recites some of his sound poems that consist entirely of nonsense syllables.

In Barcelona, **Arthur Cravan**, the belligerent critic and poet idolized by Dada artists, fights European boxing champion **Jack Johnson**. In typical Dada style, conflicting accounts of the event circulate, ranging from Cravan being drunk and knocked out in the first round to his having fought six rounds before being "put away" by Johnson.

1917

To accompany the orchestral piece *Fireworks* by **Igor Stravinsky,** the Futurist **Giacomo Balla** eliminates live performers and creates a geometric, three-dimensional, multi-colored set with opaque and translucent surfaces that are animated by 49 different lighting changes.

Richard Huelsenbeck, one of the original members of the **Cabaret Voltaire** Dadaist entourage, returns to Berlin from Zurich. Appalled by wartime and postwar conditions in Germany, he and other artists and writers, such as **Raoul Hausmann, George Grosz, Johannes Baader, Hannah Hoch, Hans Richter, Walter Mehring**, and **Otto Dix**, launch their own series of Dada publications and events. Their confrontational actions are intended to shock the public into an awareness of the country's abject political situation and escapist culture.

Arthur Cravan is invited by **Duchamp** to speak at the *American Independents Exhibition*. He arrives drunk and begins to strip while hurling insults at the crowd. Cravan is arrested but later bailed out by **Walter Arensberg**. Duchamp shows his famous work *Fountain*, an up-side-down urinal which he signs 'R. Mutt.'

During the inaugural exhibition of **Galérie Dada** in Zurich, **Hugo Ball** lectures on **Kandinsky**, recounting his theories on the spiritual dimension of art—its ability to overcome rank materialism and its connection to pure abstraction in painting and language. This important lecture articulates the desperate milieu of the time and the nihilist attitude of the Dadaists in the years to follow:

> God is dead. A World disintegrated. I am dynamite. World history
> splits into two parts...Religion, science, morality—phenomena that
> originated in the states of dread known to primitive peoples...a

thousand-year-old culture disintegrates…Chaos erupted. Tumult erupted…Man, stripped of the illusion of godliness, became ordinary, no more interesting than a stone…. (Hugo Ball, *Flight Out of Time*)

At a **Galérie Dada** soirée, *Negresses*, a dance choreographed by **Hugo Ball**, is performed by several **Laban** dancers wearing masks designed by **Marcel Janco**. Also on the program is **Oskar Kokoschka**'s cabaret classic *Sphinx and Strawman*.

Diaghilev's Ballet Russes performs *Parade*, a collaborative production with book by **Jean Cocteau**, sets by **Pablo Picasso**, and music composed by **Erik Satie**.

Guillaume Apollinaire's 'surrealist drama' *Les Mamelles de Tirésias* is performed at the **Conservatoire René** in Montmartre, Paris. In their post-war nihilism and rejection of the validity of art, **Jaques Vaché**, who is with **André Breton**, stands during the performance brandishing a pistol in protest of Apollinaire's pretension.

1918

The first performance of *Mystery-Bouffe*, by **Vladimir Mayakovsky**, is staged by **Vsevolod Meierkhold**, with sets by **Kazimir Malevich**, at the **Petrograd Conservatory**, Russia. The work, a parody of a medieval morality play, portrays the international proletariat being led by the Bolshevik regime to a mechanized promised land.

Due to constant harassment and arrests for radical activities, the **Ferrer Center** and the **Modern School** are forced to close down their New York operations.

With the financial backing of **Gloria Vanderbilt Whitney**, the **Whitney Studio Club** is founded in New York as an artists' co-op to provide exhibition opportunities.

1919

In Zurich, **Francis Picabia, Tristan Tzara,** and others collaborate on the publication of the extremist Dada periodical *391*. The title is named after **Alfred Stieglitz's** New York gallery and publication for which Picabia had worked in 1913 and 1915.

After World War I, **Marcel Duchamp** returns to Paris with a star shaved on the back of his head, an act that becomes emblematic of the idea that the artist and art work are one and the same.

The cabaret **Schall & Rauch** (Sound & Smoke) becomes a center of Dadaist activity in Berlin.

Jaques Vaché, a friend and inspiration to **André Breton**, chooses to die of an overdose of opium, as he said he would, at a self-appointed time with friends gathered around.

Francesco Cangiullo publishes *Luce* (Lights) which calls for performers planted throughout the house to incite the audience to demand the house lights. When the uproar reaches its peak, the lights are to come on and the curtain is to fall.

The **Bauhaus** opens in Weimar, Germany. Founded by **Walter Gropius**, this idealistic school spearheads new outlooks in fine arts, design, architecture, performance, and stage design.

André Breton and **Philippe Soupault** collaborate on the first important Surrealist work, *Les Champs Magnétiques* (The Magnetic Fields). They spend two weeks at Breton's apartment dictating to each other their unconscious thoughts. This work reflects the Surrealists' interest in psychology and, in particular, **Freud's** investigations of the subconscious and the imagery of dreams.

1920

Marinetti's call for short-form works to counter the pretentious burden of epic drama leads to the condensation of familiar classics. Futurist **Giuseppe Stein** reduces the well-known five act tragedy *Saul*, by **Vittorio Alfieri,** to two sentences per act.

Tristan Tzara and **Francis Picabia** move to Paris. Artists from the review *Litterature* perform in Tzara's first presentation at the **Palais des Fetes**. Tzara reads a newspaper while an electric bell rings continuously, aggravating many of the artists.

A Dada event at the **Salon des Independents** in Paris includes 38 performers, among them **Tristan Tzara**, **André Breton**, **Louis Aragon**, and **Paul Éluard**. It is announced that **Charlie Chaplin** will appear; when he fails to show, the angry audience is treated to the Dadaists' abusive manifestoes.

Manifestation Dada is presented at the **Maison de l'Oeuvre**. Among other things, it includes a Dada fashion show, a musical manifesto by **Picabia**, a reading of the manifesto by **Breton**, and a play by **Tzara**, *The First Celestial Adventure of M. Antipyrine.*

The *Erste Internationale Dada Messe* (First International Dada Fair) is organized at the **Burchard Gallery** in Berlin.

Richard Huelsenbeck, Raoul Hausmann, and **Johannes Baader** undertake a Dada tour of Germany and Czechoslovakia. Their performances are attended by upwards of 2,500 people. In *Memoirs of a Dada Drummer*, Huelsenbeck recalls annoying and bewildering their audiences because the artists never knew in advance what they were going to do.

Erik Satie presents *musique d'ameublement* (furniture music) at **Barbazange Gallery** in Paris. During intermission, the musicians spread throughout the room and play overlapped popular tunes in repetitive rhythmic arrangements. Satie entreats the audience to talk and walk around, to regard the music as an aural backdrop, and to consider a new kind of listening.

A Dada Festival is held at the plush **Salle Gaveau** in Paris. Advertisements announcing that the Dadaists will have their heads shaved on stage draw a large crowd. This does not happen and the artists' unrehearsed pieces are delayed and dissolve into confusion. The audience, which is accustomed to the Dada affronteries, comes well prepared with vegetables and veal cutlets to throw at the performers.

Kurt Schwitters, a favorite of the Dadaists and renowned for his environmental assemblage *Merzbau* (Merz House), writes *Merz*, an essay that discusses fusing diverse materials—"solid, liquid, and gaseous bodies, such as white wall, man, barbed wire entanglement, blue distance, light cone"—to create the *Merz* stage. He suggests using "man-traps, automatic pistols, infernal machines...all of course in an artistically deformed condition...in short everything from the hairnet of the high class lady to the propeller of the S.S. Leviathan...Even people...can be tied to backdrops."

Meierkhold's *The Dawn* is staged at the **R.S.F.S.R. Theater** in Moscow. The epic drama about world revolution had Constructivist sets by **Vladimir Dimitriev**. Red, gold, and silver cubes, cylinders, and planes, with intersecting ropes attached to the flies, reflect the influence of **Tatlin's** "counter reliefs."

The Storming of the Winter Palace is staged by **Nikolai Evreinov** at 10 p.m. in Urisky Square, with a cast of 10,000 and an audience of 100,000. A 500-piece orchestra plays a

Varlich symphony and ends with the *Marseillaise*. To cries of "Lenin! Lenin!," truckloads of workers converge on the set (by **Yurii Annenkovwith)**. The building is illuminated and a dramatic fireworks display accompanies an armed forces parade.

Director **Nikolai Foregger** and playwright, poet, and theater critic **Vladimir Mass** enlist in an agit-train group in Russia, where they collaborate on mechanized set designs with several important filmmakers, including **Sergei Eistenstein**. Foregger's movement training system merges contemporary theater-circus forms with industrial, Futurist forms to create stylized political satires and abstract dance works that emulate the geometric movements of machines.

1921

In keeping with the Futurists' attempts to break down barriers between performers and audience members, **Bruno Corra** and **Emilio Settimelli** write *Grey + Red + Violet + Orange*, in which an actor accuses a spectator in the front row of murder. This work, produced by **Ettore Petrolini**, tours Brazil.

Images of the renowned "mother of Dada," the **Baroness Elsa von Freytag-Loringhoven**, appear in *New York Dada*. Embodying the spirit of Dada, she shellacks her shaven skull, colors it vermillion, wears military helmets and an inverted coal bucket for hats, and applies implements such as metal teaballs to her body. She is also seen wearing a black dress with a bustle on which an electric tail light rests. She is repeatedly arrested for her brazen gestures.

The Dada group, including **Louis Aragon**, **Jean Arp**, **André Breton**, **Paul Éluard**, **Francis Picabia**, **Philippe Soupault**, and **Tristan Tzara**, schedules a tour of Paris "... to become aware of human progress in possible works of destruction and of the need to pursue our action...."

The Dada trial of **Maurice Barrès** is held. A writer whose novels from the 1880s-90s championed individual liberty, Barrès became a mouthpiece of nationalism and socially acceptable moral codes after the turn-of-the-century.

Breton begins to disassociate himself from Dada in dissatisfaction with its directionless anarchy and anti-intellectualism.

Mayakovsky visits Paris and is feted by the Surrealists.

A London *Times* critic describes a Futurist performance in which a furious audience drives the actors off stage with a fusillade of fruits and vegetables. The artists are forced to use their paintings as shields and eventually succumb to throwing objects back at the audience, bringing the piece to a premature end.

1922

As part of the **Dada Salon,** at **Galérie Montaigne, Tristan Tzara** presents his play *Le Coeur a Gaz.*

Figural Cabinet I, **Oscar Schlemmer's** first performance at the **Bauhaus,** occurs during one of their infamous parties. Using Constructivist/Cubist-style costumes inspired by the 1919 film *The Cabinet of Dr. Caligari,* the piece is performed with exaggerated and absurd actions to parody the prevailing "faith in progress."

At a performance in Paris at the **Théa(^)tre des Champs-Elysées,** the **Dada Salon** protests the "insipid melodies" of the Italian noise musicians led by **Marinetti**. A year earlier, the Surrealists showed their disapproval of the Futurists by protesting a lecture by Marinetti.

Meierkhold presents *The Magnanimous Cuckold* in the former **Sohn Theater** in Moscow. **Liubov Popova's** sets reflect a total re-orientation of their content and aesthetics from contrived theatrical settings to utilitarian, sculptural environments. The set's grouping of platforms, stairs, ramps, and planar backdrops have the syncopated graphic virtues of a Constructivist drawing.

In Berlin, **Karel Capek's** *R.U.R.* depicts a futuristic factory run by robots. A panorama by **Frederick Kiesler** uses film for the first time in performance. The production also incorporates animated neon lights and reflected images of the performers, all integrated within the live actions.

1923

Tristan Tzara presents a remake of the 1921 *Le Coeur a Gaz,* at the **Soirée du Coeur à Barbe,** with costumes by **Sonia Delaunay**. This performance is vigorously protested

by **Breton** and other Surrealists who are in the habit of railing against artists with whom they disagree, and demonstrating in favor of those with whom they agree.

1924

Erik Satie's *Relache,* a burlesque ballet of the absurdist realm, is presented in Paris. A collaborative work with **Francis Picabia** and **Jean Borlin,** its cast includes **Marcel Duchamp** and **Man Ray.** The first scene is set against a backdrop of rows and rows of large reflective metal discs, each illuminated by a high intensity light bulb. Various simultaneous events include Man Ray pacing up and down, measuring the stage; dancers revolving upstage in darkness; the motionless figures of Adam and Eve (after a Cranach painting); and a fireman who continuously smokes and pours water from one bucket to another. At intermission, **Rene Clair's** film *Entr'acte* is shown. It is a series of disconnected images: a male dancer in a gauze tutu, shot from below through a pane of glass; Man Ray and Duchamp playing chess, shot from above; and a funeral procession which ends with the coffin falling off the hearse and breaking open to reveal a grinning corpse.

1925

Antonin Artaud directs **Louis Aragon's** play *At the Foot of the Wall.* Its proceedings are stopped by a violent protest led by the Surrealists.

1926

Oscar Schlemmer creates *Gesture Dance* using diagrams of spiraling and linear movement through space. Three figures, dressed in primary colors, follow the geometric paths of the diagrams and perform everyday actions, such as "pointed sneezing, broad laughing, and soft listening." Schlemmer's mechanical actions, which emphasize the "object quality" of the dancers, reflect an optimistic fascination with technology. Many of his costumes severely restrict the dancers' movements.

1928

André Breton writes *Surrealism and Painting.*

Antonin Artaud founds the **Théâtre Alfred-Jarry** and stages **Auguste Strindberg's** *Dream Play.* **André Breton,** who had excommunicated Artaud from the Surrealist

movement, attempts to stop the performance. Artaud and his associates are forced to call the police to prevent Breton's disruption.

1929

André Breton writes the *Second Surrealist Manifesto.*

1930

Mayakovsky commits suicide.

Members of the Surrealist movement split onto two different paths: political action, led by **Louis Aragon,** and the exploration of the unconscious, led by **Salvador Dali. André Breton** serves as arbitrator and conciliator between the two groups.

1932

The final performance of **Oscar Schlemmer's** *Triadic Ballet* is presented at the **International Dance Congress** in Paris. The *Ballet,* consisting of 12 dances, employs three dancers who wear 18 costumes which obscure the bodies of the dancers in architectural geometry. The music, a score for player-piano by **Hindemith,** makes reference to mechanical manipulation. The dancers' abstract movements are influenced by the choreography of **Rudolf von Laban** and **Mary Wigman.**

The **Bauhaus** in Dessau closes. With its closing and with the rising repression of the Nazis in the years to come, most artists and intellectuals are forced into exile.

Aragon is indicted for his poem *Front Rouge.* In the poem, Aragon calls for the murder of the leaders of the regime and the "trained bears of democracy."

1933

Breton is expelled from the Communist-sponsored **Revolutionary Writers and Artists Association** for criticizing a propagandistic film on Soviet life, *The Road to Life.*

Black Mountain College is founded in North Carolina by **John Rice** and his colleagues. With its communal life style and integration of the arts into the school's curriculum, Black Mountain becomes a unique model in the evolution of higher education. It is established just as many of Europe's most progressive artists are fleeing wartime

repression. The **Bauhaus** professor **Joseph Albers** is recruited to teach, and his views on the spiritual efficacy of art become a major influence on the school. With a deep interest in pre-Columbian art and the art of the Southwest Indians, Mexico, and Central America, Albers rejects a Euro-centric orientation in the study of art. Instruction in visual arts and theater emphasizes process and problem-solving, rather than product.

In a late writing, **Marinetti** proposes a *total theater*, which is to include a large round central stage, 11 small circular stages throughout the seating area, and a perimeter stage to span its circumference. It is also to provide revolving chairs for audience members to view film, television, poetry, and painting projected on the walls of the theater. "The spectators are expected to participate in their usual way by throwing things at the actors and by *improvised intervention*."

1934

John Dewey publishes *Art as Experience*. This book becomes a major influence on the development of the **Works Progress Administration** (WPA). It advocates a unity of art with everyday experience and the closest possible collaboration between the artist and the public.

1935

Through the establishment of the WPA, large-scale commissions and a variety of socially engaged arts projects are funded. Under the WPA, art is viewed as an important benefit to the masses, similar to the ritual, ceremony, and folk art forms of ancient and indigenous cultures. Underlying this public-minded, frequently propagandistic art is the optimistic notion that art is meant to synthesize the whole of human experience.

1936

Recruited by **Joseph Albers**, **Xanti Schawinsky** teaches at **Black Mountain College**. Schawinsky, who had worked with **Oscar Schlemmer** at the **Bauhaus**, advocates a theater of "total experience." He is perhaps the first Modernist theater artist in the U.S. to create multi-disciplinary, non-narrative work, anticipating **John Cage's** 1952 piece at Black Mountain which became the prototype for the first Happenings.

1938

The *International Exhibition of Surrealism* is presented at the **Galérie des Beaux-Arts**, Paris. **Duchamp's** sacks of coal hang from the ceiling, and the uneven floor is covered with twigs. In each corner of the room is a bed covered with stained and rumpled sheets. On one bed, the actress **Hélène Vanel** writhes around in a torn night gown, periodically jumping up to splash in an adjacent pool.

Xanti Schawinsky produces *Dance Macabre: A Sociological Study* at **Black Mountain College**. *Dance Macabre* portrays the social and cultural structure of the modern world in a form analogous to the "Dance of Death," a ritual performance that has its origins in the Middle Ages. The audience members are cloaked in dark hooded robes before they are ushered into the gymnasium where the work is performed in the round.

1946

In the aftermath of War World II, many European and American artists lose their belief in a utopia driven by material technology. Artists who become associated with Abstract Expressionism turn to ancient myth, ritual, psychological primitivism, and anthropology for new meanings and motivations. Many American artists look to the European Surrealists for direction and insight in their efforts to create work of universal meaning.

1948

John Cage and **Merce Cunningham** visit **Black Mountain College**, where Cage presents his recently completed *Sonatas and Interludes* for prepared piano. **Albers,** who recognizes their extraordinary creative energy, invites them to return the following summer, when a remarkable confluence occurs through the convergence of faculty members and students such as **Buckminster Fuller, Willem de Kooning**, and **Beaumont Newhall**.

John Cage organizes the *Amateur Festival of the Music of Erik Satie* at **Black Mountain College**. His lecture on the significance of Satie's compositions points to temporal perception, not melody, as the basic structural component of music. A recreation of Satie's *Le Piege de Meduse* (The Ruse of Medusa) is directed by **Arthur Penn**, with **Buckminster Fuller** and **Elaine de Kooning** in the lead roles. **Merce Cunningham** performs *Monkey Dances* in the piece.

1951

Important texts on Dada, Futurism, and Russian Constructivism begin to appear in the U.S., **Robert Motherwell's** *The Dada Painters and Poets: an Anthology* among them. These become an important influence on artists who are experimenting with performative approaches, which contribute to the emergence of Happenings and the work of **Fluxus** artists in the late 1950s and early 1960s.

1952

John Cage's *4'33"* is performed for the first time by **David Tudor** in Woodstock, New York. This work takes Cage's interest in the principle of chance and the selflessness of the artist to its logical conclusion. It consists of three movements, each signaled by the raising and lowering of the piano keyboard cover. Otherwise, the performer remains still for the duration of the composition, allowing whatever sounds that occur by chance to constitute the piece. In Woodstock, these sounds include wind in the trees, raindrops on the roof, and the mutterings of disgruntled audience members.

At **Black Mountain College,** **John Cage** creates *Theater Piece No. 1,* a light/sound/movement work that is subsequently recognized as the first Happening. The piece is conceived over lunch and performed the same evening, without rehearsal, script, or costumes. The seats are arranged in four triangles facing inward, with the action occurring in and around the audience. Four of **Robert Rauschenberg's** white paintings are hung in a cross formation from the rafters, along with several black-and-white paintings by **Franz Kline.** According to differing accounts, each performer is assigned a time bracket determined by chance procedures. Activities include Cage on a ladder reading from **Meister Eckart** and the *Bill of Rights,* and giving a lecture on Zen Buddhism; **M.C. Richards** and **Charles Olsen** reading from other ladders; **Merce Cunningham** dancing among the chairs; Rauschenberg playing scratchy records; **David Tudor** playing a prepared piano; and a movie projected upside-down on slanted surfaces at the end of the hall.

The use of chance, non-narrative, simultaneous actions, and the self-determination of performers, by **Cage** and others at **Black Mountain** in the early 1950s, come from several significant sources: an interest in Zen Buddhism and the *I-Ching* (The Chinese

Book of Change); the neo-Dada movement in New York, which challenges the eminence of "high art" and rational meaning; and the theories of **Antonin Artaud.**

1955

Artists in the Japanese **Gutai** group of Osaka, **Akira Kanayama, Sadamasa Motonaga, Shusu Mukai, Saburo Mirakami, Shozo Shinamoto, Kazuo Shiraga, Atsuko Tanaka,** and others, explore performative methods for creating art.

Anna Halprin founds the **San Francisco Dancers' Workshop.** A pioneer of participatory dance-theater based on improvisation and natural movement, Halprin develops large-scale spectacles, rich in props, people, and activities, that become a highly visible part of the growing counter-culture in San Francisco in the early 1960s. **Simone Forti** and **Trisha Brown** attend Halprin's workshops, as do many artists, poets, and musicians.

1956

Rachel Rosenthal starts the **Instant Theatre Group** in Los Angeles; the group disbands in 1966.

From 1956-60, the increasingly influential **John Cage** teaches a class at the **New School for Social Research** in New York. In 1958, the members of the class include **Al Hansen, Allan Kaprow, Dick Higgins, George Brecht, Florence Tarlow,** and **Scott Hyde.** Visitors include **Jackson MacLow, Harvey Gross, George Segal, Jim Dine,** and **Larry Poons.** Cage encourages students to create unconventional instruments from found materials. He discusses sound properties, techniques for notation and the philosophy of his own and his students' pieces. **Robert Motherwell's** anthology, *The Dada Painters and Poets,* provides the historical antecedents for non-theatrical performance.

1957

In his seminal essay *Chance Imagery,* **George Brecht** discusses the concept of chance, its artistic origins in Dada, Surrealism, and **Jackson Pollock's** "sacred disorder," and the formation of images resulting from chance in nature. Like **Jean Arp** earlier in the century, Brecht suggests the use of coin-tossing from the *I Ching* as a way of arriving at

chance formations.

1958

Yves Klein moves from painting with a brush on canvas to using the bodies of his nude models to produce monoprints. Recognizing the inherently theatrical value of this way of working, and wanting to "tear down the temple veil of the studio to keep nothing of my process hidden," Klein presents *Anthropometries of the Blue Period* at **Robert Godet's** in Paris. In 1960, *Anthropometries* is performed publicly at the **Galérie Internationale d'Art Contemporaine**, accompanied by an orchestra playing **Pierre Henry's** *Symphonie Monotone*.

In Ann Arbor, **Milton Cohen** and other members of the **ONCE Group** develop *Space Theatre*, performances of shifting color patterns and forms using mirrors and prisms to project slides and motion-picture images in complex trajectories around the space. The orchestration of live performers, light, and sound frees the film from its flat, frontal orientation and breaks down the distance between spectator and spectacle.

1959

Allan Kaprow uses the term 'Happenings' for the first time in his text *Something to take place: a happening*, in which he discusses his desire to create an entirely new art form. This text becomes the script, in essence, for his participatory environment *18 Happenings in 6 Parts*, which he installs later in the year at the **Reuben Gallery**, New York. The term very quickly comes into popular usage, taking on, in Kaprow's mind, the unfortunate connotation "of being no more than a casual and indifferent event, or...at best, a 'performance' to release inhibitions."

The term Happening is also applied by the media to performance works by other artists that follow in quick succession; these include **Red Grooms's** *The Burning Building,* **Al Hansen's** *Hi-Ho Bibbe*, and **Robert Whitman's** *Small Cannon*. Not all of the artists doing performance work at this time accept the term. Although these works each have their own unique qualities, in general, the characteristics of Happenings include:

- site-specific concepts and structures
- a tendency to use recycled materials and/or trash
- brief or limited rehearsal time

- non-hierarchical, simultaneous, and fragmented actions, frequently a combination of the iconic and the pedestrian
- non-narrative, yet somewhat logical, progression or cycle of events
- the use of noise as an abstract material, rather than background accompaniment
- a limited use of text
- the use of non-professional performers and participation of the artist
- incorporation of the audience into the performance

In **Kaprow's** formulation of Happenings, he states that "The line between art and life should be kept as fluid and perhaps indistinct as possible." This tendency to dissolve the boundary between art and life can be regarded as one of the primary characteristics of performance art.

In **Allan Kaprow's** environmental installation *18 Happenings in 6 Parts*, members of the public are given programs that instruct them to participate in a series of events performed by Kaprow and fellow artists **Robert Whitman, Sam Francis, Alfred Leslie, George Segal**, and **Lucas Samaras** (substitutes include **Robert Rauschenberg** and **Jasper Johns**). Kaprow partitions the gallery into three areas, using translucent plastic with various materials and objects collaged onto the surface. For example, on one wall is a ragged collage of roughly-torn canvas with crude and unevenly-lettered words across the lower portion. Each space is lit by a different color and slides of old master and contemporary paintings are projected. The actions of the cast, which have been methodically rehearsed, are precisely timed and occur simultaneously in each of the three rooms. The actions consist of expressionless movements, ranging from everyday activities like squeezing oranges, to painting a canvas, to the recitation of non-sequitur texts. A sound track of overlapping noises plays intermittently throughout the event.

San Francisco Mime Troupe is founded by **Ron Davis**. Its first major production is a Brechtian version of **Alfred Jarry's** *Ubu Roi*. The Troupe goes on to perform radical street theater, using a combination of commedia dell'arte, vaudeville, and political satire to confront a wide range of issues from racism and modern American corporate capitalism to election year politics. Although the Mime Troupe's style of performance remains within classical theatrical conventions, its influence on performance art is in its

commitment to social change through its choice of subject matter and its close involvement with popular audiences.

Julian Beck and **Judith Malina** found **The Living Theater** in New York.

George Brecht exhibits assemblages and instructions for performance pieces at the **Reuben Gallery**. Brecht's event scores demonstrate his interest in achieving the greatest economy of means possible in aesthetic practice, in getting "the maximum meaning with a minimal image."

Gustav Metzger writes *Auto-destructive Art*, the first of five manifestoes on destruction in art.

Red Grooms presents *The Burning Building* in his New York loft. At the time Grooms considers his performance a play, as he had previously produced two other plays at the **Sun Gallery** in Provincetown, Massachusetts. The approximately ten-minute performance opens without rehearsal and plays to audiences as small as one. A series of tenuously-connected images and actions, suggestive of fire, firemen, or what fire symbolizes, is enacted in a set constructed of cardboard and plastic curtains.

1960

Robert Whitman's first theater pieces are presented at the **Reuben Gallery**. Although closely associated with Happenings, Whitman's early works are distinguished by their emphasis on units of duration and rhythmic repetition and the use of carefully constructed, rather than "found," environments in order to surround the audience with a continuous flow of imagery. The pieces are executed in a cool, matter-of-fact manner, yet through the use of film and slide projections, hidden or obscured images, and sudden blackouts, they evoke the primal qualities of a dream. Ordinary objects and activities simultaneously retain their "thingness," while bearing rich metaphoric associations.

Claes Oldenburg organizes *Ray Gun Spex*, a program of events at the **Judson Memorial Church** in New York. The program includes performance pieces by **Jim Dine**, *The Magic Room* and *The Smiling Workman*; **Red Grooms**, *The Big Leap*; **Al Hansen**, *Requiem for W.C. Fields Who Died of Acute Alcoholism*; **Dick Higgins**, *Cabarets, Contributions, Einschusz*; **Allan Kaprow**, *Coca Cola Shirley Cannonball*; Oldenburg, *Snapshots from the City*; and **Robert Whitman**, *Duet for a Small Smell*. In *The Smiling*

Workman, Dine wears a red, paint-spattered smock; with his face and hands painted red and his mouth black, he rapidly paints "I love what I'm doing...Help" on a large canvas. As he paints, he drinks from jars of paint, then pours the remaining paint over his head and dives through the canvas. This 30-second performance conveys his "feeling of being a happy, cumpulsive painter, which is what I am." Oldenburg's *Snapshots* is a series of 32 posed tableaux with elaborately-costumed performers in a garbage-strewn set of charred paper and a cardboard automobile, accompanied by retching noises. Periodic flashes of light reveal the misery and deprivation of life at the margins of society.

Happenings are introduced to Europe by the poet **Alain Jouffrey** and the artist **Jean-Jacques Lebel**.

Hommage à New York, **Jean Tinguely's** self-destructing sculpture is activated in the garden of the **Museum of Modern Art**, New York.

Yves Klein publishes the photo-collage *The Painter of Space Hurls Himself into the Void,* photographer **Harry Shunk**. This photo, which depicts Klein leaping, head first and unprotected, from a building to the street, along with Klein's other performative works, portrays a more active, immediate, and conceptual view of art, with the artist's or model's body as the center of signification.

From 1960-61, a series of proto-**Fluxus** events in New York brings together a number of artists who later become associated with Fluxus. The *Chambers Street Series*, organized by **La Monte Young** and held at **Yoko Ono's** loft, presents performances by **Henry Flynt, Jackson MacLow, Philip Corner,** and **Toshi Ichiyanagi**. **Dick Higgins** and **Al Hansen's Audio Visual Group** presents works, and **George Maciunas** organizes several events at his **AG Gallery**, including taped works by **John Cage**.

Nam June Paik performs *Etude for Pianoforte* in the studio of **Mary Bauermeister** in Cologne. **John Cage, David Tudor,** and **Karlheinz Stockhausen** are in the audience. After playing some Chopin, Paik breaks off, weeping, and throws himself on the innards of another eviscerated piano. He then proceeds to cut up Cage's shirt and tie, pour shampoo over Cage's and Tudor's heads, and run from the studio. A few minutes later, he telephones to say that the concert is over. Years later, Cage remarks, "It is hard to describe why (Paik's) performances are so terrifying...You get the feeling very clearly

that anything can happen, even physically dangerous things."

1961

Yoko Ono performs *A Grapefruit in the World of Park: A Piece for Strawberries and Violin* at **Carnegie Hall**, New York.

Ellen Stewart founds **Cafe LaMama Experimental Theater** in New York.

George Maciunas coins the name **'Fluxus'** for an interdisciplinary magazine he is planning to publish, but as a result of his involvement in the activities and performances of artists, writers, and musicians on both sides of the Atlantic, he develops the idea of Fluxus as an organization to support new work that is emerging worldwide. Although Fluxus resists definition, it comes to refer to both a collective of individuals and a sensibility concerned with discovering the essence of aesthetic practice and with demonstrating the principles of change, fluidity, and indeterminacy that characterize daily life. **Dick Higgins** enumerates nine criteria for Fluxus: internationalism, experimentalism, iconoclasm, intermedia, the resolution of the art/life dichotomy, implicativeness, play or gags, ephemerality, and specificity. **Cage**, **Duchamp**, and **Dada** are considered to be the main influences on Fluxus.

1962

The **Judson Dance Theater** is formed by a group of young choreographers coming out of **Robert Dunn's** experimental workshops in **Merce Cunningham's** studio and influenced by the San Francisco choreographer **Anna Halprin.** Scores of choreographers, poets, artists, and musicians—including **Trisha Brown, Lucinda Childs, Judith Dunn, Ruth Emerson, David Gordon, Deborah Hay, Fred Herko, Robert Morris, Steve Paxton, Yvonne Rainer, Robert Rauschenberg, Charles Ross, Carolee Schneemann,** and **Elaine Summers**—present almost 200 works over a two-year period at the **Judson Memorial Church** in New York. Dance critic **Jill Johnston** notes three qualities that distinguish this work:

> [First,] the dancing itself is often so physical in such a natural way
> that it bears little resemblance to any conventional "attitudes" of
> dance. Secondly, the choreographer may be a painter, a sculptor, or
> a composer as well as a dancer, and that means the emphasis often

settles on a theatre "situation" ("happening") " event," rather than on legitimate dancing...Thirdly, there is an attitude of pure non-dance which is neither physical nor theatrical but a state of being...Dancing is what you think it is. Possibly the whole world of movement is dancing.

Two proto-**Fluxus** concerts are held in Wuppertal and Düsseldorf. The latter, organized by **Nam June Paik**, includes his influential violin destruction piece *One for Violin Solo*, as well as the simultaneous performance of separate pieces by Paik, **George Maciunas, Wolf Vostell, Ben Patterson,** and **Tomas Schmidt**. The first of a series of European Fluxus festivals is presented in Wiesbaden with works by Paik, **Dick Higgins, La Monte Young, George Brecht, Alison Knowles, Robert Filiou, Emmett Williams** and **Jackson MacLow**.

Raphael Montanez Ortiz (known at the time as Ralph Ortiz) writes *Destructivism: a Manifesto*.

Claes Oldenburg produces *Injun* at the **Dallas Museum of Contemporary Art**. Performers lead 200 attendees (with varying degrees of willingness) with a rope—festooned with large rock-shaped lumps and mosquito netting—out of the Museum and across the grounds, past a girl tied to a post and a shed containing another motionless female figure, to a number of nearby empty houses. The spectators are led through a series of rooms where events are performed like snapshots of real or imagined occurrences—paint slinging, banging on the windows, balloons covered with newspaper being chucked off the roof. The activities in and around the houses builds to such a pitch that the neighbors, thinking there is a riot going on, call the police. The furor subsides and the spectators wander back to the Museum.

Anna Halprin creates *Five Legged Stool*, a work that exemplifies much of her seminal and influential work. The piece takes tasks based on ordinary life situations and juxtaposes them in illogical and unexpected relationships. For example, near the end, two dancers repeatedly run toward each other, collide in mid-air, and crash to the floor. This series of collisions and falls is intensified by a very loud, chaotic tape sound, as a chorus in the audience sings *A Mighty Fortress is Our God*. This suddenly stops without resolution and the scene shifts into absolute silence as, one by one, tiny feathers cascade

down from a single spot on the ceiling. Halprin recalls that the work is not meant to have a formal ending so that the audience can take "the theater over, hopefully, in their own lives. A theme...then, [is] non-separation of art and life."

Bread and Puppet Theater is founded by **Peter Schumann** in New York's Lower East Side. Besides puppet shows for children, the concerns of the first productions are rents, rats, police, and other problems of the neighborhood. More complex stagings of stark visual images using bigger and bigger puppets follow. Annual presentations for Christmas, Easter, Thanksgiving, and Memorial Day often include people from the community as participants. Many performances are done in the street and, during the Vietnam War, Bread and Puppet Theater becomes part of every major anti-Vietnam demonstration in the eastern United States. In 1970, the troupe loses its rehearsal space and moves to Vermont, where it becomes "theater-in-residence" at Goddard College. Bread and Puppet Theater is committed to reaching theatrically unsophisticated audiences and to responding to political issues. In this regard, it sees itself in a long line of puppet theater going back to the Middle Ages.

Robert Rauschenberg, Jean Tinguely, Niki de Sainte-Phalle, and **Kenneth Koch** collaborate on *The Construction of Boston*, a 15 minute performance featuring a rain-making machine with real water and the participation of art-world figures such as **Henry Geldzahler** and **Frank Stella**.

The **Institute of American Indian Art** is founded in Santa Fe, New Mexico.

1963

Romare Bearden, Alvin Hollingsworth, and **William Majors** form *The Spiral*, an African-American artists' organization, to aid the civil rights movement.

Free Southern Theater, an integrated ensemble of amateur and professional performers, is founded at Tougalou College, Mississippi, by activists in the Freedom Movement (including the Student Non-Violent Coordinating Committee). Actor **John O'Neal** is a founding member. The Free Southern Theater is disbanded in 1985, but O'Neal continues to perform both solo and group works dealing with racism and the recovery of Black cultural forms, particularly through the *griot* storytelling tradition.

George Brecht and **Robert Watts** organize *The Yam Festival*, a series of performances, street events, and get-togethers at **Smolin Gallery**, **George Segal's** New Jersey farm, and the **Hardware Poet's Playhouse** to welcome **George Maciunas** and other **Fluxus** artists back from their European "concert" tour.

In the *Pop Art Festival*, organized by **Alice Denny** for the **Washington Gallery of Modern Art**, choreographers from the **Judson Dance Theater** present *Concert of Dance Number Five—America on Wheels*. Performances take place in a skating rink, with the audience seated in groups so that they are surrounded by the performers. A critic for *The Washington Post* notes that the program is "a long and arduous one, with an extraordinary melange of dance, calisthenics, acrobatics, recitals, poetry readings, imitations, strip teases, roller-skating and music." **Robert Rauschenberg's** *Pelican* provides some of the most arresting images of the program.

Claes Oldenburg moves to Los Angeles for six months. Inspired by the centrality of the car to the lives of Californians and the slow-motion television images of President Kennedy's motorcade at the time of his assassination, Oldenburg stages *Autobodys* in a downtown parking lot. He casts only black and white cars, selecting a range of body styles, ages, and sizes, a white Volkswagen pickup truck, and a cement mixer, along with assorted "live" performers and a mannequin with a mechanical arm normally used to direct traffic. The movements of the cars and performers are choreographed like a dance. **Lloyd Hamerol,** a sculptor who participates in the piece, describes it as "a charged scene of barricades and flashing lights and cement trucks and milk bottles and all sorts of things relating to vehicles, what they do and whom they serve."

Charlotte Moorman organizes the first *New York Avant-garde Festival* at **Carnegie Hall**, New York.

The **Judson Dance Theater** presents *A Collaborative Event*, a series of dance-theater works by nine choreographers in an environment by **Charles Ross**. Pieces include **Carolee Schneemann's** *Lateral Splay*, an exuberant work that involves dancers running at high speeds through the space, tumbling or collapsing when they collide, and **Yvonne Rainer's** *Room Service*.

Ellen Stewart opens **La MaMa Experimental Theatre** (often called **Cafe La MaMa**) at 82 Second Avenue. Of the numerous experimental theaters located in New York's

EastVillage at the time, La MaMa is the only one to survive into the present. Established to produce new plays, over the years it expands to present limitless performance modes, maintaining its important role of supporting experimental work.

In 1963-64, **Carolee Schneemann** performs *Eye Body*, her first work to use her body as an extension of her painting-constructions. "Covered in paint, grease, chalk, ropes plastic, I establish my body as visual territory. Not only am I an image maker, but I explore the image values of flesh as material I choose to work with." Six months later, the artist presents *Meat Joy* at the *Festival de la Libre Expression* in Paris; at **Dennison Hall**, London; and at **Judson Memorial Church**, New York. The piece uses meat, raw fish, chickens, sausages, wet paint, transparent plastic, rope, brushes, and scrap paper to enact "a psychic and imagistic stream" of activities. This and Schneemann's other work from this period anticipate the development of contact improvisation, body art, and feminist performance in the early 1970s.

1964

Kenneth King performs *cup/saucer/two dancers/radio*, the first of his dance-theater pieces that are known for their "Joycean wordplay." Trained in philosophy, King explores the subtle connections between language and movement, charting the patterns of thought itself. He creates complex works that integrate dance and text while speculating on everything from telepathy and cybernetics to Suzanne Langer's work on the evolution of symbolic thought. His fantastic alter egos include the likes of Mater Harry, a transvestite spy, and Pontese Tyak, the Custodian for the TransHimalayan Society for Interplanetary Research.

Yoko Ono publishes *Grapefruit*, a collection of her "instruction pieces" written in the 1950s and early 1960s. Ono's scores function both as directions for actual activities—performances of music, painting events, dance, and ordinary actions—and as purely mental events, impossible to realize in concrete terms. Critical views of Ono's works tend to approach these instructions from multiple perspectives: as proto-feminist explorations concerned with intimate physical and psychological processes; as affirmations of the deeply personal and political nature of art; and as radical attacks on materiality and materialism.

This same year, **Ono** performs *Cut Piece* at **Yamaichi Concert Hall** in Kyoto, Japan,

and later in New York. She invites the audience to cut away pieces of her clothing as she sits motionless on the stage until everything is gone. A highly charged, resonant piece, viewers have interpreted it as an enactment of passivity and aggression which forces participating audience members to confront their own potential for violence against others. In light of the on-going Vietnam War, Ono's performance also has a strong political message. On another level, the work demands that viewers take responsibility for their aesthetic experience.

In 1965, while on tour of Europe with **Nam June Paik, Charlotte Moorman** performs *Cut Piece* in front of the Brandenburg Gate in Berlin.

James Lee Byars exhibits three versions of his folded-paper performance pieces in the *Pittsburgh International* at the **Carnegie Museum of Art.** These one-hour actions consist of the performers carrying a folded-paper work to the center of the Carnegie court, delicately and deliberately unfolding it to full length, and finally refolding it to its original state. One version, *A Mile-Long Paper Walk*, is performed by dancer **Lucinda Childs** in a full-length ostrich feather costume.

Allan Kaprow organizes the Happening *Household* at a dump outside Ithaca, New York. The performance activities are divided along gender lines, with the men building a tower and the women building a nest and hanging laundry on a line. The men cover a wrecked car with strawberry jam, while the women screech in their nest. The women lick the jam off the car while the men destroy the nest. Then the men chase the women from the car, put bread on the jam and begin to eat. There is much shouting and cursing. As a group of people advance, banging on pots and pans, the women destroy the men's tower.

In 1964-65, **George Brecht** and **Robert Watts** organize *Monday Night Letter*, a series of weekly performances at the **Cafe au Go Go** in New York.

From 1964-66, **The New Music Workshop** at the University of California, Los Angeles, co-founded by **Joseph Byrd**, features music/dance and theater events by **Marcel Duchamp, Walter de Maria, La Monte Young, Emmett Williams, Nam June Paik,** and **George Brecht.** Paik's *Playable Music No. 4* calls for a performer (Byrd) to "cut your left forearm for a distance of 10 cm."

From 1964-66, **Festivals of Free Expression** are organized in Paris by **Jean-Jacques Lebel.**

1965

After presenting a series of Dionysian performances in Vienna, **Hermann Nitsch** creates the **Orgies, Mysteries, Theater (OM)**. "In OM presentations the performers tear apart and disembowel a lamb or bull, cover themselves and the environment with blood and gore, pour the entrails and blood over one and another and so on. These events last up to three hours." (Thomas McEvilley) Nitsch regards these rituals as an extension of action painting and as a way to release and purify repressed primal energies.

Luis Valdez founds **El Teatro Campesino** with amateur actors recruited from among striking Mexican farm workers. Issues-oriented *actos,* performed at the picket lines, range from union recruitment and strike propaganda in the early years, to broader sociopolitical and historical concerns after 1967.

Robert Morris and **Yvonne Rainer** perform *Waterman Switch* at the **Judson Memorial Church** in New York. One reviewer describes the performance as "chaste as a handshake — he and Miss Rainer (totally nude) clasped one another face to face and made a slow round trip of the floor, chaperoned by **Lucinda Childs** (totally dressed). Unsensational and unsuggestive, its attempt to shock seemed, oddly enough, only touching."

Shigeko Kubota performs *Vagina Painting* at the *Perpetual Fluxfest* in New York. Using a brush dipped in red paint and attached to her underwear, Kubota produces "an eloquent gestural image that...redefine(s) Action Painting according to the codes of female anatomy...In this action, she recovers woman as the source of her own artistic inspiration, as the gender able to produce both actual life and representational form." (Kristine Stiles "Between Water and Stone" in *In the Spirit of Fluxus*, Minneapolis: Walker Art Center, 1993)

Pursuing his interest in the processes by which art is made, **Bruce Nauman** does his first performance piece at the **University of California, Davis.** Manipulating his body like a piece of sculptural material, the artist moves through a series of 28 stationary positions — e.g. sitting, lying down, facing left, facing right, and so on. In order to

explore and expand the phenomenological and body-based aspects of the art-making process, he turns to photography in 1966, and film and video in 1968-69.

Robert Whitman presents *Prune Flat* at the **Filmmaker's Cinematheque** in New York. The piece juxtaposes filmed images and live performers, eliciting a sense of theatrical spectacle as well as an awareness of its illusory nature. Because the two women who appear in the countryside or on the city streets of the film are the same performers on stage wearing identical costumes, they seem at times to be in the film and at times in front of it.

Steve Paxton and **Alan Solomon** organize the first *New York Theatre Rally*. Works are by **Robert Whitman, Claes Oldenburg, Jim Dine, Robert Morris, David Gordon, Trisha Brown, Steve Paxton, Deborah Hay, Alex Hay**, and **Robert Rauschenberg**.

Nam June Paik purchases the first portable video camera-recorder to become available in New York and immediately begins to produce tapes, which he shows to a weekly gathering of artists and filmmakers at the **Cafe au Go Go**.

1966

Over 50 artists and poets from 10 countries participate in or send works to the *Destruction in Art Symposium* (D.I.A.S) in London. Organized by **Gustav Metzger**, D.I.A.S. brings together diverse artists who are working to integrate art with social and political conditions, among them **John Latham, Jean-Jacques Lebel, Hermann Nitsch, Yoko Ono, Raphael Montanez Ortiz, Carolee Schneemann**, and **Wolf Vostell**.

Robert Rauschenberg and **Billy Kluver** organize *9 Evenings: Theater and Engineering* at the location of the historic *Armory Show* in New York. Participants include Rauschenberg, **David Tudor, John Cage, Yvonne Rainer, Steve Paxton, Robert Whitman, Oyvind Fahlstrom, Alex Hay, Deborah Hay,** and **Lucinda Childs**, who each present a performance piece. While recognized as a serious attempt to make use of advanced technology, *9 Evenings* is generally considered to be disappointing for the technical failures that mar the performances. In the months leading up to *9 Evenings*, Kluver and Rauschenberg establish **Experiments in Art and Technology** (EAT) "to

catalyze the inevitable active involvement of industry, technology, and the arts."

George Maciunas, with support from the National Endowment for the Arts and the Kaplan Fund, begins *Fluxhous Cooperatives Inc.* to renovate SoHo (South of Houston Street) buildings into cooperative artists' lofts.

1967

Allan Kaprow stages *Fluids* at the **Pasadena Art Museum**. 15 monumental ice structures are assembled by volunteers and left to melt in surprising shapes under the California sun. It is the last of Kaprow's large-scale Happenings. His subsequent work focuses on the ordinary activities and interactions of everyday life.

Robert Rauschenberg stages his last theater piece, *Urban Round*, at the **School of Visual Arts**, New York.

12 Evenings of Manipulations, a show of destructionist art at the **Judson Gallery**, includes **Al Hansen, Bici** and **Geoffrey Hendricks, Jon Hendricks, Allan Kaprow, Kate Millet, Charlotte Moorman, Nam June Paik, Lil Picard, Carolee Schneemann,** and **Jean Toche.**

Charlotte Moorman performs **Nam June Paik's** *Opera Sextronique* at the **Filmmakers' Cinematheque** in New York. The work has four "arias" or acts. In the first, Moorman wears a bikini made of small electric light bulbs and plays the cello on a darkened stage; in the second, she wears a topless evening gown. By the fourth, she is to be totally nude, playing an upright aerial bomb instead of her cello. The New York police stop the performance at the end of the second act and arrest both Moorman and Paik. They are released on parole the next day. Paik's charges are later dismissed, but Moorman is convicted of indecent exposure and given a suspended sentence, which ends her career with the American Symphony Orchestra.

Raphael Montanez Ortiz performs *Henny Penny Piano Destruction Concert with Paper Bag Destruction* in his New York studio. Ortiz starts the performance with each person blowing up and exploding paper bags; he then passes a chicken among audience members. Ortiz reclaims the chicken and then gently rubs it on a piano. Once more the chicken is returned to the audience and once again returned to Ortiz, who then snaps its neck with a single blow against the piano. Next, he proceeds to destroy the

piano with an ax and beat the splintered structure with the chicken carcass. Ortiz's destruction performances are evolved from his background in Abstract Expressionism and a series of sculptures entitled *Archaeological Finds*—mutilated, excavated pieces of furniture (e.g. cushions, mattresses, chairs). Ortiz arrives at destruction in his quest to express primal psychic states that are fundamental aspects of life-affirming sacred rituals. The work also acknowledges violence as part of the human condition.

1968

The *Destruction in Art Symposium/D.I.A.S.-U.S.A. 1968 Preview*, at **Judson Gallery**, includes events by **Al Hansen**, **Bici Hendricks**, **Charlotte Moorman**, **Hermann Nitsch**, **Ralphael Montanez Ortiz**, **Nam June Paik**, and **Lil Picard**.

Joan Jonas presents her first performance pieces, all involving mirrors, either as a central motif or as a prop or costume. A distinguishing characteristic of Jonas's work is the strategy of spatial displacement and temporal de-synchronization. Her use of mirrors (from 1968-71) fragments the performance space, alters the spectator's perceptual field, and allows reflections of the spectator to be included in the work.

Alex Hay, **Steve Paxton**, and **Yvonne Rainer** lead a series of workshops in the Los Angeles area that culminate in performances. These workshops are very influential in the development of performance art in Southern California.

As part of a national emergence of Chicano artists groups, the **Mala Efe** group is formed in the San Francisco Bay Area. In ad hoc meetings, members debate issues of form and content of artwork in relation to *El Movimiento* (the Chicano political movement born from *La Causa*, Cesar Chavez's efforts to unionize California farmworkers).

Reese Palley Gallery opens in San Francisco. Over a four-year period, Director **Carol Lindsley** presents performances and exhibitions by **Bruce Nauman**, **Steve Kaltenbach**, **Dennis Oppenheim**, **Howard Fried**, **Paul Kos**, **Terry Fox**, **Jim Melchert,** and others.

Anna Halprin leads dance workshops in San Francisco and at **Studio Watts** in Los Angeles. These lead to the formation of a multi-racial dance company and the performance of *Ceremony of Us* (at the **Mark Taper Forum**), a piece that directly confronts racial prejudice.

Performers for *Anti-war Angry Arts Week* in New York include **Yvonne Rainer** and **Carolee Schneemann**.

In the late 1960s, performance becomes the primary focus of a loose-knit group of artists in Berkeley that includes **Michael Haimoritz, Paul Cotton,** and **Stephen Laub**. Art historian **Moira Roth** notes that they are often overlooked in art historical accounts but "are some of the most inventive in all the Bay Area....Mysticism, mystery, and mockery form communal bonds among these artists, composers, and poets. They are not overtly political in their art; rather, there is a social utopian vision implicit in their work, and surely utopian visions inspired much of the political activity of the decade." (*Arts Magazine*, February, 1978)

Tom Marioni, Terry Fox, Paul Kos, Mel Henderson, and others present conceptual and performance art at **Reese Palley Gallery**, at the **Richmond Art Center** (under Marioni's curatorship, 1968-71), and at the **University Art Museum**, Berkeley.

From 1968-69, **Terry Fox** performs street-theater pieces, including *What Do Blind Men Dream?*, in which he asks a blind accordionist and her boyfriend (who perform regularly in downtown San Francisco) to sing at a particular time and place. Announcements are sent and many people attend.

Led by **Abbie Hoffman** and **Jerry Rubin,** *Yippies* (members of the Youth International Party) throw money from the visitors' gallery onto the floor of the New York Stock Exchange.

The Studio Museum in Harlem opens with a community ritual performed by **David Hammonds**.

Ant Farm, an artists' collective, is created in San Francisco and Houston by **Chip Lord** and **Doug Michaels**.

1969

Andy Warhol begins publication of *Interview* magazine.

Vito Acconci performs *Following Piece* on the streets of New York. Over a 23-day period, Acconci selects at random people walking on the street and follows them until they enter a private place such as a home or office. *Following Piece*, dependent on the

actions of others, is anticipated by the artist's earlier poetry experiments, in which he distributes pieces of paper to audience members and invites each to write a letter, which then serves as a cue for an improvised adverbial or prepositional phrase.

Women Artists in Revolution (WAR) is formed in New York.

Robert Wilson stages his first "silent opera," *The King of Spain*, in a run-down, defunct theater in New York. The cast of 45 non-professionals gathers in near silence in a musty old drawing room, oblivious to each other for the most part. The performers' slow but natural movements are carefully focused on various minimal activities. At the end, the players move off stage in a procession, the King rises from his chair, and a gigantic cat—so huge only its legs are visible—walks across the room. Later in the year, *The King of Spain* becomes the second act of *The Life and Times of Sigmund Freud*, presented at the **Brooklyn Academy of Music**.

Paul McCarthy attends a seminar taught by **Allan Kaprow** in San Francisco and begins to do collaborative works with other students. The previous year McCarthy had emulated **Yves Klein** by leaping from a second-story window while attending the **University of Utah**, Salt Lake City.

Meredith Monk creates *Juice: a Theater Cantata,* a large-scale work for 80 voices that takes place over a one-month period and requires the audience to see the performance in three locations in New York: the **Solomon R. Guggenheim Museum**, **Barnard College**, and the artist's loft. As the scale of the performance spaces diminishes, key images and performers reappear in reduced or altered form. For example, four principle dancers from the Guggenheim installation are seen at Barnard discussing aspects of their personalities while engaging in "real-life" activities. At the loft, a videotape of them describing the creation of their stage roles is presented.

John White does his first performance pieces. These site-specific events involve schematic considerations of the performance space, manipulation of novel materials, and repetitive activity. After 1970, he begins to include references to personal experiences as a psychiatric-therapy aide, a teacher, and a participant in recreational sports. White diagrams the interaction of his thoughts, feelings, statements, and body movements. He uses stories, jokes, puns, quasi-logical word games, zany choreography and casual asides to the audience to digress through a wide range of themes.

Nam June Paik and **Charlotte Moorman** perform *TV Bra* at the **Corcoran Gallery of Art**, Washington, DC.

Gain Ground opens on the Upper West Side of New York. Director **Robert Newman** exhibits bookworks, art, and word art, and at the **Filmmaker's Cinematique** organizes screenings of film works, and a performance/installation series. Gain Ground closes in June, 1970.

Apple opens in mid-town New York. Director **Billy Apple** shows primarily performance events and process/situations. By 1973, when Apple closes, 30 artists have participated, including Billy Apple, **Jacki Apple**, **Geoffrey Hendricks**, **Taka Imura**, **Larry Miller**, **Jerry Vis**, and **Bob Watts**.

James Lee Byars participates in the *Art and Technology* exhibition at the **Los Angeles County Museum of Art**. Subsequently, he is accepted as *Artist of the Hudson Institute*, where he works with **Herman Kahn**. One of his proposals for the Institute is the *World Question Center*. In the same year, he publishes *Book of One Hundred Questions*, which is distributed as a public performance.

Holly Solomon opens **98 Greene Street** in SoHo. Until its closing in 1973, its programs include performances, film, video, installation, sculpture, painting, drawing, photography and text, and poetry readings.

The invention of the videocassette makes it possible to record performances and distribute video-performance art.

The New Feminist Theater in New York and the **Los Angeles Feminist Theater** are formed.

Barbara Smith stages *Ritual Meal* at the Los Angeles home of art collectors **Stanley and Elyse Grinstein**. 16 dinner guests, dressed in surgical gowns and caps, participate in a ritualistic meal served entirely with surgical implements while the sound of a heartbeat pulses through the house. Many of Smith's subsequent performances revolve around the ritualization of food, either as a purely aesthetic and sensual experience or as symbolic of issues in daily life and of the enrichment exchanged by artist and audience. In her 10-day performance *The Celebration of the Holy Squash* (1971), Smith establishes a new religion with its own priesthood, converts, symbolism, and rites.

Tom Marioni performs *One Second Sculpture*, a "performance sculpture" in which a metal tape measure flies open like a spring in one second, making a loud sound. The object leaves the hand as a circle, makes a drawing in space as it opens itself, and falls to the ground as a line.

Allan Kaprow begins teaching at **California Institute of the Arts**. In the three years that follow, faculty include **Alison Knowles**, **Dick Higgins**, **Simone Forti**, **Nam June Paik**, **Steve Paxton** and others. Numerous student activities—poetry, music, meditations, and various celebrations—take place in Knowles's environmental sculpture *The House of Dust*. In its original form, this computer-generated poem randomly mixes four lists of possible building materials, geographic locations, methods of lighting, and inhabitants. The composer **Max Newhaus** creates a sound installation for the sculpture, using thermal circuits which respond to the changing heat of the sun.

1970

University Art Museum, Berkeley opens. Curator **Brenda Richardson**, recalls:

> (**Tom**) **Marioni** floating chicken feathers all around the building, **Paul Cotton** in his bunny suit posing...with **George Segal**. **Steve Reich's** magic concert. **Jim Melchert's** chair piece. The **San Francisco Ballet** performing Shaker dances. (**William**) **Wiley** leading a parade of people playing Jew's harps. **Terry Fox** inducing a trance in himself—and all of us watching—by shaping a labyrinth out of flour. **Simone Forti**. Somebody climbing the concrete museum building. **James Lee Byars** with yards and yards of fuchsia satin draped over and around hundreds of participants in the old powerhouse gallery." (Moira Roth, *Arts Magazine*, February, 1978)

Joan Jonas begins outdoor performance works for vast landscapes and urban spaces. Works such as *Delay, Delay* are organized to delineate the spaces in which they are performed—in this case, a 10-block area along the Hudson River on New York's Lower West Side. The audience watches from the roof of a nearby building as the performers carry out various activities coordinated to heighten visual and aural relationships that result from working in a large area. Plywood signs are placed around the site indicating various distance-points from the spectators' building. When the performers make

clapping sounds with blocks of wood, the signs enable the audience to relate distance to sound delay.

Terry Fox performs *Levitation* at the **Richmond Art Center**. Fox recalls:

> I wanted to create a space that was conducive to levitation. The first
> thing I did was to cover the 60 by 30 foot floor with white paper,
> then I laid down a ton and a half of dirt, taken from under a freeway
> on Army Street...I fasted to empty myself. I drew a circle in the
> middle of the dirt with my own blood. Its diameter was my
> height—according to the medieval notion that creates a magic space.
> Then I lay on my back in the middle of the circle, holding clear
> polyethylene tubes filled with blood, urine, milk and water. They
> represented the elemental fluids that I was expelling from my body.
> I lay there for six hours with the tubes in my hand trying to levitate.
> The doors were locked. Nobody saw me. I didn't move a muscle.
> I didn't close my eyes. I was trying to think about leaving the
> ground, until I realized I should be thinking about trying to enter
> the air. For me that changed everything, made it work. I mean, I
> levitated.

Afterwards, an imprint of the artist's body remains in the dirt and a sense of charged energy fills the gallery. The work is ordered closed by the city of Richmond's Chief of Police, Fire Inspector, and Health Inspector on the grounds that it is an "obvious" fire hazard. They claim that the paper placed underneath the dirt to protect the floor is highly flammable.

Adrian Piper performs *Untitled* at **Max's Kansas City**, a well-known night club frequented by **Andy Warhol** and other art-world luminaries and, according to Piper, an "Art Environment, replete with Art Consciousness and Self-Consciousness about Art Consciousness." Demonstrating her desire for autonomy, the artist wears a blindfold, earplugs, gloves, and noseplugs in a symbolic attempt to avoid being co-opted into the art consciousness of the day. A new type of **Fluxus** performance begins to emerge. In contrast to the earlier, simply structured event pieces, works by Fluxus artists **Larry Miller, Geoffrey Hendricks, Sara Seagull, George Maciunas, Yoshimasa Wada,**

and others are more elaborate, collaborative, and interactive. An example is the three-part festival *Fluxmass*, *Fluxsports*, and *Fluxshow* at **Douglass College, Rutgers University**. Maciunas's *Fluxmass*, a humorous interpretation of the structure and traditions of the Catholic mass, rouses the ire of the Episcopalian chaplain in whose church it is held. It becomes a local *cause célèbre*.

Willoughby Sharp and **Liza Bear** launch *Avalanche (1970-76)*, the first major artist-produced magazine to report on post-object art. Sharp writes a seminal article, *Body Works: A Pre-Critical, Non-Definitive Survey of Very Recent Works Using the Human Body or Parts Thereof*. He explains:

> Variously called actions, events, performances, pieces, things, the works present physical activities, ordinary bodily functions and other usual and unusual manifestations of physicality. The artist's body becomes both the subject and the object of the work. The artist is the subject and the object of the action. Generally the performance is executed in the privacy of the studio. Individual works are mostly communicated to the public through the strong visual language of photographs, films, videotapes and other media, all with strong immediacy of impact. In focusing on the creative act itself, body works are yet another move away from object sculpture—but body works do not represent a return to figuration—at most their relation to figurative art is ironic. On another level, the new work can be seen as a reaction to Conceptual Art which tries to remove experience from sculpture. This does not mean that body works are a return to some kind of expressionism. Artists feel no need to vent their personal emotions in their work. The artist's own body is not as important as the body in general. The work is not a solitary celebration of self.

Judy Chicago organizes the first *Feminist Art Program* at **Fresno State College**. Students include **Suzanne Lacy**, **Faith Wilding**, **Janice Lester**, **Vanalyn Green**, and **Nancy Youdelman**. Chicago notes that "Performance can be fueled by rage in a way painting and sculpture can't. The women at Fresno did performances with almost no

skills, but they were powerful performances because they came out of authentic feelings."

The **Women's Interart Center** is founded in New York.

In San Francisco, **Tom Marioni** founds the **Museum of Conceptual Art (MOCA)**, a museum for "actions, not objects" with a permanent collection based on residue, relics, and created environments that become part of the building's architecture. In addition to serving as an invaluable site for new works that explore the parameters of performance, MOCA is also a "social work" as Marioni sees it. The museum's principle activity is **Cafe Society**, an on-going salon that takes place in **Breen's Bar**, which is located underneath MOCA. There, Marioni holds receptions, invites artists to stage situational works, and organizes (with **Willoughby Sharp**) the first video exhibition of body works. Marioni also organizes a one-night show, *Sound Sculpture,* featuring 10 Bay Area sculptors. Assuming the stage name **Allan Fish**, Marioni performs *Pissing*, which consists of his drinking beer all day and then urinating into a tub. As the tub fills, the pitch drops.

Allan Kaprow publishes *Assemblage, Environments & Happenings*, which documents 42 Happenings by members of the Japanese **Gutai** group, **Jean-Jacques Lebel**, **Wolf Vostell**, **George Brecht**, **Kenneth Dewey**, **Milan Knizak**, and Kaprow.

Terry Fox performs his first political work, *Defoliation Piece*, at the **University Art Museum**, Berkeley. The artist uses a flame-thrower to burn rare plants near the Museum. The artist recalls:

> Everyone likes to watch fires. It was making a roaring sound, but at
> a certain point people realized what was going on—the landscape
> was being violated; flowers were being burnt. Suddenly everyone
> was quiet. One woman cried for 20 minutes.

112 Greene Street, an artist-run gallery, opens in SoHo. Over an eight-year period, hundreds of artists and artist-groups use the space for site-specific installations, process sculptures, performances and video performances, music concerts, photography, and unjuried exhibitions called *Group Indiscriminates*.

Tom Marioni performs *The Act of Drinking Beer with Friends is the Highest Form of Art* at the Oakland Museum. The debris left over from the event (e.g. beer cans, cigarette butts) is exhibited as documentation of the activity.

Galeria de la Raza begins storefront exhibitions of the work of Chicano artists in San Francisco's Mission District.

At the **Museum of Modern Art**, New York, **Kynaston McShine** organizes *Information*, an exhibition of Conceptual Art—which quickly becomes a forum for protesting the U.S. presence in Vietnam.

Adrian Piper begins her series *Catalysis*, which examines xenophobia, fear of the foreign or strange. **Jane Farver** writes in Piper's **Alternative Museum** catalogue:

> In these unannounced street performances, she grotesquely trans-
> formed herself to elicit reactions from her unsuspecting "Viewers,"
> her fellow pedestrians and subway passengers...In time, these self-
> transformations consolidated into a single art persona, the Mythic
> Being, who appeared in many of her works from 1972-1981. The
> Mythic Being self-transformation, a young, angry, third-world male,
> allowed Piper to investigate the male "other" in her own personality,
> as well as to experience society's indifferent or fearful reactions to
> this type of individual, and act out resulting feelings of alienation and
> hostility.

The **Basement Workshop**, an Asian-American artists' organization, is founded in New York.

Teatros Nacionales de Aztlàn (TENAZ) is founded as new Chicano theater groups form in Las Vegas, Los Angeles, New Mexico, San Antonio, San Diego, San Jose, Santa Barbara, Seattle, and Tucson. TENAZ sponsors the first of many annual Chicano theater festivals.

1971

Alanna Heiss produces a three-day art festival under the ramps of the Brooklyn Bridge. Participants include **Carl Andre, Sol Le Witt, Mabou Mines, Rudy Burckardt**, and **Gordon Matta-Clark**.

Robert Wilson's seven-hour *Deafman Glance* is presented at the **Brooklyn Academy of Music** and then tours Nancy, Rome, Paris, and Amsterdam. It is a sensation in France, where **Louis Aragon** writes a review in the form of a letter of reconciliation with his dead Surrealist colleague **André Breton**:

> I have never seen anything more beautiful in the world. [Theater] has never come close to this, which is simultaneously life awake and life with closed eyes...reality mixed with a dream...[It is what we,] from whom Surrealism was born, dreamed it would become after us...[This] strange spectacle, neither ballet, nor mime, nor opera (but perhaps a deaf opera)...is an extraordinary freedom machine.

Gordon Matta-Clark creates a performance piece in the basement of **112 Greene Street** in which performers lie concealed under piles of dried leaves and bushes for a very long time. Then they begin to move very slowly so that parts of their bodies become exposed. Suddenly they burst forth and run from the basement.

Joined by several of her students from **Fresno State College, Judy Chicago** moves to Los Angeles and, together with **Miriam Schapiro,** sets up a *Feminist Art Program* at the **California Institute of the Arts**. There, Chicago teaches performance as a separate discipline. It is the first time that performance art is recognized as an independent genre within academia.

Annually until 1985, **Pat Oleszko** appears in New York's Easter parade, in one of her many witty costumes or accompanied by one of her parade-scale inflatables. Using popular art forms from pageants and burlesque shows, Oleszko pokes fun at a wide range of topical subjects, such as the absurdity of protecting oneself against the effects of nuclear war, urban gentrification, and censorship of the arts.

For his first performance work, *Five Day Locker Piece*, **Chris Burden** remains in a 2'x2'x3' locker for five days, without leaving. Several days prior to entry, he had stopped eating. The locker above him contains a five-gallon bottle of water and the locker below contains an empty five-gallon bottle. Responding to the work of Conceptual artists at the time, Burden begins to create work that acts out or materializes the idea. *Five Day Locker Piece* anticipates several themes that recur in the artist's subsequent performances: an interest in experiencing a task that is outside the accepted norms of behavior and

endurance; separation of the artist's and viewer's experiences; and use of the body as both subject and object of actions.

F Space, an off-campus cooperative gallery, is established by **University of California, Irvine's** School of Fine Arts graduate students **Chris Burden, Nancy Buchanan, Barbara Smith,** and others. Buchanan (who is also a founding member of **Grandview Gallery**, a feminist cooperative in Los Angeles) performs *Hair Transplant* (1972), in which she shaves off all of **Bob Walker's** body hair, cuts off her own red hair, and glues it to his body.

Chris Burden performs *Shoot* at **F Space**. A friend shoots him in the left arm with a copper-jacket 22-long-rifle bullet. This piece catapults Burden into the public eye; it becomes his signature image and the cause for intense speculation that his self-destructive behavior is merely a careerist strategy. This notoriety significantly influences subsequent performances in which Burden manipulates the expectations of the public and the museum or gallery that presents him. These pieces amplify, in an impersonal manner, the autobiographical content of the artist's work and of the public's and presenting organization's expectations of the artist. For instance, during *White Light/White Heat* (1975), Burden climbs into a specially constructed platform in **Ronald Feldman Gallery**, New York, where he remains unseen, without eating or conversing for the duration of the show. Without instruction, but faced with the artist's isolated and immobile presence, the Gallery is forced to serve his basic bodily needs.

On their 10th wedding anniversary, **Geoffrey Hendricks** and **Bici Forbes** enact *Fluxdivorce*, a celebration of their decision to "come out" and to separate from each other. Hendricks recalls:

> We were separated by a tug-of-war with the men pulling on a rope
> tied around me and the women on a rope tied around Bici. I had
> arranged a "Division of Property" in the bedroom and with paper
> cutter, scissors, power saw, ax, etc. wedding documents, clothing,
> double bed, wicker loveseat were all literally cut in half, followed by
> a celebration party.

Art critic **Jill Johnston** notes that:

> Geoff was the first male in our time to deal openly in his work with
> issues of sexual identity posed by the Stonewall riots of 1969. This is
> not to say that he participated in the riots or even became political
> per se. But because of the riots and the new gay politics, a consen-
> sus in America, in particular in New York at that moment, existed
> that made possible for the first time—a passage of identity from the
> normative heterosexual to the hitherto secret and unnamed homo-
> sexual.

Linda Nochlin publishes *Why Have There Been No Great Women Artists*. This article
becomes pivotal in the feminist revision of art history and is a source of affirmation for
women in performance at the time.

Bonnie Sherk performs *Public Lunch* at the **San Francisco Zoo**. The artist sets out
and eats a formal lunch in an empty cage in the Lion House right at feeding time, when
there are sure to be the largest number of spectators.

The Kitchen Center for Video and Music is founded by video artists **Steina &
Woody Vasulka** as a new media and performance center. When its first location in the
kitchen of the Broadway Central Hotel on Mercer Street collapses the following year,
The Kitchen moves to new quarters in SoHo. Although The Kitchen's mandate focuses
on hybrid contemporary arts, such as video (screening, installation, and production for
television), music, dance, performance, film (screening and production), and literature,
The Kitchen invites works which combine these elements in new ways.

British duo **Harry** and **Harry Kipper**, or **The Kipper Kids**, begin a series of untitled
"engagements" in galleries and bars which reveal the undercurrent of violence that lies
beneath the surface of social ritual and mannered behavior. In the words of **David
Ross**:

> Cartoon-like, with their clean-shaven heads, bizarre costumes,
> drawn-in beards, and exaggerated motions, the Kippers portray two
> battling geezers who might have escaped from a Krazy Kat comic
> strip. In nearly every piece that they have performed the following

scenario takes place: first, a ritual is introduced (high tea or a birthday party, for example); second, an array of props (mostly found objects whose repeated use give them nearly equal status with the performers) are arranged on a small tabletop; finally, the tableau is utilized as the scene disintegrates into a morass of restrained violence, punctuated by monosyllabic grunts and sounds of gastric distress. (From 1993 *Serious Fun* program notes.)

The Kipper Kids go on to perform extensively across the US and influence a significant number of American performance artists.

On December 24, Chicano artists **Willie Herron, Gronk,** and **Harry Gamboa** perform *Stations of the Cross* on Whittier Boulevard in East Los Angeles. Staged as "an alternative ritual of resistance to belief systems that glorified useless deaths," *Stations* subverts traditional Christian imagery and attracts strong criticism from conservative members of the Chicano community. The work, it was said, left people with the feeling of nausea. These artists are joined by **Pattsi Valdez, Diane Gamboa,** and others, to form the group **Asco,** which continues to create performances, mixed media works, murals, films, slides, and "No Movies" - photographic, pseudo-documentaries derived from performances. The group's work ranges through sardonic social criticism, media manipulation, and quasi-religous send-ups.

1972

Cuban-born **Ana Mendieta** stages her first performances in Iowa. Mendieta, whose life ends prematurely in 1985, plays an influential role in formulating a connection between temporal earth works, feminist body art, and the ritual forms and symbols of her Cuban Santeria heritage (a mixture of cultures from Africa and the Americas). Primarily through photography, Mendieta documents her poetic actions. "By using my self-image in my art, I am confronting the ever-present art and life dichotomy. It is crucial for me to be part of all my works. As a result of my participation, my vision becomes a reality and part of my experiences."

At **112 Greene Street, Tina Girouard** installs *Four Stages,* four architectural structures for the use of performers. The artist explains, "What I mean by 'perform' is, the door was open, people would come in, take their shoes off, and get to work. None of the

other performers sent out announcements; it was just clear in my announcement that there'd always be something going on in the space." Performers include members of **Mabou Mines**, some members of **Grand Union** dance company, **Barbara Dilley**, **Suzanne Harris**, Girouard, and the musician **Richard Landry**.

Vito Acconci creates the performance/installation *Seedbed* at the **Sonnabend Gallery** in New York. This notorious piece consists of a slanted wooden ramp, under which Acconci lies masturbating, his voice transmitting into the gallery through loudspeakers. Reacting against minimalism and the over-intellectualized Conceptual Art of the day, *Seedbed* reverts to the body as psycho/sexual metaphor and medium.

A.I.R., a cooperative gallery for women, is founded in New York.

Robert Wilson creates a seven-day continuous event, *KA MOUNTAIN AND GUARDenia TERRACE* for the *Shiraz Festival of the Arts* in Iran. The piece is presented on the seven hills of Haft-Tan Mountain.

Through the use of video technology, **Joan Jonas** continues to explore the strategies of displacement, fragmentation, and de-synchronization started in her earlier work. The major structuring element of her new work is the simultaneity of live performance activity and video image, both closed-circuit and taped. Jonas creates perceptual shifts and insights by changing the scale and relationships of images to each other through the placement of cameras and monitors. Images that can only be seen as fragments in the performance space are completed on the screen. In *Organic Honey's Vertical Roll*, for example, Jonas choreographs her movements in relation to the vertical roll-over of the image caused when a TV monitor's receiving and transmitting frequencies are de-synchronized.

Inspired by popular heroic figures in 1950s movies, Mexican *photonovelas,* and the image of the famous masked wrestler and movie star, Mil Mascaras, **Réné Yanez** begins a series of ritual performances on the streets of San Francisco's Mission District. During the 1980s, Yanez performs a "capitol cleansing for the nation," in front of the White House, in which he takes aim at President Reagan's policy to close many psychiatric hospitals, a decision that "created a new class of homeless people." His masked appearance arouses the suspicion of secret service agents, who detain him.

Artists in the Feminist Art Program at **California Institute of the Arts** convert an old mansion in downtown Los Angeles to **Womanhouse**, where performances are an integral part of the project. **Faith Wilding's** *Waiting* is often cited as the epitome of feminist performance at this time in California. In it she rocks back and forth monotonously, reciting the litany of waiting that women experience from birth to death.

Performed in Venice, California, *Ablutions* is a collaborative piece by **Judy Chicago, Suzanne Lacy, Sandra Orgel,** and **Aviva Rahmani** about the reality of rape. Its aim is to discredit popular beliefs, such as that rape cannot occur against one's will. As one nude woman is being bound from her feet up to her head, and two other women bathe themselves in eggs, blood, and clay, audiotaped testimonials of women who have been raped are heard. Art Critic **Moira Roth** calls it "a landmark in the early history of feminist performance."

Eleanor Antin begins to develop four alter egos—a King, a Ballerina, a Black Movie Star, and a Nurse—which she elaborates in live performances and video. As the King, she can be seen on the streets and byways of Solana Beach "discoursing with her subjects." She conceives of her art as an exploration of the self, not simply as a single self-image but as a collection of several possible roles open to an individual. This work continues for years, producing congruences and disjunctures between Antin's identity, fantasies, autobiography, and fictive roles.

Vito Acconci constructs *Fitting Room I* for *Documenta V* in Kassel, Germany. This work connects the artist's intensely self-exploratory and self-exhibiting body work of the late 1960s-early 1970s, with his later sculptures that engage the viewer in playful activities and exercises designed to initiate an examination of interpersonal and social interaction.

Chicano *grupos*—collectives of artists working in diverse media but sharing similar goals— emerge as a significant political and cultural force in the Chicano movement, operating outside the gallery/museum system. One of the most influential, the Sacramento-based **Royal Chicano Airforce**, performs actions as media events designed to draw attention to the Farmworkers' boycott. Appearing at demonstrations costumed in paramilitary gear and driving jeeps, the group's performance succeeds in creating "a metafiction of liberation."

Alanna Heiss begins the **Institute for Art and Urban Resources** under the funding umbrella of the Municipal Art Society, using a Coney Island warehouse for exhibitions.

Ping Chong presents *Lazarus,* his first performance piece. His multimedia works, using multitrack audio tapes, film, slides, electronic read-outs, dance, puppetry, and toys, are often concerned with intense psychological states, and, as a Chinese-American, he poses questions about cultural identity, alienation, and "otherness." By cutting from stage to screen, he is able to roam across continents and centuries for intriguing perspectives on different cultures. An array of androids, robots, dictators, naifs, angels, animals, and insects inhabit his works.

1973

Chris Burden buys air time on Los Angeles TV, "advertising" himself as a Conceptual Artist.

NAME Gallery opens in Chicago.

One of **Linda Montano**'s primary interests at this time is the nature of personal relationships and ways of working on them in the context of art. *Handcuffed to Tom Marioni for Three Days* is performed at the **Museum of Conceptual Art** and the public is invited. Everything Montano and Marioni do is framed as art.

Meredith Monk's *Education of the Girlchild: An Opera* premiers at **Common Ground Theater** in New York. This work, regarded as one of the artist's most celebrated theater pieces, is presented several times in New York and in 1975 at the *Venice Biennale.* In *Part I* of the opera, a girl is educated by her female companions and initiated into the cult of the ancestress. *Part II* is a long vocal solo in which Monk passes from old age into youth. This work resists precise interpretation because it uses an incomprehensible musical and kinetic language.

The Woman's Building is founded in Los Angeles. It houses the **Feminist Studio Workshop, Womanspace** (a gallery), and **Grandview**, a newly-formed art cooperative for women. The first women invited to create performances and participate in workshops are **Eleanor Antin, Nancy Buchanan, Pauline Oliveros,** and **Barbara Smith**.

Jacki Apple and **Martha Wilson** create *Transformance: Claudia,* in which they share the

fantasy persona of a glamorous and powerful woman, followed by an entourage, as she lunches at the Plaza Hotel and tours SoHo galleries. The piece raises questions about the conflict between media-created images of the "powerful woman" and reality, and the ways those images shape women's identities.

Lucy Lippard's book *Six Years: the Dematerialization of the Art Object from 1966 to 1972* focuses on so-called Conceptual or information or idea art, with mention of such areas as minimal, anti-form, systems, earth, and process art. This landmark publication reflects the considerable proliferation of performative modes in recent art.

From 1973-74, **Pauline Oliveros** develops *Sonic Meditations* as a way of producing sound involuntarily and allowing the body to respond to the imagination without conscious interference. Since 1971, she had been working with a group of women practicing physical and spiritual exercises, keeping dream journals and diaries, and meditating together. *CROW Two: A Ceremonial Opera* entails a complex arrangement of 'meditations': a visual one, based on a mandala formation with a large circle of people, and aural ones, created by visualizations of the movements required to produce various musical sounds.

Artists Space is founded and becomes one of the most important and longest lasting artist organizations in New York City. Over the years, performances by **Laurie Anderson, Vito Acconci, Martha Wilson, Eric Bogosian,** and **Ping Chong** are presented, in addition to artist selected exhibitions.

Creative Time is founded by **Anita Contini** to offer artists the opportunity to interact with new audiences in unusual public places - in plazas, lobbies, taverns, and terminals, on beaches, piers, street corners, and cable TV. In helping artists to cross disciplines, reinvent forms, rescue neglected sites, and participate in unusual collaborations, Creative Time aims at redefining "public art." Some of Creative Time's celebrated projects include *Art on the Beach*, on the Battery Park landfill and subsequent locations (1978-94); *Art in the Anchorage*, in the substructure of the Brooklyn Bridge (1983-present); and *42nd Street Art Project* (1993-94).

1974

Alanna Heiss opens **Idea Warehouse** in the top floor of an abandoned city building in downtown New York. **Mabou Mines** theater company, **Philip Glass Ensemble,**

Charlemagne Palestine, Simone Forti, Ken Jacobs, and many others work and perform there until 1975, when the space closes.

Allan Kaprow joins the faculty of the **University of California, San Diego**, a campus which becomes a flourishing center for performance in Southern California.

Theresa Hak Kyung Cha, a Korean-born artist living in the San Francisco Bay Area since the early 1960s, presents *Barren Cave Mute*, her first performance piece. Cha's work, comprised of installations, performances, film and video productions, and published texts, is primarily concerned with the "roots of language before it is born on the tip of the tongue." As an individual living in exile, Cha explores the theme of displacement by way of cinematic forms and the psychoanalytic aspects of French film theory. Her performances embody, through visual and linguistic shifts and ruptures, the experience of detachment from the very structure of communication itself. The artist is murdered in New York in 1982.

A major conference, exhibition, and performance series is held at the **Women's Building** in Los Angeles.

Spalding Gray, together with **Leeny Sack, Ellen** and **Elizabeth Le Compte, Alex Ivanoff, Erik Moskowitz**, creates *Sakonnet Point,* the first piece of *Three Places in Rhode Island*. Working in an improvisational process of free association, the group develops a series of simple actions—images that can be read "like personal, living Rorschachs" by audience members. *Rumstick Road* (1976), the second piece in the trilogy, deals with Gray's mother's suicide. Its confessional impulse is to become Gray's primary mode of performance in later work. The third piece, *Nyatt School*, is created in 1977 with **Ron Vawter,** Elizabeth Le Compte, **Bruce Porter,** and **Libby Howes**.

Joseph Beuys performs a one-week action, *Coyote: I Like America and America Likes Me,* which concerns Native Americans' history of persecution, the relationship between the United States and Europe, and the transformation of ideology into the idea of freedom.

A *Video Performance Series*, organized at **112 Greene Street** by **Liza Bear** and **Willoughby Sharp,** presents work by **Joseph Beuys, William Wegman, Ulrike Rosenback, Chris Burden, Dennis Oppenheim,** Sharp, **Vito Acconci, Cosmos Sarchiapone, Keith Sonnier, Richard Serra,** and **Robert Bell**.

Laurie Anderson performs *Duets on Ice* (subtitled *Bach to Bach*) at five street locations around New York. Anderson stands on skates, frozen in blocks of ice, playing her violin with a hidden tape-recorded accompaniment. This work embodies many of the major currents found in Anderson's work to the present: performing solo with her signature violin augmented by an electronic device; the use of humorous personal narrative which comments on social conditions or current events; the use of animated props (or images) that reveal something about their own use or making; and an unswerving drive to connect with a broad, heterogeneous public.

A group of artists organizes the *South of the Slot* performance series in a rented space on Bluxome Street in San Francisco. Participants include **Richard Alpert**, **Joel Glassman**, **Pat Ferrero**, **Steven Laub**, **Terry Fox**, **Tom Marioni**, **Paul Kos**, **Jim Melchert**, **Jim Pomeroy**, **Paul Demarinis**, **Linda Montano**, and **Simone Forti**.

1975

Washington Project for the Arts (WPA), Washington, DC, is founded by **Alice Denney** as a forum for "multi-disciplinary, multi-aesthetic theater, performing art, and experimental art." Thriving in its early years in a rent-subsidized, city-owned building slated for demolition, the WPA presents an array of regional and national programs, including: **Meredith Monk and Ping Chong's** *Venice/Milan* (1976); **Bird in the Dirt**, *Pomba Gira's Festival*, a 13-hour festival of film, video, live performance, and dancing, directed by **Jonas dos Santos** (1976); a *Punk Art* festival (1978) featuring performances by artists such as **Rupert Chappel, The Egg Lady (Edith Massey),** and the **Slickee Boys**, plus the notorious rectal portrait of Andy Warhol by **Neke Carson** which was stolen during the exhibition but was later returned; **Hannah Wilke** (1979); **Sam Sheppard** (1980); and **Allen Kaprow** (1981).

Geno Rodriguez founds the **Alternative Museum**, an artist-run museum of contemporary art in New York.

Lynn Hershman founds the **Floating Museum** in San Francisco in order to commission works of art for spaces outside the traditional museum context. Hershman also begins to develop *Roberta Breitmore,* "a portrait of alienation and loneliness." Over a three-year period, Hershman creates a persona based on the physical traits and mannerisms of women around her, assumes the identity of Roberta,

and has adventures while playing that role. She opens a checking account, obtains a driver's license, and rents a room, which is on display for two hours each day.

Carolee Schneemann performs *Interior Scroll* for the *Women Here and Now* series in East Hampton, Long Island. Having painted herself in large strokes to define her body and face, she reads from a text as she assumes action poses from life-drawing class. She concludes by reading from a scroll that she slowly unravels from her vagina about a structuralist filmmaker who complains that Schneemann's film is full of "personal clutter...persistence of feelings...hand-touched sensibility...diaristic indulgence...," and so on.

Paul McCarthy takes his messy, unsacramental work to a new level of intensity, performing *Sailors Meat* for video, in Pasadena, California. Since 1972, McCarthy has been performing visceral bodily actions such as spitting and sucking, using materials such as ketchup, mayonnaise, hand lotion, hot dogs, and raw hamburger, and props such as dolls, stuffed animals, kitchen utensils, and car parts, and dressing in a variety of costumes that range from women's underwear or sailor suits to Jimmy Carter masks.

Ant Farm (Chip Lord, Hudson Marquez, Doug Michaels, Curtis Schreier) performs *Media Burn* in a huge parking lot in San Francisco. "President John F. Kennedy" gives a speech: "Mass media monopolies control people by their control of information. I ask you, my fellow Americans, haven't you ever wanted to put your foot through your television screen?" Then the artists, dressed like astronauts, drive a Cadillac "Phantom Dream Car" through a flaming wall of television sets. Some 50 cameras record the event.

In San Francisco, **Carl Loeffler** founds **La Mamelle** gallery and a group of artists establishes **80 Langton Street** to accommodate video and performance, as well as music, dance, poetry, lectures, and panel discussions.

Ant Farm and **T.R. Uthco (Doug Hall** and **Doug Michaels)** stage *The Eternal Frame: an Authentic Remake of the JFK Assassination* in Dallas. "Fearing that their desecration of an American myth could result in an unpleasant confrontation with the citizens and authorities of Dallas, the artists' motorcade made its first pass through Dealy Plaza at 7 a.m. By two in the afternoon, the artist-President had been assassinated 17 times. Dealy Plaza had become jammed with tourists who eagerly photographed the event for family

and friends back home. Even the Dallas police were cooperative." (*La Mamelle Magazine: Art Contemporary*, no.5, vol.2, 1976)

Real Art Ways is founded in Hartford, Connecticut, and becomes one of the foremost presenters of new art and performance in New England.

Jim Pomeroy creates *Fear Elites* at the **Hansen Fuller Gallery**, San Francisco. In this installation, described in *SPACE TIME SOUND Conceptual Art in the San Francisco Bay Area: The 70's* by **Suzanne Foley**, "visitors could activate twelve music boxes, each of which played Beethoven's "Fu(..)r Elise" in whatever sequence or number they chose." Pomeroy's vocabulary employed an array of media and phenomena juxtaposed in ways that made humorous but "often cynical comments on the objects or the phenomena themselves and our faith in their social value."

In December during the winter solstice, at Riis Park in Queens, New York, **Donna Henes** initiates *Reverence to Her*, the first of her ritual celebrations of "celestial auspicious occasions" — solstices, equinoxes, eclipses. The artist points out that in pagan times, the winter solstice was traditionally celebrated with goddess worship, but "this isn't a feminist event. A tempering force is needed, a ceremony dedicated to the femaleness in all of us—both men and women." Henes continues to organize these events to the present.

1976

Feminist Art Workers is founded in Los Angeles. Members include **Nancy Angelo, Cheri Gaulke, Candace Compton,** and **Laurel Klick.** When Compton drops out, she is replaced by **Vanalyne Green.** Their performance piece, *Traffic in Women: A Feminist Vehicle,* grows out of research into the actual traffic in women between Los Angeles and Las Vegas. After building a sense of kinship and support among themselves by performing different personae, they join women in Las Vegas for a weekend of workshops, performances, and dialogue on violence against women.

Paul McCarthy performs *Class Fool* in a math classroom at the **University of California, San Diego.** His extreme behavior in the performance is child-like, obsessive, deeply psychological, and cathartic. Using his signature materials, McCarthy presses the audience's tolerance level with his abject, self–deprecating,

and self-injurious actions. **Linda Frye Burnham** writes:

> After eating hand cream and applying ketchup to his penis he began
> to crawl beneath the chairs in which the audience sat. To avoid
> getting the muck on their clothes, they stood on the chairs. He
> drank ketchup...and began to vomit. There was a rush to the door
> with five or six people remaining.
> (*High Performance*, issue 29, 1985)

In Europe, **Marina Abramovic** and **Ulay** begin their *Relation Work*, a series of *Body Art*
pieces that explore the limits of the mind/body relationship and involve feats of
endurance. For their final work together, each begin at opposite ends of the Great Wall
of China and walk along the Great Wall until they meet three months later.

Ann Sutherland Harris and **Linda Nochlin** organize the exhibition *Women Artists
1550-1950* at the **Los Angeles County Museum of Art**.

Faith Ringgold stages *The Wake and Resurrection of the Bicentennial Negro* at various
locations around the United States.

Einstein on the Beach, a four-act opera by **Robert Wilson,** with music by **Philip Glass**
and choreography by **Andy de Groat**, premieres at the **Festival D'Avignon**, tours
Europe, and returns for two sold-out performances at the **Metropolitan Opera** in
New York. **Robert Brustein** writes:

> *Einstein* dramatizes (so subtly one absorbs it through the imagina-
> tion rather than the mind) the change in perception—especially the
> perception of time—that accompanied [our] technological
> development. The interminable length of the performance [five
> hours], therefore, becomes a condition of its theme, as do...the
> vertical and horizontal shafts of light...the visual effects are the most
> dazzling aspects of the work: Wilson is essentially a painter who
> paints in motion.

Franklin Furnace is founded by **Martha Wilson**, located on Franklin Street in Lower
Manhattan. The Furnace's unique focus is on performance and artist books. Over the
years, the Furnace will amass the largest collection of artist books in the US and will

pioneer performances and projects consistent with the impulses that engendered the bookworks in its permanent collection. Many artists from across the US and around the world will look to the Furnace as one of the most significant venues to advance their work. Those that will perform include well known artists such as **Eric Bogosian** (1977), **Linda Nishio** (1981), **Karen Finley** (1983), and **Guillermo Gómez-Peña** (1985).

Jean Dupuy organizes *Grommets* at **P.S. 1 (Institute for Art and Urban Resources)**, Long Island City, and later in the year at his New York loft. The work presents 20 different events simultaneously for an hour, with each visible through a metal eyelet set in a muslin curtain. Among the artists to perform are **Larry Miller**, who hypnotizes viewers with a rotating fan that has "Deep Sleep" printed on it and a seductive voice over headphones; **Laurie Anderson**, who plays one violin note obsessively; **Julia Heyward**, who sings old songs as the viewer looks back through a seemingly infinite space containing courtyards and windows; **Elaine Hartnett**, who is surrounded by stuffed animals while chatting to **Charlemagne Palestine**, visible only on a monitor; and **Olga Adorno**, whose two grommets are focused on her face and bare crotch, as she whispers obscene messages.

Larry Miller performs *The Suitcase*. Having found an abandoned suitcase on the Bowery, where he had worked some years earlier, the artist makes a video piece in which he displays the suitcase's contents—a woman's wig, clothing, and an inflatable doll—and reconstructs the derelict-owner's persona, as if on an archaeological dig. Miller recalls, "The more I looked, the more it spurred my imagination. It was a voyeuristic act to be peeping into his private life, but he was gone..." In the performance, the artist takes on the derelict's identity, using the items in the suitcase as props.

1977

Heresies: A Feminist Art Publication on Art & Politics is inaugurated in New York.

Barbara Smith performs *Pucker Painting* for a special event run by the **Women's Caucus for Art** at the **College Art Association** conference. Smith primes her naked body white like a canvas and stands on a small pedestal in a sunlit room of the **Women's Building**. In front of her on a table is a wide assortment of lipsticks, from traditional

reds and pinks to theatrical colors of blue, black, and green. Visitors are invited to select a color, apply it to their lips and kiss her body on a place of their choosing.

Empire by **Robert Longo**, with **Bill T. Jones** and **Arnie Zane**, is performed at the **Corcoran Gallery of Art**, Washington, DC. Emulating Longo's drawings, the performers depict slow-motion and frozen moments of tortured actions derived from media images.

Suzanne Lacy organizes *Three Weeks in May* to protest the high incidence of rape and violence against women. Los Angeles city officials, feminist groups, and artists participate in a three-week series of meetings, performances, and self-defense classes. Later in the year, Lacy and **Leslie Labowitz-Starus** organize *In Mourning and in Rage*, a public performance aimed at the media to protest the Hillside Strangler rapes and murders, and the irresponsible media coverage of the slayings.

Larry Miller presents *C'Mon America*, at **Franklin Furnace** in New York. He begins with a saga about his attempt to place a personal ad stating, "What I need is a thrill, I think," its acceptance by the *New York Review of Books*, and a deluge of responses from "perverts, lonely souls and kooks." In another piece, Miller discusses fashion photographs shown on one screen, while ignoring slides of badly-scarred men on another.

Concerned with the lack of exposure for women in performance, **Judith Barry** organizes *Seven Days After the Fall*, a major women's performance series at **La Mamelle** in San Francisco. Barry performs *Past Present Future Tense*, using dissolve slides on three screens and a soundtrack featuring complex themes of linguistics and feminist dialogue. At one point, she lies in a hammock while a ton of sand showers her from above until she is completely covered.

In *Venus Cafe*, **Theodora Skipitares** appears as a woman perched on a high stool, dressed in 20 layers of men's white cotton shirts and pants, with a variety of dinner plates hung about her neck. This evocative image reflects contemporary feminist concerns by symbolizing women as suppressed, restricted, and bound by traditional household duties. The costumes she designs are viewed as a theater of objects, rather than as an artificial identity for herself or others in the role of the performer. This approach to object-costumes, which includes masks, leads her to a concentration in puppetry.

The Waitresses, a feminist performance collective, is formed in Los Angeles by **Jerri Allyn, Leslie Belt, Anne Gaudin, Patti Nicklaus, Jamie Wildman-Webber,** and **Denise Yarfitz**.

LACE (Los Angeles Contemporary Exhibitions) evolves out of a community arts program initially located in El Monte and run by a group of ten artists who are funded by the Los Angeles County's Comprehensive Employment Act (CETA). Comprised mainly of artists from the Chicano community and Otis Art Institute, the group renovates a space in downtown Los Angeles and inaugurates a vigorous program of performance events, films, videos, and exhibitions by "local and national: emerging and established" artists.

1978

Performing for the camera to create a photographic installation at **P.S. 1**, **Hannah Wilke** creates *So Help Me Hannah*. Wilke juxtaposes poster-sized nude self-portraits with abbreviated quotes from critics, poets, artists, philosophers, and political figures—among these are **Karl Marx, Ad Reinhart, James Joyce**, and **Donald Kuspit**. Accompanying the installation at P.S. 1 is a soundtrack of Wilke reading the entire quotes from which the phrases have been excerpted. Her use of text reflects the influence of **Marcel Duchamp** in that it is punning, erotic, and self-reflexive. One of the first artists at the time to use the vulva form prodigiously, Wilke is an important figure in 1970s feminist art, yet she is frequently chastised for her exhibitionism. Wilke challenges the mythology and iconography that represent women in a male-dominated culture.

High Performance, the first art magazine devoted entirely to performance art, is founded in Los Angeles by **Linda Frye Burnham**.

Stefan Eins and **Joe Lewis** establish **Fashion/Moda** in the South Bronx, New York. There artists experiment with a blending of their own goals and reaching a wider audience, decidedly beyond the "elite" traditionally associated with the art world.

Disband, an all-woman music group, is formed by **Martha Wilson**. Members include **Ilona Granet,** Wilson**, Ingrid Sischy, Donna Henes,** and **Diane Torr.**

George Maciunas, the principal organizer of **Fluxus** activities, dies.

THE EMBRACE...ADVANCED TO FURY, a "theater occurrence" by **Terry Allen**, is staged at the **Spinoza Arena/Theatre** in Houston and the following year at the **University Art Museum**, Berkeley. *THE EMBRACE* is part of a four-part work entitled *THE RING*. The other three parts consist of multimedia installations at various venues around the United States and Paris. A paradigmatic work about conflict between two people, **HIM** and **HER, THE RING** uses the metaphor of wrestling to portray the dissolution of their relationship. The two central characters, represented by male and female professional wrestlers and two offstage "secret readers," engage in a "complex, ferocious, ritualistic exploration" of their relationship. **Marcia Tucker** notes that there is a "lack of both physical and emotional distance...because there is no proscenium stage...we are privy to their personal effects, their uncensored thoughts and feelings, their secret diaries and letteres...their battles and their lovemaking...."

A Lesbian Show is organized by **Harmony Hammond** at **112 Workshop** in New York. In addition to visual art, artists give professional performances, readings, film, video, and discussions on lesbian art and politics.

In Los Angeles, in a series of performances on the street and in public venues, **Kim Jones** as *Mud Man* smears himself with mud and attaches sticks to his body like jungle camouflage. These and Jones's other performances involving the death of rats are influenced by his experiences in the Vietnam war, sadistic experiences with childhood friends, and destructive images found in everyday life.

Stuart Sherman performs his *Eleventh Spectacle* at **Artists Space**, New York. As in most of his solo performances, Sherman manipulates a perplexing array of small toys and common household objects in a manner that simultaneously suggests sleight-of-hand and ecclesiastical ritual. Before producing his own eccentric solo performances, Sherman worked with **Charles Ludlam's Ridiculous Theatrical Company** and with **Richard Foreman's Ontological-Hysteric Theater Troupe**. In spite of these associations, Sherman's work explores a distinctly different manner of animating objects. It suggests that they be read as a sequence of non-sequiturs that are unerringly familiar. All of his work hinges on associations between the banal and the sublime, the ordinary and the profound.

P.S. 122 is founded by **Charlie Molton, Charles Dennis, Peter Rose,** and **Tim**

Miller in a defunct public school on New York's Lower East Side. P.S. 122 goes on to become one of the definitive forums for performance art of the 1980s. Emphasis is placed on a new generation of performance, with a concentration on movement works and artists addressing gay and lesbian issues. Among the numerous artists to present their work there will be **John Bernd,** Miller, **The Blue Man Group, Eric Bogosian, Karen Finley, Ann Carlson, David Rousseve, DANCENOISE, Johnny Leguizamo,** and **Reno.**

CAGE (Cincinnati Artist Group Effort) is founded to "promote more art for more people," presenting a wide variety of performances in diverse venues throughout Cincinnati.

1979

Eric Bogosian creates *Ricky Paul,* the first of a series of male characters inspired by 1950s' TV, radio, and nightclub acts. **RoseLee Goldberg** describes *Ricky Paul* as "a belligerent, macho entertainer with a twisted, old-fashioned dirty humor...As much concerned with form as content, Bogosian's portraiture [takes] the best from performance, its imagistic focus and appropriations from the media...and [matches] them with the finesse and confidence of the highly skilled actor." (RoseLee Goldberg, *Performance Art,* 1988)

Art Attack, a collective guerilla-art group, is founded in Los Angeles. The group moves to Washington, DC, in 1981 and subsequently to New York. Primarily, Art Attack constructs installations or creates events in abandoned buildings and other unauthorized sites. Their work is fueled by an interest in the particular advantages and challenges of collaboration and the idea of art as intervention. They acknowledge that "references to the malleability and transience of culture form the bulk of our installations' subject matter." Seeking to "represent society as a transforming entity," they paradoxically combine high-tech audio and mechanical apparatus with cast-off materials, frequently taken from the sites of their works.

In San Francisco, **Mark Pauline** founds **Survival Research Laboratories (SRL).** The following year he is joined by **Matt Heckert** and **Eric Werner.** SRL creates large-scale techno-punk spectacles with mechanical and exploding devices engaged in apocalyptic combat.

Collaborative Projects (Colab) inaugurates a series of non-curated densely packed exhibitions, performances, and social events on odd themes such as *Batman, Dog*, and *Income & Wealth*. Unable to afford the increasing rents in SoHo and Tribeca, many of **Colab's** artists are drawn to New York's Lower East Side, a slum area. Commensurate with urban renewal and gentrification nationwide, a new group of real estate speculators have moved in on the East Village neighborhood. In response to impending evictions and hard economic realities of the tenants, Colab organizes the *Real Estate Show*, which precipitates the opening of **ABC No Rio**. Riding on the wave of a new generation of artists living and working the East Village, many clubs and galleries open there. Artists exhibiting and performing at No Rio and related spaces include **Jack Waters, Kiki Smith, Rebecca Howland, Christy Rupp, Justen Ladda, Judy Rifka, Erotic Psyche, Edit deAk, Dean Mathiesen**, and many others.

Yellow Springs Institute is founded by **John Clauser** in Chester Springs, Pennsylvania, as a retreat for artists with backgrounds in diverse performance and related disciplines, to develop and present new work.

1980

Political Art Documentation/Distribution (PAD/D), an artists' resource and networking organization, is formed in New York by **Lucy Lippard**, **Irving Wexler**, **Greg Sholette**, and others.

For the next three years, **Bread and Puppet Theater's** annual two-day outdoor performance, *Domestic Resurrection Circus*, is held on **Peter Schumann's** farm in Glover, Vermont, and focuses on the theme of imminent nuclear warfare. In 1984-85, the *Circuses* are dedicated to grassroots struggles in Central America.

Hudson performs *Poodle Theater*, his "beauty parlor dog act," at **SPACES** in Cleveland. The performance concerns itself with *Poodle Beauty, Poodle Life, The Killer Poodles of Hollywood*, and *Poodle Dog Love*. The work blends theatrical dance and visual elements.

Collaborative Projects mounts the *Times Square Show*, an exhibition and performance series, in a former bus depot and massage parlor discovered by **John Ahearn** and **Tom Otterness**. In site-specific installations and individual pieces, hundreds of artists create a funhouse environment that emulates the surrounding Times Square neighborhood.

Alan Moore recalls, "Nightly performances made it almost like a month-long party, coalescing the diverse new art energy, revealing it to a broad new public and to the artists themselves."

At the opening of the relocated **Just Above Midtown** (JAM) **Downtown, Lorraine O'Grady** arrives wearing a rhinestone and pearl tiara, a floor-length gown and cape made of 180 pairs of white gloves, and a beauty-pageant sash reading "Mlle. Bourgeoise Noire 1955." She moves elegantly through the crowd with a male escort in black tie, smiling broadly and distributing chrysanthemums. The dispersal of the flowers reveals a cat-o-nine tails in the center of her bouquet. Removing her cape, donning white gloves and clutching a whip, she paces the floor and lashes herself to a frenzy, stops and screams:

> THAT'S ENOUGH!
>
> No more boot licking...
>
> No more ass-kicking...
>
> No more buttering-up...
>
> No more pos...turing
>
> o super-ass...imilates...
>
> BLACK ART MUST TAKE MORE RISKS!!!

She then leaves the scene abruptly.

1981

At **California Institute of the Arts, Guillermo Gómez-Peña** and **Sara-Jo Berman** found **Poyesis Genetica**, an interdisciplinary, inter-ethnic performance group that develops an intercultural style which results from "the blending of Mexican *carpa* (a tradition of urban popular theater), magical realism, kabuki, and U.S. multimedia." Before each performance, members of the group undergo a series of ritual steps to reach a trancelike state that includes fasting, chanting, breathing exercises, and ritual dinners.

Arts Coalition for Equality organizes *Missing in Action,* a large performance to protest **Los Angeles County Museum of Art's** *60s* exhibition, which excludes women and minority artists.

Anna Homler transforms a 1960 turquoise Cadillac into *The Whale* by decorating its interior with artifacts—buddhas, snails, candles, and seaweed draperies—suggestive of an inner and aquatic realm. The audience gathers at **Espace DBD**, Los Angeles, in a blue-green "submarine waiting room" hosted by mermaids. Small groups are then taken on 15-minute cruises around the city. During the ride, Homler's taped voice relates the history of *The Whale*, accompanied by whale songs.

CAGE organizes *Out Art*, an exhibition of gay and lesbian work.

1982

Starting in the late 1970s, **Christian Marclay** gives performances in New York clubs, using turntables as instruments and cut-up vinyl records to mix and juxtapose fragments of big-band jazz, opera arias or silly TV shows. His performances comment on and disrupt the objectification of music as a material commodity. Influenced by **Cage** and **Duchamp**, as well as punk rock, Marclay's work exposes the fixed and immutable quality of the record to chance, returning the production of music to the context of live performance. His use of accident and collage technique to reference popular culture reveals an understanding of music both as collective unconscious and as a physical phenomenon. His performances anticipate the manipulation of recorded sound by hip-hop DJs.

Ann Magnuson publishes an article, "I dreamed I was an Androgynous Rock Star in my Maidenform Bra," in *ZG* magazine. In self-mocking humor, she describes the current East Village club scene in New York. Magnuson manages **Club 57**, located in the basement of the Holy Cross Polish National Church on St. Marks Place. Magnuson's performances consist of a panoply of characters, including Heavy Metal rock singers, Gala Dali, and TV evangelists. She frequently collaborates with other East Village regulars, such as **John Sex**, **Eric Bogosian**, and **Joey Arias**. In the spirit of her insightful character studies, she writes:

> They came from the outermost regions of America, suburban
> refugees drawn to the big city in search of fame, fortune and
> fun...Weaned on television and rock'n'roll, these exponents of the
> 15-minute attention span generation turned the club into a center
> for personal Exorcism. Nightly services of bloodletting rituals

released spirits buried deep within their collective subconscious. Media heathens, re-enacting scenes from the communal memory grooved in a group mind with a one-way ticket to Nirvana....

In spite of Magnuson's tip-of-the-hat to Dada artists and Happenings, a shift in content, approach, attitude, and subject matter distinguishes this work from earlier generations. East Village artists' use of stand-up and cabaret forms (then becoming a nationwide trend) include pointed commentary on economic and social inequities. These accessible, text-based forms are widely criticized by art world critics who view stand-up comedy (within the realm of the avant-garde) as low-brow and retrograde. The East Village performance clubs peak in 1985, as they fall victim to tourism, city regulations, and a shift by some performance artists to mainstream entertainment.

In New York's Central Park, **Lorraine O'Grady** sites *Rivers, First, Draft*, a work with over a dozen performers. In a series of vignettes near a stream, the piece is concerned with "uniting two heritages, [those of] the West Indies and New England."

John Jesurun presents *Chang in a Void Moon*, his first performance work at the **Pyramid Club** in New York. Scripted and cut together like a movie, *Chang* runs over a period of several years and through over 40 episodes. Jesurun's multimedia performance pieces pit live actors against sternly omnipotent screen figures, as in *White Water* (1986), where a boy, who claims to have visions of a miraculous water-bearing woman, is interrogated by 24 video monitors and a pair of live actors.

Cheri Gaulke performs *This is My Body*, her first work in a series to explore cultural and religious attitudes about the body. In *This is My Body*, she historically deconstructs the image of the dead Christ on the cross from a feminist perspective.

In an effort to expand performance art into the air space of radio, **Jacki Apple** inaugurates *Soundings*, a weekly, one-hour program on KPFK-FM in Los Angeles.

Lin Hixon and **Jane Dibbell** produce and direct four interdisciplinary/intermedia, large-scale collaborative group works in Los Angeles through 1983. Using cinematic syntax, the pieces deconstruct the transformation of real events into media fictions. In **Rockefeller Center**, the artists use the exterior of a real train station like a movie set to stage a series of highly-choreographed tableaux that resemble scenes from the movies.

For example, a familiar image of a man and woman approaching each other from across a field, in slow motion, evokes romantic memories and nostalgic yearnings.

Headlands Center for the Arts, in Sausalito, California, is incorporated and becomes fully operational in 1986 as a laboratory for artists with a focus on the development of new work and the creative process. The Center's art activities are integrated into the gradual renovation of their site—a complex of former army buildings constructed at the turn-of-the-century on 13,000 acres of land.

The **NEXT WAVE Festival** is established at the **Brooklyn Academy of Music**. As a festival of new performance in a mainstream venue, NEXT WAVE is emblematic of the coming-of-age of performance art and experimental work in dance, music, opera, and theater.

1983

Tehching Hsieh and **Linda Montano** begin a one-year performance event, in which they are tied together at the waist with an eight-foot rope for the duration of the piece. Their statement reads, "We will stay together for one year and never be alone. We will be in the same room at the same time, when we are inside. We will never touch each other during the year." Each artist's interest in the work turns out to be radically different and these differences become the focus of fraught moments, when issues of power and control in the relationship come to the fore. While Hsieh is primarily concerned with the form and documentation of the work, Montano is interested in the experience (content), in issues of character, cooperation, and compassion.

Sherman Fleming, under the pseudonym **RODFORCE and Generator Exchange**, performs *Something Akin to Living* in Baltimore. In this endurance action, a network of approximately 40 wood boards is constructed around Fleming, who serves as their support until he becomes exhausted and is forced to walk away.

Anna Homler creates the persona *Breadwoman*, a universal mother whose face is made of bread dough. In a series of performances, the artist wears a mask of dough and peasant clothes as she sings shamanistic incantations in an invented language that is at once playful and mysterious. This imaginary language becomes the central focus of many of the artist's later works, in which audiences are alchemically transported to other realms through the artist's vocalization of abstract sounds.

At **Brecht Auditorium** in New York, **Robbie McCauley** presents *San Juan Hill*, the first in a trilogy of "Family Stories" entitled *Confessions of a Working-Class Black Woman*. The second, *My Father and the Wars* (1985), is performed at **Franklin Furnace**. The third, *Indian Blood*, is staged at **The Kitchen**. *My Father and the Wars* deals with the everyday life-and-death struggles of African-American men and with her father's and grandfather's use of patriotism as a strategy for survival. Using slide projections and video, McCauley doubles as both storyteller and witness: "Bearing witness about racism informs everything I do."

Laurie Anderson premieres *United States, Parts I through IV* at the **Brooklyn Academy of Music**. This extravagant multimedia performance, four years in preparation and seven hours running, is presented in four parts: *Transportation, Politics, Money,* and *Love*. The titles of the sections suggest the accessible and iconographic contents of the piece. Familiar images are juxtaposed in incongruous, yet illuminating ways, emulating her text, which frequently employs non-sequiturs. Of particular importance is Anderson's sophisticated, though adroitly unaffected use of technology in an unjudgmental scrutiny of a post-industrial and technologically dependant society. As a result of *United States*, Anderson becomes one of the few performance artists to successfully cross over to the commercial pop world.

Over a two-year period, **Guillermo Gómez-Peña**, **Marco Vinicio,** and others organize "border performance art" pieces and other bi-national arts projects on both sides of the Mexican-U.S. border at Tijuana/San Diego. This leads to formation of **Border Arts Workshop/El Taller de Arte Fronterizo**.

1984

On Mother's Day, **Suzanne Lacy** stages *Whisper, the Waves, the Wind* in the **Children's Cove** at La Jolla, California. In this work, 154 older women, dressed in white, gather at tables to talk about the problems and pleasures of aging. The tables are wired for sound so that the audience, watching the event from a cliff above the beach, can hear the women's comments. In *The Crystal Quilt,* a subsequent performance event in Minneapolis, 430 women join together to form a gigantic living quilt. These events reflect Lacy's ongoing concern with addressing major social issues through community-oriented participatory artworks.

In New York's East Village **Lady Bunny** inaugurates *Wigstock*, a drag show that becomes a major festival attended by transvestite luminaries, artists, and eclectic fans such as New York City Councilman Thomas Duane and Comptroller Elizabeth Holtzman.

For *Artists Call Against U.S. Intervention in Central America*, 200 cities hold simultaneous performances, exhibitions, poetry readings, marches, demonstrations, and film and video screenings.

Linda Montano begins *7 Years of Living Art (1984-91)*, a multi-layered personal experiment in attention. The artist wears only one-color clothes; listens to one note for seven hours each day; stays in a colored space for three hours a day; speaks in a different accent each year (except with her immediate family); and, once a month for seven years, reads palms and gives Art/Life counseling to members of the public in an installation at **The New Museum of Contemporary Art**, New York.

At **Hunter's Point**, an industrial area outside San Francisco, **Diamanda Galas** performs *Masque of the Red Death*, her first work in a trilogy on the AIDS epidemic. Galas, a classically trained pianist and operatic vocalist, conveys an extreme and theatrical persona with her extraordinary voice, which extends three-and-a-half octaves. She manipulates and projects sounds that range from menace to ecstasy.

1985

The **Guerilla Girls**, an anonymous women's collective, is established to combat sexism and racism in the art world.

At **The Museum of Man**, San Diego, **James Luna** creates an anthropological installation, *The Artifact Piece*. He uses his own live body lying prone in a display case.

After working as a welfare advocate, **John Malpede** founds the **Los Angeles Poverty Department** (LAPD), which invites homeless people from skid row to participate in free performance workshops. One step beyond the adventurous artists' organizations such as **Fashion/Moda, Collaborative Projects (Colab), ABC No Rio**, and **Political Art Documentation and Distribution** (PADD), all of which are located in or produced projects in marginal neighborhoods, LAPD quickly garners acclaim as an experimental performance group that directly engages a disfranchised constituency. Their

first show is primarily a series of monologues based on a performance exercise in which the participants are asked to enact a physical activity with which they feel comfortable and talk about whatever comes into their minds. Malpede explains:

> Frank Cristian had been a boxer, so he was boxing. Kevin Williams was jumping rope. Robert Clough was washing clothes. Jim Beam was playing baseball. Pat Perkins was sort of adulating a singer...What turned out to be interesting about them...was, even though they were consciously about something that made people feel good, all this subtextural stuff came in that revealed all sorts of other emotions. Like Robert's for example, "Boy I love washing clothes (r-r-r-ing) MMmmmm. The smell of the Downy and the Tide. It smells so good. And the bubbles between my fingers...and on and on...And another reason I love washing clothes is because (wringing out the clothes) it reminds me of wringing my father's neck! He used to beat my mother. He was an alcoholic and he called her retarded. And I don't think that's very funny.

Ann Hamilton creates an installation at the **Twining Gallery**, New York. It consists of a person sitting at a table with head and forearms covered by a mound of sand while another person sits in a lifeguard chair at a level which positions his head through the ceiling, out of sight. This early work of Hamilton's reflects two key elements in her *oeuvre*: the actual presence or suggestion of the figure (most often performing simple, repetitive, if not obsessive acts), and the use of massive amounts of tactile materials. In other works, her background in textiles is reflected in her use of natural, fibrous materials, bundled, abundantly piled, or laid out in grids with frequent references to domestic labor.

The **Border Arts Workshop/El Taller de Arte Fronterizo**, is formed by a multicultural group of artists, including Chicanos **David Avalos** and **Victor Ochao**, Trinidadian **Jude Eberhard**, Americans **Michael Schnoor**, **Sara-Jo Berman** and **Philip Brookman**, and Mexicans **Isaac Artenstien** and **Guillermo Gómez-Peña**. They proclaim the U.S.-Mexican border as their "intellectual laboratory" and stage a series of "Border Performance Art" pieces and other bi-national projects on both sides of the border at Tijuana/San Diego.

1986

At **SPACES** in Cleveland, **The Dark Bob** performs a multimedia event titled *Uncontrollable Love*, in which he challenges middle-class mores in a humorous vein. The performance is The Dark Bob's solution to personal and political alienation in the world. It deals with brotherly love, romantic love, and love for the survival of our planet. *Uncontrollable Love* is politically motivated and highly personal. The performance includes original music, singing, films, story-telling, and live, on-stage painting.

Jason Tannen, **Kate Gallion**, and **John Bender** perform the collaborative piece *Johnny Vortex Presents 'D' Street: Avenue of Fear* at **SPACES** in Cleveland. *Avenue of Fear* explores the darker side of love, romance, suspense, and neurosis in the big city. It is an evocative and complex fusion of slides, video, sound, and live action vignettes creating the atmosphere of a tongue-in-cheek *film noir* murder mystery. The piece looks at desperate people in dire situations as they race through dark and hostile cityscapes toward an unpleasant end.

1987

Ethyl Eichelberger and **Katie Dierlam** perform *Klytemnestra: The Nightingale of Argos* at **Performance Space 122**.

The **Guerilla Girls** organize *Guerilla Girls Speak Back to the Whitney* at **The Clocktower**, New York.

Theodora Skipitares produces *Defenders of the Code: A Musical History of the Uses and Abuses of Heredity*, a full-length musical, puppet-theater piece about the lives of Madame Curie and Charles Darwin. In *Defenders*, Skipitares uses the lives of Madame Curie and Charles Darwin as vehicles to demythologize the "masculine notion that science is neutral and deals only with cold, objective truth rationally, logically, and without emotional investment."

1988

At the **Mary Boone Gallery**, New York (in conjunction with **Michael Werner Gallery**), **James Lee Byars** installs one work, *This This*, in the front gallery, and two

works in the second gallery. The walls are painted deep red, a mixture of "blood and lipstick." *This This* consists of two basalt spheres, each 39 3/8" in diameter and part of a series of spheres which Byars refers to as books. As reflected by their titles and associations as books, these works differ from minimalist geometric sculpture in that they invoke questions about knowledge and perfection in a pre- or post-language state. Each day during the exhibition at Boone, Byars performs an action in front of the **Guggenheim Museum**. Dressed in his signature gold suit and top hat, he holds up a circular, golden paper with the inscription, "Do not touch this Holy Building."

Cleveland Performance Art Festival (PAF) is initiated by **Thomas Mulready**. For its premiere run, the PAF presents a survey of performance art activity, mostly from the Cleveland area. Among the artists who perform are **Rob Bliss, Clara Crockett**, and **Ralph Rosenfeld**. The Festival lasts six nights and presents a total of 30 performances. The first festival devoted exclusively to performance art, the PAF runs an open invitational, with a panel of arts professionals reviewing applications and recommending featured artists. Those who are not chosen are invited to participate in the *Performance Open*, an unjuried segment of the Festival. Over the years, the Festival has grown and has featured internationally-known artists together with emerging talent. Activities include performances and workshops in theater spaces and alternative sites around the Cleveland area, including **Cleveland Center for Contemporary Art**.

Kay Lawal and **Joyce Scott**, as the **Thunder Thigh Revue**, perform *Women of Substance* at the **Theater Project**, Baltimore (and subsequently throughout the United States and in Scotland and Canada). This satirical work focuses on obsessive sexual and eating behavior and critiques conventional notions of beauty, probing issues of identity and self-esteem.

The London-based performance group **Station House Opera** performs *Piranesi in New York* at the **Anchorage**. Using over 2,000 concrete insulation blocks, the performers erect a 45-foot structure that includes a tower, stairs, chairs, and beds to fill the rooms. The project is sponsored by **Creative Time**, an arts organization that presents performances in alternative sites around New York City.

As part of the *First New York International Festival of the Arts*, **Performance Space 122** organizes the *East Village World's Fair*, a series of performance art works by artists from

across the United States and around the world. **John Fleck** performs *I Got the He-Be-She-Be's*, an early work that the artist notes is "inspired by the AIDS crisis and the fear that it has engendered." In this and Fleck's other performances, he combines outrageous physical virtuosity, hilarious, razor-sharp satire, and histrionic operatic vocals in manic commentaries on everything from consumerist binging and media overload to gender, birth, and AIDS.

1989

Working out of **Capp Street Project**, San Francisco, **Border Arts Workshop/El Taller de Arte Fronterizo** creates a massive telephone, fax, and mail network to exchange information among groups in Canada, the U.S., and Mexico about issues such as immigration, human rights, censorship, AIDS, and abortion.

Raphael Montanez Ortiz organizes *Art and Invisible Reality*, a series of performances and panels at **Franklin Furnace** in New York and at **Rutgers University,** NJ, "to bring native culture practitioners together with contemporary artists."

Visual AIDS inaugurates *A Day Without Art*, an annual national event memorializing those who have died of AIDS.

After moving from New York, where he co-founded **Performance Space 122**, **Tim Miller** moves to Los Angeles and, with **Linda Frye Burnham**, helps to found **Highways Performance Space** in Santa Monica. A performance artist since 1979, Miller also sees himself as "an activist, teacher and troublemaker...committed to creating and encouraging queer culture in this troubled country." In 1990, his piece *Stretch Marks* is deemed obscene by the **National Endowment for the Arts'** Chair **John Frohnmayer,** and an NEA grant is withdrawn, along with grants to **Karen Finley, John Fleck,** and **Holly Hughes**. *Stretch Marks*, which combines and juxtaposes images and music from advertising and popular culture, is an autobiographical memoir of growing up a gay man in America.

Dan Kwong presents his first solo work, *Secrets of the Samurai Centerfielder*, at **Highways** in Santa Monica. Blending gospel-style preaching with Asian oracular pronouncements, the artist tells the story of his family's immigration to the United States and subsequent internment during World War II. *Secrets* is a moving account of Kwong's mixed Asian

heritage and his experience of racism as revealed in his love and pursuit of the great American pastime—baseball. He uses the qualities of the game—its slow tempo, non-violent action, and its thinking-man's finesse—to convey the emotional tone of the piece.

In *Topper*, which premieres at the **La MaMa Experimental Theatre** in New York, **Liz Prince** wears a dress made entirely of bottle caps and two cat-food cans. Prince does a song-and-dance depicting her sundry hankerings and infatuations as she wrestles with adoration and adornment.

Los Angeles artist **Rachel Rosenthal** performs *Rachel's Brain* at the **Contemporary Arts Center**, New Orleans. The show opens with a quote by Arthur Koestler stating that the evolution of the brain not only overshot the needs of prehistoric man, but that it is also evolution's only example of providing a species with an organ that it doesn't know how to use. Like much of Rosenthal's work, this performance conveys an ecological-feminist message. Her foot-high Marie Antoinette wig, adorned with a sailing ship, symbolizes Western culture's worship of intellect and rejection of or isolation from nature. Like the cabaret artists at the turn of the century, Rosenthal reveres circus techniques, especially clowning, as particularly effective and accessible ways to simultaneously provoke and amuse the audience.

1990

Joyce Scott performs *Generic Interferences Genetic Engineering* at the **Walker's Point Center for the Arts**, Milwaukee. This solo work, written, acted, and sung by Scott, uses the futuristic images of genetic engineering to critique the human tendency to avoid dealing with societal and personal problems, such as discrimination against other races and the disabled. **Leslie King-Hammond** has described Scott as:

> ...a rhyming, rapping, rapacious, raconteur... This rapscallion is a complex blend of internal and external forces, ancestry and generational legacies which have fused into a single force, like lava erupting from an active volcano...Using wit and wisdom, cunning and trickery, Joyce Jane seduces the viewer...No topic escapes the wrath of (her)...analysis. In her own words she explains how, 'People ought stop, should realize life and death are

the same, and messages we leave are trapped in our shadows.'
She is the master of earthly havoc.

Luis Alfaro performs his solo work *Downtown* at **Highways**. Using cliches about Los Angeles's sunny beaches and entertainment industry, the work weaves together the political, spiritual, and sexual threads of Alfaro's life. His performance uses highly energetic, corporealized oral poetry that exemplifies the theatrical qualities of performance art in recent years (e.g. lyricism, spectacle, and persona). He views his work as a way of giving voice to the disenfranchised Latino gay community.

Laure Drogoul produces *The Workshop of Filthy Creation (Victor's Workshop)* at the **Baltimore Theater Project**. Inspired by a line from Mary Shelly's *Frankenstein*, the work is a series of vignettes about contemporary monstrosities from a biological and social perspective. Drogoul is founder (in 1989) of **The 14 Karat Cabaret** at **Maryland Art Place**, Baltimore.

National Endowment for the Arts grants awarded to **Karen Finley**, **John Fleck**, **Holly Hughes**, and **Tim Miller** are rescinded by Endowment Chair **John Frohnmayer**, following complaints by Senator **Jesse Helms**. Finley, whose intense and vociferous performances lash out against injustices, especially toward women, becomes a central iconic figure in the ensuing battles between Congress, the NEA, and the artists who fight to maintain freedom of expression within the realm of federal grants.

Rirkrit Tiravanija installs *Untitled (Blind)* at the **Randy Alexander Gallery**, New York. The work consists of three pairs of binoculars, set on the gallery's windowsill, and packages arranged in a grid on the gallery floor. The packages contain tapes made with a voice-activated recorder which Tiravanija carries with him throughout the duration of the exhibition. The arrangement of the packages is left to the discretion of the gallery, which acknowledges the role performed by the postman who delivers the parcels every few days. The postman is asked to select a number to determine the position of each package within a grid of squares on the floor. The packages remain unopened at the artist's direction.

Jimmie Durham, a former activist in the **American Indian Movement**, performs *Crazy for Life* in *The Decade Show*, organized by the **Museum of Contemporary**

Hispanic Art, The New Museum of Contemporary Art, and **The Studio Museum in Harlem**. Durham sees his work as part of his on-going struggle of sedition and resistance and uses it to critique the dominant culture's portrayal, regard, and consumption of Native American culture and identity. Employing techniques that are Native American as well as avant-garde (shifting identities and territories, unlikely juxtapositions, contradiction, and sometimes self-deprecating humor), Durham challenges the identification of Native Americans with otherness, redresses and investigates their "official" history, and attempts to subvert and break out of colonialist limitations.

During an exhibition at the **Pat Hearn Gallery**, New York, **Gretchen Faust** periodically performs a piece which consists of standing on a stool under a white cloth and pushing its rim outwards with a pole, in an interminable attempt to lay out a complete circle. This spare image of a ghostly, draped figure reflects her interest in counteracting the identification of art as a commodity. In its suggestion of a holy vestment, it alludes to Faust's interest in religious models, which in her own words:

> ...satisfy the human need for control and discipline...I am interested
> in an activity not limited to pure painterly, sculptural or formal
> concerns, and participate in an active investigation into the commu-
> nication and construction of ideas: a secular ontology.

On four different days and in four different locations, **Ben Kinmont** and three other performers wear jump suits with *I am for You* written on their backs, and hand out flyers that begin with "We are the Social Sculpture. This is the Third Sculpture. You are the Thinking Sculpture," followed by explanatory text. Each flyer emphasizes a different aspect. The performers talk to passersby and answer questions. Responses recorded by Kinmont range from "Am I a sculpture?" and "You will go to Hell!" to one instance where a Tiffany's employee tries to have them arrested for handing out flyers in front of the elite store. Kinmont's use of the term "Social Sculpture" is a direct reference to **Joseph Beuys**, yet the intent of Kinmont's public actions contrasts with Beuys's shamanistic posture. The concept behind *I am for You* is the idea that every person is an artist by virtue of how each of us takes in various stimuli and, based on these stimuli, makes decisions to act and, therefore, create.

For *The Buffalo Project*, **Robbie McCauley** works with local theater workers in Buffalo, New York, to create a "performance dialogue" about the city's 1967 riots. Based on interviews that the performers do with blacks and whites around the city, and on their own responses to these interviews, the piece exposes the fear, shame, and denial underlying years of silence among those who lived through the disturbances. McCauley says in the piece, "We don't know enough about history. That's why the rage lives in our bones." The show plays to sold-out houses in various locations around the city. McCauley goes on to create two other site-specific pieces involving community collaboration, *The Mississippi Project* (1992) and *The Boston Project* (1993). The former is concerned with the voting rights and civil rights struggles, and the latter with busing in the city of Boston.

Penny Arcade's *Bitch!Dike!Fag!Hag!Whore!* premieres at **P.S. 122** as a 4-day work-in-progress for her NEA Solo Fellowship during the Helms/NEA crisis. This controversial piece, which affectionately portrays characters in the sex industry and porn world, becomes so widely renowned that it is eventually expanded and moved to the **Village Gate**, in New York's Greenwich Village, for a one-year run.

1991

William Pope.L produces *The Aunt Jenny Chronicles* at **Performance Space 122**. According to the artist:

> My work is an exploration of the space where black disenfranchise-
> ment, sexuality and consumerism intersect. Some major influences
> are urban street-culture, Body Art, rock n' roll, and literature and
> various language philosophies...In performance, my goal is to re-
> enact the 'conundrum' consciousness which is the American
> experience...a plenitude at war with itself; a continual clash of hope,
> desire and fear. My body, in the performance is the locus for these
> forces...by juxtaposing it to danger by singing in the gutter or by
> annexing it to unpopular issues by ranting naked in a gallery...The
> solo-body is the living representation of societal forces at work in the
> world-body...The Black body (my body) is an excellent site, a
> wonderful distorting-mirror for this exploration because it repre-
> sents, simultaneously, in our culture, both a huge hunger and great
> lack."

Judith Alexa Jackson performs *WOMBman WARs*, a one-woman comedy inspired by the "high-tech lynching" of Anita Hill by the media, the Senate Judiciary Committee, and Judge Clarence Thomas. Integrating masks, dance, mime, video, canned sound, and bare-blade satire, Jackson examines the myths and realities of the age-old gender battle in a contemporary context. Through the fictional character Anima Animus, this political satirist has found a vehicle to explore the yin and yang contradictions of metaphysical being.

Phil Simkin creates the participatory installation *a tissue to "C," fishin' for Wittysch/SM's* in the duck pond at **Snug Harbor Cultural Center**, Staten Island, New York. The work is designed to poke fun at the tendency of critics and historians to categorize art into "isms" and "ists." It uses physical play and word play to lighten, enliven, and twist the discourse on art. Participants, provided with fishing poles, walk onto an M-shaped dock to fish for plastic ducks containing random "isms."

Jacki Apple initiates *The Culture of Disappearance Project* in the form of an audio performance for broadcast space. Subsequently, the project is realized as a series of installation/performance works in which the viewer is provided with an environment in which to meditate on the impermanence of being and the environmental crisis of the planet.

Ann Hamilton creates *indigo blue* for the exhibition *Places with a Past*, organized by **Mary Jane Jacob** for the *Spoleto Festival U.S.A.* in Charleston, South Carolina. The exhibition of public work sited throughout the city uses the history of Charleston as its subject. For example, Hamilton's installation at **Mike's Garage** features a 14,000-pound pile of men's blue work shirts, which have been laundered and neatly folded under her supervision. Throughout the exhibition she or another person sit at a desk behind the mountain of shirts silently erasing the contents of old history books. The work is a monument to the men who wore the shirts and the women who laundered them, and suggests a re-writing of history on the cleared pages of working-class peoples.

1992

A federal judge in Los Angeles rejects the so-called decency law by means of which the **National Endowment for the Arts** denied grants to **Karen Finley**, **John Fleck**, **Holly Hughes**, and **Tim Miller**. The law had been enacted in 1990 in a compromise

effort to extend the life of the NEA, which some members of Congress tried to abolish under pressure from their conservative and fundamentalist constituents.

At *The Art Mall: A Social Space*, in **The New Museum of Contemporary Art**, the **National Civil Rights Museum**, Memphis, and on the streets of Manhattan, **Danny Tisdale** performs *Transitions, Inc.* Tisdale creates a fictitious company that offers services to eliminate physical and stylistic cultural differences, to provoke public discussion of conformity, and to challenge prevailing ideas of race assimilation, appropriation, and ideals of success.

Guillermo Gómez-Peña and **Coco Fusco** collaborate with **Nancy Lytle, Stephen Erikson**, and visual artists **Maria Magdalena Campos, Enrique Chagoya, Richard Lou, Inigo Manglano-Ovalle, Pepón Osorio, Leonard Peltier, Alfred Quiroz, Angel Rodriguez-Diaz, Maruca Salazar, Robert Sanchez**, and **Ernest Whiteman** to create *Year of the White Bear*, an international, interdisciplinary arts project involving performance, multimedia installation, radio art, visual arts, a book, and a brochure. The project interrogates and criticizes the official celebration of the Quincentenary of the United States.

In **Norman Durkee's** performance *Pattern Recognition*, presented by **On the Boards**, each seat is wired with audio headphones and special L.E.D. glasses, which the audience wears as they "watch" the performance with their eyes closed.

The Hittite Empire, a California-based African-American male experimental theater collective, performs *In My Living Condition* at the **Walker Art Center**. The performance resurrects the images and thoughts that occurred during the Los Angeles riots and examines the plight of African-American men.

Janine Antoni soaks her hair in hair dye and mops the floor of **Art Awareness** in Lexington, New York, in a performance entitled *Loving Care* (repeated in several other galleries). This piece and others employ materials such as lipstick, chocolate, and mascara, which are considered by an earlier generation of feminists to be emblems of control. By using these ubiquitous materials, accessories, and gestures in systematic, albeit obsessive, actions she turns the feminist critique inside-out to explore a complex of associations.

Guillermo Gómez-Peña and **Keith Antar Mason** perform their collaborative work *Mano a Mano* (Hand to Hand) at the **Nexus Contemporary Art Center**, Atlanta. They had been performing *Mano a Mano* since the mid-1980s as an ever-changing exploration of multiculturalism and ongoing search for new formats for their material.

Survival Research Laboratories veteran **Matt Heckert** performs with his *Mechanical Sound Orchestra* at the **University Art Museum**, Berkeley. Heckert creates an installation of computer-controlled, mechanical sound sculptures in the Museum's central atrium. Distinguishing himself from predecessors such as **Jean Tinguely**, **Naum Gabo, James Seawright**, or other artists who experimented with kinetic or performative, robotic sculpture, Heckert has been concerned equally with the sculptural, gestural, and musical qualities of his sound machines.

Paul Dresher Ensemble's *Slow Fire* features **Rinde Eckert** in a solo performance as a man caught in the psychosis of modern society. Presented at the **Nexus Contemporary Art Center**, Atlanta, the performance employs samplers, computers, and real-time interactive electronics together with opera, music, narrative, and lighting effects.

In an installation entitled *No Radio* at the **Pat Hearn Gallery**, New York, **Gretchen Faust** and **Kevin Warren** create a situation in which the viewer is invited to sit in a chair facing a wall and gaze until the wall itself changes into "pure perception of ever-changing light." Faust and Warren write, "there is nothing of value in this show because each viewer already possesses the content of each work."

At the **Institute for Contemporary Art**, Boston, **Betsy Salkind** performs *All My Life*, a comedic self-portrait that exposes societal expectations of children during the 1960s, when she was growing up. The work strikes out at the dysfunctional family.

Art Attack performs *2:1 McCarren Park Pool Project* in New York. It is a collaboration among **Steven Bennett, Lynn McCary, Evan Hughes, Alberto Gaitan, Noel Clarke, Adegboyega Adefope, Susi Schropp**, and **Isaac Racine**. The 10-minute performance uses fireworks to bring to life an abandoned swimming pool.

At the **Mincher/Wilcox Gallery** in San Francisco, **Nayland Blake** spends the duration of the exhibition in the gallery selling his "time," documented on video for $250/hour, or multiples ($250 each or seven for $1,500) made on the spot from

commodities purchased at K-mart, Walgreens, and a local porno store. One hour of the artist's time consists of Blake, dressed in a bunny suit, bound, gagged, and tied to a plastic-leafed and rose-decked bower. The multiples include such items as a "batch of fudge packed by the artist," a shelf of hair products and over-the-counter health and beauty potions, a romantic quotation from Victor Hugo silkscreened onto a T-shirt, and a personalized pornographic novel. All of Blake's work draws from gay culture but is not simply about the gay experience. Like early Dada and Surrealist artists, his work is replete with sexual imagery. His installations and performances implicate the viewer as an extricable participant.

Tim Collins performs *Elevation* at the **Headlands Center for the Arts**, Sausalito, California. Collins sits on one end of a 16-foot beam balanced 8 feet out a third-story window, weighted on the opposite end by a 22-gallon vessel which is leaking. The piece, in Collins's words, refers to "...balancing basic needs with creative aspirations...the mental balance that would drive an individual to sit on a beam outside a third floor window...the balance between the elemental forces of life both within and outside the body..."

John Cage dies.

1993

At the **Cleveland Performance Art Festival, Ping Chong** premieres *Undesirable Elements.* Performers are seven individuals from the community who represent eight cultures and a variety of ages, genders, and professions, but share the common trait of having been born in one culture and now find themselves part of another, that of the United States.

Pat Oleszko presents *Nora's Art* at the **Walkers Point Center for the Arts**, Milwaukee, and subsequently in New York and San Francisco. The work continues Oleszko's 20-year legacy of performances in wild costumes and inflatables inspired by vernacular and popular forms such as the circus and parades. While Oleszko's art of overstated visual and verbal punning is always entertaining, its humor is underscored by social commentary.

Ulysses Jenkins performs *Videophone Transmission to the Telluride Institute*, at **Headlands Center for the Arts**.

At **Real Art Ways**, Hartford, **David Cale** performs a collection of 12 monologues. Drawn from the experiences of disparate men and women, they portray incidents that have haunted them throughout their lives.

Kazuo Ohno, one of the founders of Butoh—a highly minimalist dance genre that evolved in Japan after World War II—performs *Water Lilies* at the **Walker Art Center**. An octogenarian, Ohno dances exuberantly and passionately, depicting the male and female, as well as the young and old, in everyone.

Kain Karawahn of Berlin performs *Why Don't Cities Have Forest Fires?* at **Cleveland State University's** downtown campus, as part of the sixth **Cleveland Performance Art Festival**. Using video projection, a sound score by **Rolf Baumgart**, and fire, the artist stages a pyrotechnical environment that serves as a metaphor for conditions in American inner cities and proposes the radical solution of burning as a way to correct them. Karawahn sees fire as a healthy stage in a natural regenerative process.

Performance artist **Annie Sprinkle** brings her *Post Post Porn Modernist* show to **Real Art Ways**, Hartford. Part monologue, part photo session, Sprinkle's one-woman show is the story of her life, how she went from nice middle-class girl to prostitute, porn star, and performance artist. Sprinkle uses her performances as an occasion to pass on carnal knowledge. Sometimes she stages what she calls "Public Cervix Announcements," inviting members of the audience to peer through a speculum at her cervix.

Mexican-born artist **Astrid Hadad** performs two pieces, *Treaty of the Nun* and *Return of Heavy Nopal (Heavy Cactus)*, at **Nexus Contemporary Art Center**, Atlanta. In these performances she explores the archetypes and myths of her native Mexico.

The **National Endowment for the Arts** agrees to settle out of court and pay $252,000 to **Karen Finley, John Fleck, Holly Hughes,** and **Tim Miller,** who accused NEA Chair **John Frohnmayer** of rejecting their grant applications on political, rather than on artistic, grounds.

In New York, French artist **Orlan** performs *Omnipresence*, the seventh in a series of "intervention-performances," plastic-surgery operations designed to reincarnate Orlan into a combination of five art-historical figures: Venus (chin), Diana (eyes), Europa (lips), Psyche (nose), and the Mona Lisa (forehead).

TIMELINE PLATES

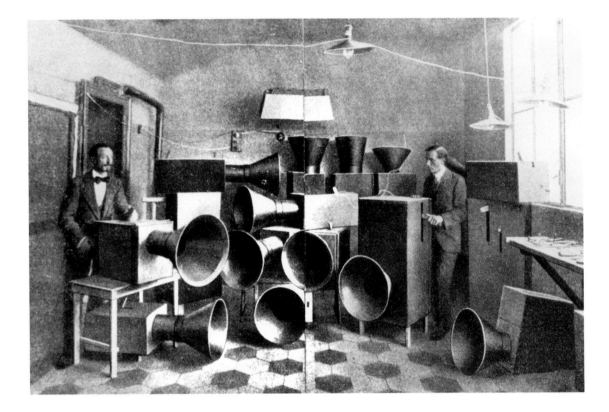

Luigi Russolo and (his assistant) Piatti
Intonarumori, (noise organ), 1913
From *Art of Noises Manifesto*

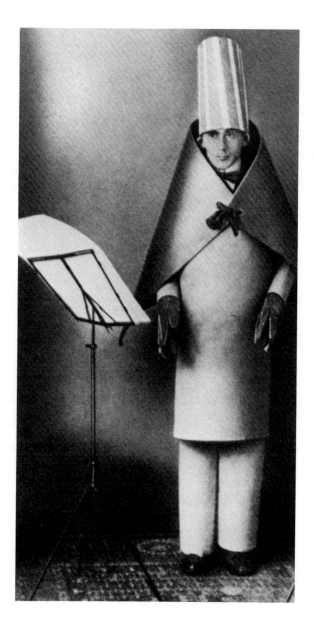

Hugo Ball
Karawane, 1916
Sound poem, recital at *Cabaret Voltaire,* Zurich

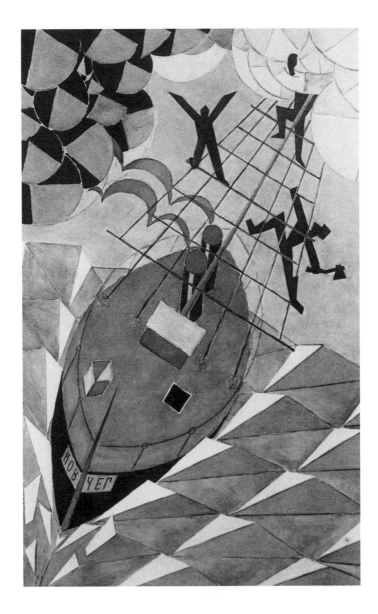

Kazimir Malevich
Set design for *Mystery Bouffe*, 1918
by Vladimir Maiakovsky
staged by Vsevolod Meierkhold at Petrograd Conservatory

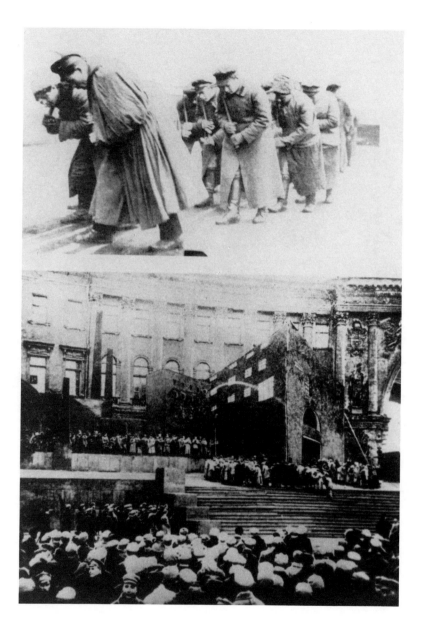

Nikolai Evreinov
The Storming of the Winter Palace, re-enactment, 1920
Sets by Yurii Annenkov, Urisky Square, Moscow

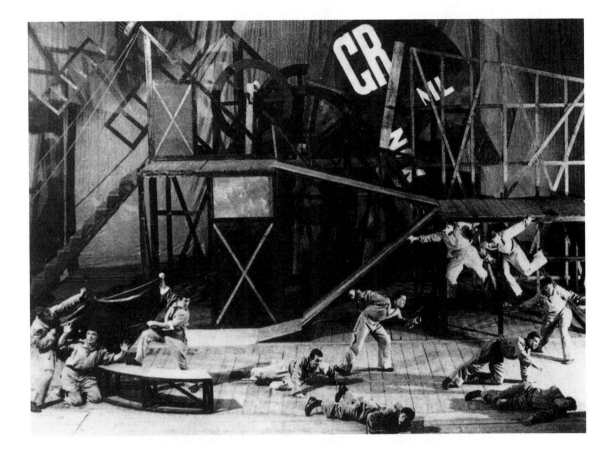

Vsevolod Meierkhold
The Magnanimous Cuckhold, 1922
Sets by Liubov Popova

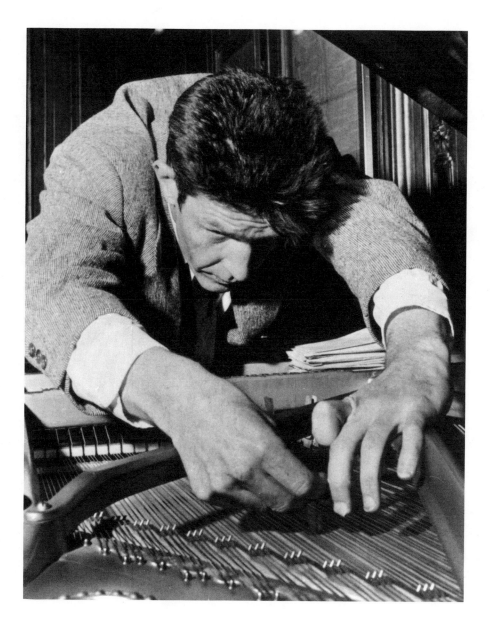

John Cage
Preparing a Piano, pre-1950
Courtesy of Cunningham Dance Foundation

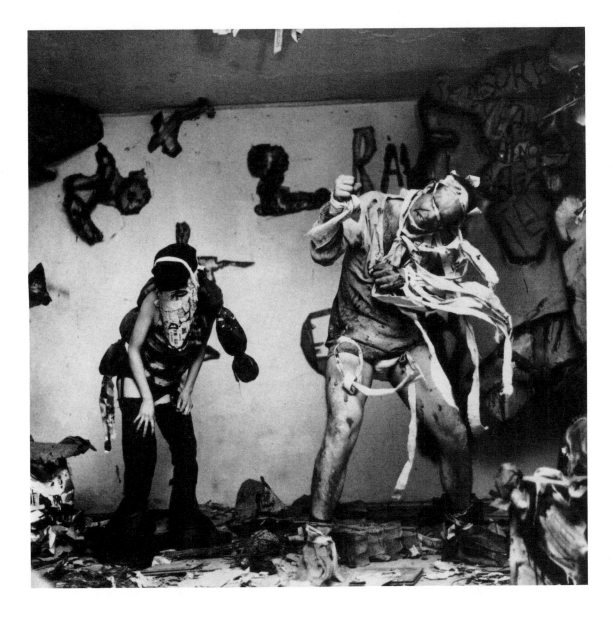

Claes Oldenberg
Snapshots from the City, 1960
The Judson Gallery, New York
Photograph: © Martha Holmes, courtesy of Judson Memorial Church

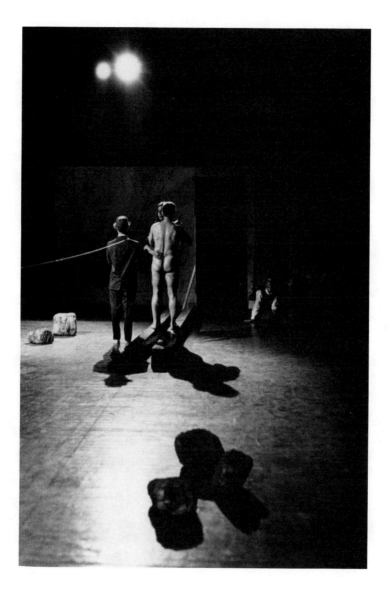

Robert Morris
Waterman Switch, 1965
Performed by Morris, Lucinda Childs, and Yvonne Rainer
Judson Memorial Church, New York
Photograph: © Peter Moore

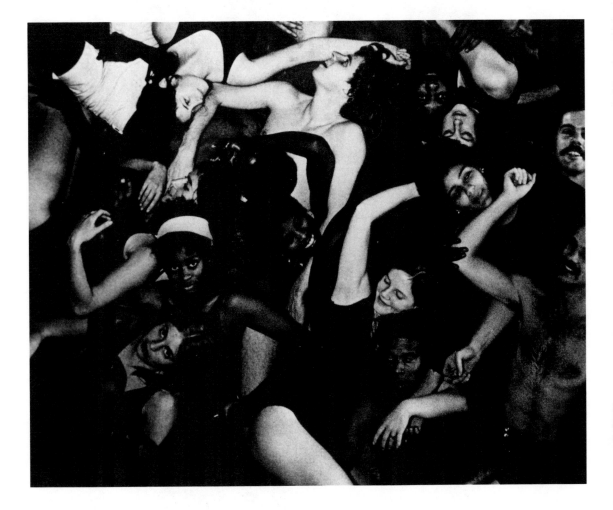

Anna Halprin and Dancers' Workshop

Ceremony of Us, 1969

Photograph: Susan Lander

Adrian Piper
Untitled, 1970
Photographic documentation of performance for Max's Kansas City, New York
Courtesy of the Artist and John Weber Gallery

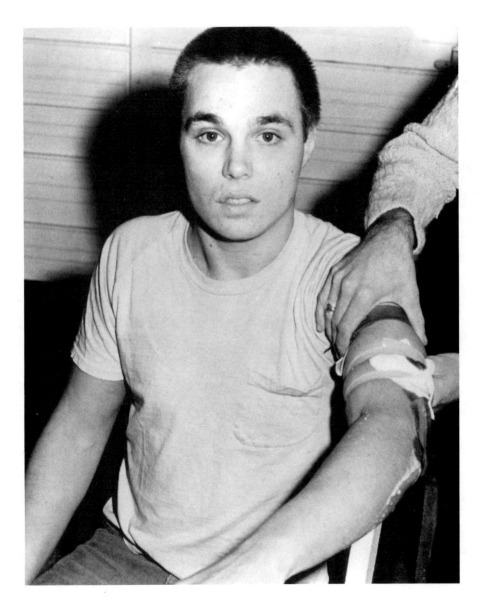

Chris Burden
Shoot, 1971
F Space, Irvine, CA
Photograph: courtesy of the Artist

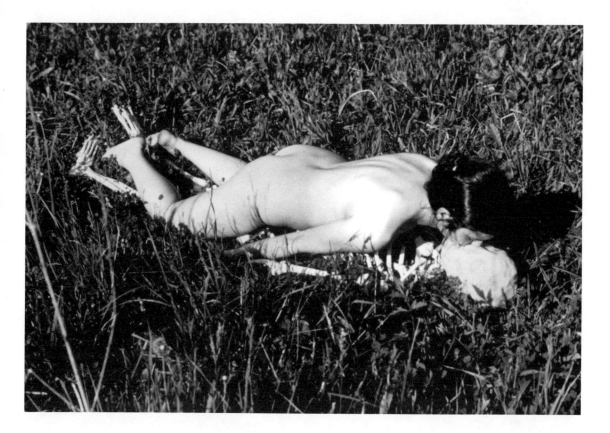

Ana Mendieta
Untitled, 1972
Photographic documentation of performance in Iowa
Photograph: courtesy Galerie Lelong, New York

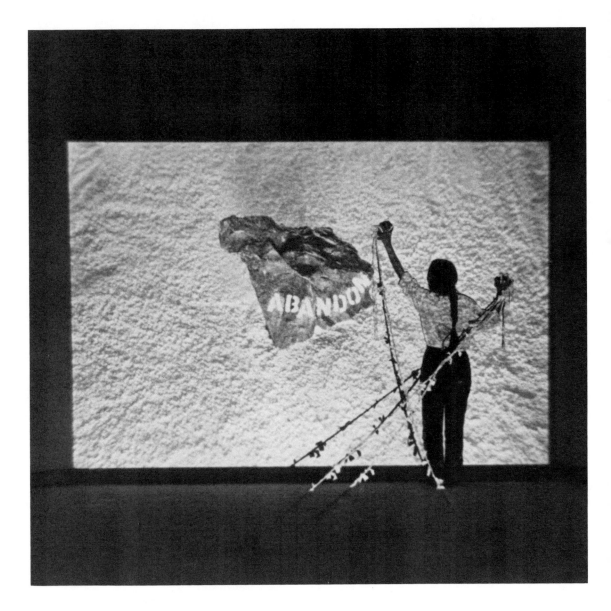

Theresa Hak Kyung Cha
Other Things Seen, Other Things Heard (Ailleurs), 1978
San Francisco Museum of Modern Art
Courtesy of Lynn Hershman and the Floating Museum

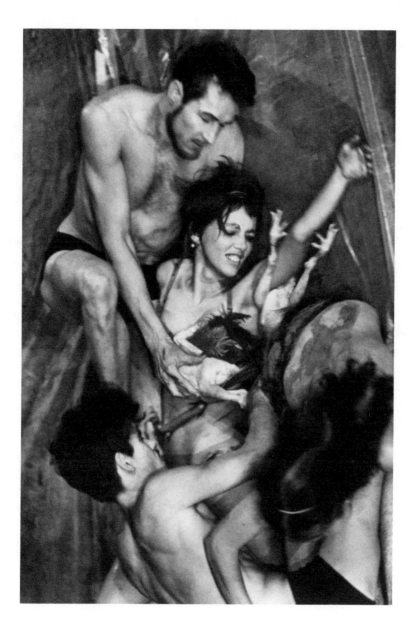

Carolee Schneeman
Meat Joy, 1979
Photograph: Al Giese

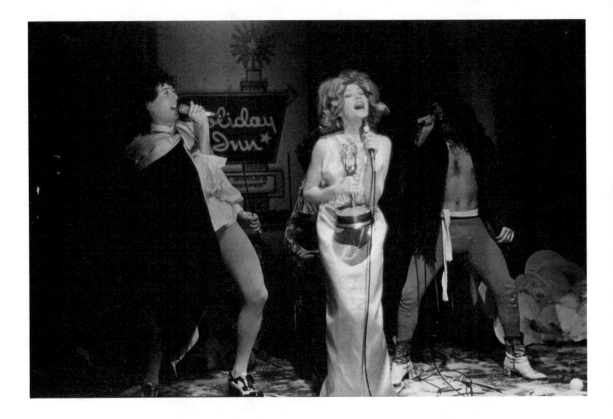

Ann Magnuson
Christmas Special, from *Tammy gets an Emmy,* 1981
The Kitchen, New York
Photograph: Paula Court

Christian Marclay with Yoshiko Chuma
Untitled, 1982
Photographic documentation of performance at Danceteria, New York
Photograph: Jacob Burckhardt

Tehching Hsieh and Linda Montano
One Year Performance, 1983
Photographic documentation of performance
Photograph: Ellen Jaffe

Laurie Anderson
United States, 1983
Photograph: Marcia Resnick

Robbie McCauley
My Father and the Wars, 1985
Franklin Furnace, New York
Photograph: the Artist and Franklin Furnace

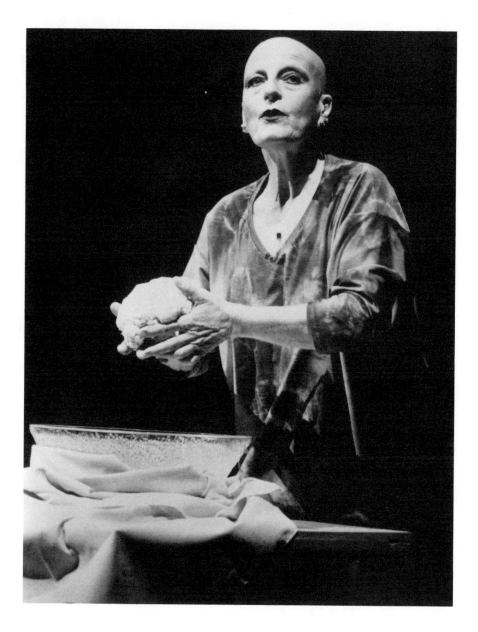

Rachel Rosenthal
Rachel's Brain, 1989
Photograph: Jan Deen

Selected Bibliography

Appignanesi, Lisa. *The Cabaret*. New York: Universe Books, 1976.

Auslander, Philip. *Presence and Resistance: Postmodernism and Cultural Politics in Contemporary American Performance*. Ann Arbor, MI: University of Michigan Press, 1992.

Avalanche, issues 1–12 (1970–1976), New York.

Banes, Sally. *Greenwich Village 1963: Avant-Garde Performance and the Effervescent Body*. Durham, NC, and London: Duke University Press, 1993.

Barber, Bruce. "Indexing and Its Heretical Equivalents." *Performance by Artists*. Edited by A. A. Bronson and Peggy Gale. Toronto: Art Metropole, 1979.

Battcock, Gregory and Robert Nicklas. *The Art of Performance: a Critical Anthology*. New York: E. P. Dutton, 1984.

Birringer, Johannes H. *Theater, Theory and Postmodernism*. Bloomington, IN: Indiana University Press, 1991.

Burnham, Linda Frye. "High Performance: Performance Art and Me." *The Drama Review* 30(1) (T109) (Spring 1986).

Carr, C. *On Edge: Performance at the End of the Twentieth Century*. Hanover, NH: Wesleyan University Press, 1993.

Elliot, James. *The Perfect Thought: An Exhibition of Works by James Lee Byars*. Berkeley, CA: University Art Museum, 1990.

Fairbrother, Trevor. *Robert Wilson's Vision*. Boston: Museum of Fine Arts (in association with Harry N. Abrams, New York), 1991.

Foley, Suzanne. *SPACE TIME SOUND Conceptual Art in the San Francisco Bay Area: The 70's*. San Francisco: San Francisco Museum of Modern Art, 1981.

Goldberg, Roselee. *Performance Art: From Futurism to the Present*. New York: Harry N. Abrams, 1988.

Gómez-Peña, Guillermo. *Warrior for Gringostroika*. Introduction by Roger Bartra. Saint Paul, MN: Graywolf Press, 1993.

Harris, Mary Emma. *The Arts at Black Mountain College*. Cambridge, MA: The MIT Press, 1987.

Haslam, Malcolm. *The Real World of the Surrealists*. New York: Gallery Press, 1978.

Herbert, Robert L., ed. *Modern Artists on Art: Ten Unabridged Essays*. Englewood Cliffs, NJ: Prentice-Hall, 1964.

Huelsenbeck, Richard. *Memoirs of a Dada Drummer*. Edited by Hans J. Kleinschmidt; foreword by Rudolf E. Kuenzli; translated by Joachim Neugroschel. New York: Viking Press, 1974.

Johnston, Jill. "Hardship Art." *Art in America* (September 1984).

Jonas, Joan. *Joan Jonas Scripts and Descriptions*. Edited by Douglas Crimp. Berkeley, CA: University Art Museum and the Stedelijk van Abbemuseum, Eindhoven, The Netherlands,1983.

Kaprow, Allan. *Assemblage, Environments & Happenings*. New York: Harry N. Abrams, 1966.

Kardon, Janet. *Laurie Anderson: Works from 1969 to 1983*. Exhibition catalogue. Philadelphia: Institute of Contemporary Art, University of Pennsylvania, 1983.

Kirby, Michael. *Happenings: An Illustrated Anthology*. New York: E. P. Dutton, 1965.

Kirby, Michael. *The Art of Time: Essays on the Avant-Garde*. New York: E. P. Dutton, 1969.

Kirby, Michael. *Futurist Performance*. New York: E. P. Dutton, 1971.

Kostelanetz, Richard. *Theatre of Mixed Means: An Introduction to Happenings, Kinetic Environments and Other Mixed-Means Performances*. New York: RK Editions, 1980.

Kuenzli, Rudolf E. *New York Dada*. New York: Willis, Locker & Owens, 1986.

Lippard, Lucy. *Six Years: The Dematerialization of the Art Object from 1966 to 1972*. New York and Washington, DC: Praeger Publishers, 1973.

Lippard, Lucy. *Mixed Blessings: New Art in a Multicultural America*. New York: Pantheon Books, 1990.

Loeffler, Carl E. and Darlene Tong, eds. *Performance Anthology: Source Book for a Decade of California Performance Art*. San Francisco: Last Gasp Press and Contemporary Arts Press, 1989.

McCormick, Carlo. "Yoko Ono Solo." *Artforum* (February 1989).

McEvilley, Thomas. "Art in the Dark." *Artforum* (Summer 1983).

Montano, Linda. *Art in Everyday Life*. Los Angeles: Astro Artz (in association with Station Hill Press), 1981.

Moore, Alan and Marc Miller, eds. *ABC No Rio Dinero: The Story of a Lower East Side Art Gallery*. New York: ABC No Rio with Collaborative Project, 1985.

Motherwell, Robert, ed. *The Dada Painters and Poets: An Anthology*. Critical bibliography by Bernard Karpel. Cambridge, MA: Belknap Press of Harvard University Press, 1981.

Nadeau, Maurice. *The History of Surrealism*. Translated by Richard Howard; introduction by Roger Shattuck. Cambridge, MA: Belknap Press of Harvard University Press, 1989.

Onorato, Ronald. *Vito Acconci: Domestic Trappings*. Exhibition catalogue. La Jolla, CA: La Jolla Museum of Contemporary Art, 1987.

Phelan, Peggy. *Unmarked: The Politics of Performance*. New York: Routledge, 1993.

Polcari, Stephen. *Abstract Expressionism and the Modern Experience*. Cambridge, MA, and New York: Press Syndicate of the University of Cambridge, 1991.

Roth, Moira. "Toward a History of California Performance: Parts One and Two." *Arts* (February and April 1978).

Roth, Moira, ed. *The Amazing Decade: Women and Performance Art in America 1970-1980*. With Mary Jane Jacob, Janet Burdick, and Alice Dubiel. Los Angeles: Astro Artz, 1983.

Sayre, Henry. *The Object of Performance: The American Avant-Garde Since 1970*. Chicago: University of Chicago Press, 1989.

Schechner, Richard. *Performance Theory*. New York: Routledge, 1988.

Schimmel, Paul. *Chris Burden: A Twenty-Year Survey*. Exhibition catalogue. Newport Beach, CA: Newport Harbor Art Museum, 1988.

Schneemann, Carolee. *More Than Meat Joy: Complete Performance Works and Selected Writings*. New Paltz, NY: Documentext, 1979.

Segel, Harold B. *Turn-of-the-Century Cabaret*: Paris, Barcelona, Berlin, Munich, Vienna, Cracow, Moscow, St. Petersburg, Zurich. New York: Columbia University Press, 1987.

Shattuck, Roger. *The Banquet Years: The Origins of the Avant-Garde in France 1885 to World War I*. New York: Random House, 1955, 1957, 1958, 1968.

Stern, Carol Simpson and Bruce Henderson. *Performance Texts and Contexts*. White Plains, NY: Longman Publishing Group, 1993.

Stiles, Kristine. "Between Water and Stone." *In the Spirit of Fluxus*. Edited by Janet Jenkins. Minneapolis: Walker Art Center, 1993.

Sundell, Nina. *Rauschenberg/Performance 1954-1984*. Cleveland: Cleveland Center for Contemporary Art, 1983.

Tiffany, Dana. "Jarry's Inner Circle and the Public Debut to Père Ubu." *Event Arts and Art Events*. Edited by Stephen C. Forster. Ann Arbor, MI and London: UMI Research Press, 1987.

Tucker, Marcia. *Choices: Making an Art of Everyday Life*. New York: New Museum of Contemporary Art, 1986.

Checklist

All dimensions are given in inches.

Vito Acconci
Fitting Rooms (Revised), 1972/1987
Wood, chalk, steel, mirror, masks, hardware, and balls
84 x 96 x 96
Courtesy of Barbara Gladstone Gallery, New York

Laurie Anderson
Handphone Table, 1978
Wood, electronics, tape, and photograph
Table: 34 x 23 x 37
Photograph: 41 x 31
Courtesy of the Artist

Eleanor Antin
The Double, 1986
Mixed media
Dimensions variable
Courtesy of Ronald Feldman Fine Arts, Inc., New York

Janine Antoni
Eureka, 1993
Bathtub, lard, and soap
Tub and lard: 30 x 70 x 25
Soap: 22 x 26 x 26
Rubell Family Collections

Jacki Apple
The Culture of Disappearance, 1994
Mixed media with audio
Dimensions variable
Courtesy of the Artist

Nayland Blake
Untitled, 1993
Nylon and steel
78½ x 25 x 14
Des Moines Art Center Permanent Collection
Purchased with funds from the Edmundson Art Foundation, Inc.

Bread and Puppet Theater/Peter Schumann
Ex Voto for Bosnia, 1993
Cardboard, papier-mache, burlap, and acrylic paint
Dimensions variable
Courtesy of the Artist

George Brecht
Scores for Events
Enlarged facsimiles of original scores
Collection of Gilbert and Lila Silverman/Fluxus Collection Foundation

Chris Burden
The Hard Push, 1983
Photomural on masonite
Wheel: 48 x 112 diameter; photomural: 24 x 40
Courtesy of the Artist

Chris Burden
Through the Night Softly (Residual glass fragments from performance 12 September 1973), 1973
Glass shards and plexiglass box
5¾ x 8¾ x 8¼
Collection Wexner Center for the Arts, The Ohio State University
Purchased in part with funds from the National Endowment for the Arts, 1979.09

Chris Burden
Through the Night Softly: TV tapes with explanation (performance 12 September 1973), 1979
Videotape — ¾" black-and-white, 5 minutes
Collection Wexner Center for the Arts, The Ohio State University
Purchased in part with funds from the National Endowment for the Arts, 1979.10

James Lee Byers
The Book of the Hundred Questions, 1969
Golden print on tissue paper
19¼ x 14¼
Courtesy of Michael Werner Gallery, New York and Cologne

James Lee Byers
IS, 1989
Marble sphere, gilded
23¼ diameter
Courtesy of Michael Werner Gallery, New York and Cologne

John Cage
Excerpt from score for *Concert for Piano and Orchestra*, 1958
Enlarged facsimile of original score
Dimensions variable
© 1960 by Henmar Press Inc.
Reproduced by permission of C.F. Peters Corporation

Jimmie Durham
Fire! or Imperialism!, 1994
Mixed media
Dimensions variable
Courtesy of the Artist

Gretchen Faust and **Kevin Warren**
Instrument for Listening and Talking, 1993-94
Cushion and tube
Dimensions variable
Courtesy of the Artists and Pat Hearn Gallery, New York

Karen Finley
Black Sheep, 1990
Cast bronze
2 pieces each 40 x 24
Collection of John L. Stewart, New York

Terry Fox
Experiment in Autosuggestion, 1973/1993
Paper, string, lead weight, and text
12¼ x 12¼
Courtesy of the Artist

Coco Fusco and **Guillermo Gómez-Peña**, with **Jean Foos**
Guatinaui World Tour, 1993
Panel with text and photos
24 x 36
Courtesy of the Artists

Coco Fusco and **Guillermo Gómez-Peña**, with **Pepon Osorio**
La True Queen Isabela, 1991
Costume and wig
Dimensions variable
Courtesy of Coco Fusco and Pepon Osorio

Ann Hamilton
Untitled, 1993
30-minute video disc, LCD screen, and video disc player
Image: 3½ x 4½
Courtesy of Sean Kelly, Inc., New York

Ann Hamilton
Untitled, 1993
30-minute video disc, LCD screen, video disc player, and color-toned image
Image: 3½ x 4½
Courtesy of Sean Kelly, Inc., New York

Matt Heckert
No Head, 1987
Machine sculpture
48 x 36 x 36
Courtesy of the Artist

Geoffrey Hendricks
Body Hair: Relic box, 1971
Mixed media
Courtesy of the Artist

Geoffrey Hendricks
Body Hair, 1971
Photographic documentation of performance
Photographs by Valerie Herouvis
Courtesy of the Artist

Geoffrey Hendricks
Body Hair: Transcription of tape made by Artist for Greg
13 Xerox pages of text
Courtesy of the Artist

Geoffrey Hendricks
"Geoffrey Hendricks *Dream Event*"
Article from *New Wilderness Letter*
Special "Dream Work" Issue #10
Edited by Barbara Einsig, December 3-5, 1971
Courtesy of the Artist

Geoffrey Hendricks
Dream Event, 1971
Photographic documentation of performance
Photographs by Valerie Herouvis
Courtesy of the Artist

Geoffrey Hendricks
Dream Event: Folder of Old Dreams from 1958-1970, 1971
Manila file folder containing a flier for the event and 63 pages of dreams dating from
1958–1970
Courtesy of the Artist

Geoffrey Hendricks and **Peter Moore**
Flux Divorce Album, 1972
Uncut version with variant album cover
Mixed media
Photographs © Peter Moore
Courtesy of Geoffrey Hendricks

Geoffrey Hendricks
Flux Divorce Box, 1973
Assemblage
16 x 20 x 4
The Resource Collections of The Getty Center for the History of Art and the Humanities

Geoffrey Hendricks
Flux Divorce Invitations, 1971
Cards
3 x 5
Courtesy of the Artist

Geoffrey Hendricks
Flux Divorce: Fragment of double bed cut in half at the "Division of Property" and a saw, 1971
Mixed media
Courtesy of the Artist

Geoffrey Hendricks
Ring Piece, 1971
Photographic documentation of performance at the 8th Annual Avant Garde Festival
69th Regiment Armory, New York City
Photograph by Fred McDarrah
Courtesy of the Artist

Geoffrey Hendricks
Ring Piece: The Journey of a Twelve Hour Silent Meditation, 1973
Hard cover books with plastic cover; Editions 88/100 and 97/100
Soft cover book
Something Else Press, Barton, Vermont
Courtesy of the Artist

Anna Homler
Pharmacia Poetica, 1987-94
Glass bottles with mixed media contents and shelves
Dimensions variable
Courtesy of the Artist

Joan Jonas
Performance relics from *Volcano Saga*, 1990
Mixed media
Dimensions variable
Courtesy of the Artist

Alison Knowles
Little Winter Moon's Younger Brother, 1990-92
48 objects and laminated tags with white floor circle
72 diameter
Courtesy of the Artist

Suzanne Lacy and **Carol Kumata**
Auto: On the Edge of Time — Children and Domestic Violence, 1994
Wall text, video, and car parts; Dimensions variable
Workshop and installation with The Center for the Prevention of Domestic
Violence, Cleveland
Courtesy of the Artists

Christian Marclay
Tape Fall, 1989
Sound installation
Wooden ladder, reel-to-reel tapedeck, magnetic recording tape
Courtesy the Artist and Tom Cugliani Gallery, New York

Paul McCarthy
Hollywood Halloween, 1978/1993
15 black and white photographs, Edition of 5
16 x 20 each photograph
Courtesy Luhring Augustine, New York

Ana Mendieta

Untitled from *Silueta Works in Iowa*, 1976-78

Color photograph - C-print (posthumous print)

20 x 13¼ (image size)

Courtesy of Galerie Lelong, New York, and the Estate of Ana Mendieta

Ana Mendieta

Untitled from *Silueta Works in Iowa*, 1976-78

Color photograph - C-print (posthumous print)

20 x 13¼ (image size)

Courtesy of Galerie Lelong, New York, and the Estate of Ana Mendieta

Ana Mendieta

Untitled from *Silueta Works in Mexico*, 1973-77

Color photograph - C-print (posthumous print)

20 x 13¼ (image size)

Courtesy of Galerie Lelong, New York, and the Estate of Ana Mendieta

Ana Mendieta

Untitled from *Silueta Works in Mexico*, 1973-77

Color photograph - C-print (posthumous print)

20 x 13¼ (image size)

Courtesy of Galerie Lelong, New York, and the Estate of Ana Mendieta

Ana Mendieta

Untitled from *Silueta Works in Mexico*, 1973-77

Color photograph - C-print (posthumous print)

20 x 13¼ (image size)

Courtesy of Galerie Lelong, New York, and the Estate of Ana Mendieta

Ana Mendieta

Untitled from *Silueta Works in Mexico*, 1973-77

Color photograph - C-print (posthumous print)

20 x 13¼ (image size)

Courtesy of Galerie Lelong, New York, and the Estate of Ana Mendieta

Meredith Monk
Silver Lake with Dolmen Music, 1980
Sound installation, *Dolmen Music* composed and performed by Meredith Monk, Monica
Solem, Andrea Goodman, Julius Eastmen, Robert Een, and Paul Langland.
Mylar, stones, chairs, tape recorder, headsets, and audio tape
28 x 236¼ x 157½
Courtesy of the Artist

Linda Montano
Postcard Tarot, 1994
Mixed media
Dimensions variable
Courtesy of the Artist

Bruce Nauman
Stamping in the Studio, 1968
Video (archively preserved)
Total of 60 minutes
Courtesy of the Artist and Video Data Bank

Bruce Nauman
Lip Sync, 1969
Video (archively preserved)
Total of 30 minutes
Courtesy of the Artist and Video Data Bank

Bruce Nauman
Wall Flash Floor Positions, 1968
Video (archively preserved)
Total of 60 minutes
Courtesy of the Artist and Video Data Bank

Bruce Nauman
Flesh to White to Black to Flesh, 1968
Video (archively preserved)
Total of 30 minutes
Courtesy of the Artist and Video Data Bank

Lorraine O'Grady
Mlle. Bourgeoise Noire, 1980
180 pairs of white gloves, beauty pageant sash, 1 pair long gloves,
cat-o'-nine-tail, and crown
Dimensions variable
Courtesy of the Artist

Lorraine O'Grady
Mlle. Bourgeoise Noire Goes to The New Museum, 1981
Cibachrome from original photograph by Coreen Simpson
40 x 30
Courtesy of the Artist

Claes Oldenburg
Dr. Coltello's Baggage, 1985
Balsa wood, canvas, and string, painted with latex
Dimensions variable
Collection of Sheila and Wally Weisman, Beverly Hills, California

Claes Oldenburg
Prototype for Coltello Guide Book, 1984
Wood, cloth, and styrofoam, painted with acrylic
2¾ x 5¼ x 9¾
Courtesy of Claes Oldenburg and Coosje van Bruggen

Claes Oldenburg and **Coosje van Bruggen**
Il Corso del Coltello Menu, 1985
Book-object
10½ x 6¼
Courtesy of the Artists

Claes Oldenburg, Frank O. Gehry, and **Coosje van Bruggen**
The Café from Il Corso del Coltello, 1985
Photographic documentation of performance
20 x 24
Courtesy of Claes Oldenburg and Coosje van Bruggen

Claes Oldenburg, Frank O. Gehry, and **Coosje van Bruggen**
The Knife/Ship from Il Corso del Coltello, 1985
Photographic documentation of performance
20 x 24
Courtesy of Claes Oldenburg and Coosje van Bruggen

Claes Oldenburg, Frank O. Gehry, and **Coosje van Bruggen**
Dr. Coltello, 1985
Photographic documentation of performance
24 x 20
Courtesy of Claes Oldenburg and Coosje van Bruggen

Claes Oldenburg, Frank O. Gehry, and **Coosje van Bruggen**
Frankie P. Toronto's Suit, 1985
Canvas, painted with latex
Pants: 35½ x 32; shirt: 28½ x 50; collar: 28½ x 38
Collection of Frank O. Gehry

Claes Oldenburg, Frank O. Gehry, and **Coosje van Bruggen**
Model for Frankie P. Toronto's Hat, 1985
Cardboard
9 x 20½ x 6
Courtesy of Claes Oldenburg and Coosje van Bruggen

Claes Oldenburg, Frank O. Gehry, and **Coosje van Bruggen**
Frankie P. Toronto (detail), 1985
Photographic documentation of performance
24 x 20
Courtesy of Claes Oldenburg and Coosje van Bruggen

Claes Oldenburg, Frank O. Gehry and **Coosje van Bruggen**
Georgia Sandbag's Book, with Dangling Punctuations, 1985
Canvas painted with latex; foam rubber, vinyl, leather, and felt pen
9½ x 13 (variable)
Courtesy of Claes Oldenburg and Coosje van Bruggen

Claes Oldenburg, Frank O. Gehry, and **Coosje van Bruggen**
Houseball with Porters, 1985
Photographic documentation of performance
24 x 20
Courtesy of Claes Oldenburg and Coosje van Bruggen

Claes Oldenburg and **Frank O. Gehry**
Umbrella, 1985-86
Handle by Oldenburg; top by Gehry
Polyurethane foam, wood, cardboard, and latex paint
48 x 28 x 30
Courtesy of Claes Oldenburg and Coosje van Bruggen

Pat Oleszko
Udder De Light, 1990
Costume, blower, and time delay unit
Costume: 7 x 48 x 48
Courtesy of the Artist

Yoko Ono
Body Piece, 1961 (drawn 1993)
Ink on Brystol vellum
9 x 6
Courtesy of the Artist

Yoko Ono
Hand Piece, 1961 (drawn 1993)
Ink on Brystol vellum
9 x 6
Courtesy of the Artist

Yoko Ono
Let's Piece I, 1960 (drawn 1993)
Ink on Brystol vellum
9 x 6
Courtesy of the Artist

Yoko Ono
Lighting Piece, 1955 (drawn 1993)
Ink on Brystol vellum
9 x 6
Courtesy of the Artist

Yoko Ono
Mending Piece, 1966-94
Table, chairs, text, cups, saucers, glue, needle, thread, and shelf
Dimensions variable
Courtesy of the Artist

Yoko Ono
Painting For The Wind, 1961 (drawn 1993)
Ink on Brystol vellum
9 x 5½
Courtesy of the Artist

Yoko Ono
Parallel Mending Piece, 1992 (drawn 1993)
Ink on Brystol vellum
9 x 5¼
Courtesy of the Artist

Yoko Ono
Pea Piece, 1960 (drawn 1993)
Ink on Brystol vellum
9 x 6
Courtesy of the Artist

Yoko Ono
Tape Piece III/Snow Piece, 1963 (drawn 1993)
Ink on Brystol vellum
9 x 6
Courtesy of the Artist

Raphael Montanez Ortiz
You Can't Make an Omelette without Breaking Some Eggs, 1993
Mixed media and video documentation
36 x 144 x 144
Courtesy of the Artist

Nam June Paik
TV Cello, 1971
3 video monitors, plexiglass, laser disc and player
Courtesy of the Artist

Nam June Paik
Charlotte Moorman's Mirror Dress, 1971
Plastic disks and metal
Courtesy of the Artist

Nam June Paik
Charlotte Moorman with Paik's TV Cello & Glasses, NYC '71, 1971
Photographic documentation of performance
14 x 11
Photograph © Peter Moore
Estate of Peter Moore; Barbara Moore, administrator

Adrian Piper
Cornered, 1988
Video installation with birth certificates, videotape, monitor, table, and chairs
Dimensions variable
Collection of Museum of Contemporary Art, Chicago,
Bernice and Kenneth Newberger Fund

William Pope.L
Rebuilding:..., 1993
Collage, paint, and ink on bags of manure
Dimensions variable
Courtesy of the Artist and Horodner Romley Gallery, New York

Liz Prince
Fit the Bill, 1989
Dollar bills, pennies, tulle, feathers, wire, beads, and talking "Teddy Ruxpin" doll
Headdress: 19 x 21 x 10; gown: 60 x 16 x 10
Courtesy of the Artist

Robert Rauschenburg
Pelican, 1965
Photographic documentation of performance
Photograph I: Alex Hay and Robert Rauschenberg
Photograph II: Alex Hay, Carolyn Brown, and Robert Rauschenberg
Photograph III: Robert Rauschenberg, Carolyn Brown, and Alex Hay
Photographs © Peter Moore
Estate of Peter Moore; Barbara Moore, administrator

Robert Rauschenburg
Map Room II, 1965
Photographic documentation of performance
Photograph I: Alex Hay, Deborah Hay, and Robert Rauschenberg
Photograph II: Deborah Hay
Photograph III: Deborah Hay, Alex Hay, and Steve Paxton
Photographs © Peter Moore
Estate of Peter Moore; Barbara Moore, administrator

Robert Rauschenburg
Linoleum, 1966
Photographic documentation of performance
Photograph I: Deborah Hay, Simone Forti, and Steve Paxton
Photograph II: Robert Rauschenberg, Simone Forti, Deborah Hay, and Alex Hay
Photographs © Harry Shunk
Collection of Harry Shunk, New York
Photograph III: National Roller Skating Rink, Washington, DC
Photograph © Peter Moore
Estate of Peter Moore; Barbara Moore, administrator

Carolee Schneemann
Venus Vectors, 1987–88
Acrylic panels, Kodaliths, paint, and video monitors
35 x 72 x 72
Courtesy of the Artist

Joyce Scott
Somebody's Baby, 1993
Beads, thread, rice, wire, and audio tape
approx. 40 x 20 x 22
Courtesy of the Artist

Stuart Sherman
Bowling, 1993
Bowling pins, oak flooring, and bowling balls
16¼ x 30½ x 85½
Courtesy of the Artist

Theodora Skipitares
Wheel of Power from *The Radiant City*, 1991
Steel, latex, and oil paint
144 x 132 x 36
Collection of Nirlilach

Jack Smith
Untitled, 1981
Leopard cap from costume and business card
Courtesy of The Institute for Contemporary Art/P.S. 1 Museum and
The Plaster Foundation

Jack Smith
Untitled 1981
Four handwritten rolodex cards
Courtesy of The Institute for Contemporary Art/P.S. 1 Museum and
The Plaster Foundation

Jack Smith
Untitled, 1981
Color photograph of Jack Smith wearing leopard costume
Courtesy of The Institute for Contemporary Art/P.S. 1 Museum and
The Plaster Foundation

Rirkrit Tiravanija
Untitled (Raw), 1994
Thai spices, vegetables, rice, and cooking utensils
Dimensions variable
Courtesy of the Artist

John White
Despertly Seeking, 1994
Mixed media
Dimensions variable
Courtesy of the Artist

Robert Whitman
Maquette for *Raincover*, 1993
Mixed media
Dimensions variable
Courtesy of the Artist

Hannah Wilke
So Help Me Hannah, 1978-84
Photographs and ray guns
Collection of Estate of Hannah Wilke
Courtesy of Ronald Feldman Fine Arts, Inc., New York

Robert Wilson
Danton's Death, 1992
Act II, Scene 1; Houston, Texas
Charcoal on Arches Cover paper
Sheet: 29½ x 41½; image: 27¼ x 40
Collection of Stanley T. Stairs, New York

Robert Wilson

Danton's Death, 1992
Act II, Scene 1; Houston, Texas
Charcoal on Arches Cover paper
Sheet: 29½ x 41½; image: 27¼ x 39½
Courtesy of Paula Cooper Gallery, New York

Robert Wilson

Danton's Death, 1992
Act II, Scene 7; Houston, Texas
Charcoal on Arches Cover paper
Sheet: 22 x 30; image: 20 x 28½
Courtesy of Paula Cooper Gallery, New York

Robert Wilson

Danton's Death, 1992
Act III, Scene 3; Houston, Texas
Charcoal on Arches Cover paper
Sheet: 22¼ x 30; image: 20¼ x 28¾
Courtesy of Paula Cooper Gallery, New York

Robert Wilson

Danton's Death, 1992
Act III, Scene 6; Houston, Texas
Charcoal on Arches Cover paper
Sheet: 22¼ x 30¼; image: 20½ x 28½
Courtesy of Paula Cooper Gallery, New York

Robert Wilson

Danton's Death, 1992
Act IV, Scene 5; Houston, Texas
Charcoal on Arches Cover paper
Sheet: 29½ x 41½; image: 27 x 39½
Courtesy of Paula Cooper Gallery, New York

Robert Wilson
Danton's Death, 1992
Watermill, New York
Charcoal on paper
Sheet: 24½ x 34¾; image: 21¾ x 32¾
Courtesy of Paula Cooper Gallery, New York

Robert Wilson
Robespierre Bathtub, 1992
Galvanized sheet metal and stainless steel
30½ x 71 x 35
Courtesy of Alley Theatre, Houston, TX

Documentary Photographs

Peter Moore
17 Untitled Photographs, 1964-76
Signed and unsigned prints
Various dimensions
© Estate of Peter Moore, Barbara Moore, administrator

Performances and Events

Raphael Montanez Ortiz

You can't make an Omelette without Breaking Some Eggs

Raphael Montanez Ortiz, with Monique St. Patrick-Lorenz

Cleveland Center for Contemporary Art

7:30-8:30 pm, Thursday, February 10

John White

Despertly Seeking

John White, with Michael Mufson and Gary San Angel

Cleveland Center for Contemporary Art

7:30-8:30 pm, Friday, February 11

Linda Montano

Postcard Tarot

Cleveland Center for Contemporary Art

Multiple performances

7:30-8:30 pm, Friday, February 11

2:00-4:00 pm, Saturday, February 12

2:00-4:00 pm, Sunday February 13

Geoffrey Hendricks

Dream Event

Geoffrey Hendricks, and Scott Simmerly, Steve Muiscevich,

Scott Cataffa, and Sally Miklowski

Cleveland Center for Contemporary Art

Multiple performances

overnight, Friday, February 11

overnight, Saturday, February 12

1:00-4:00 pm, Sunday February 13

1:00-4:00 pm, Saturday, February 19

1:00-4:00 pm, Sunday, February 27

1:00-4:00 pm, Saturday, March 5

Anna Homler
Pharmacia Poetica
Cleveland Center for Contemporary Art
1:00–5:00 pm, Saturday, February 12

Bread and Puppet Theater/Peter Schumann
The Old Art of Puppetry in the New World Order
Cleveland Center for Contemporary Art
3:00–4:00 pm, Saturday, February 12

Artists' Panel Discussion
With **Jacki Apple, Raphael Montanez Ortiz, John White, Gary San Angel,** and **Michael Mufson**
Performance Art is Dead: Long Live Performance Art...
Cleveland Center for Contemporary Art
12:30–2:00 pm, Sunday, February 13

Artist Discussion
Geoffrey Hendricks
Cleveland Center for Contemporary Art
3:00–4:00 pm, Sunday, February 13

Robert Whitman
Prune Flat
Hall Auditorium, Oberlin College, Oberlin, Ohio
8:00–8:45 pm, Tuesday, February 15

Jimmie Durham
Fire! or Imperialism!
Cleveland Center for Contemporary Art
7:30–8:15 pm, Saturday, February 19

Rirkrit Tiravanija
Untitled (Raw)
Cleveland Center for Contemporary Art
12 noon–5:00 pm, Saturday, February 19
12 noon–5:00 pm, Sunday, February 20

William Pope.L

Eracism
Karamu House, Cleveland
8:00-9:00 pm, Friday, February 25
8:00-9:00 pm, Saturday, February 26

Matt Heckert

The Boxers and *Disc/Cable Mechanism*
2 sound installations of members of the Mechanical Sound Orchestra
SPACES, Cleveland
5:00-8:00 pm, Friday, March 4
11:00 am-5:00 pm, Saturday, March 5
1:00-5:00 pm, Sunday, March 6

Larry Miller

Fluxus Concert
Larry Miller, concertmaster; with Dennis Barrie, Jocelyn Chang, Edwin London,
Thomas Mulready, Kay Raplenovich, Gary Sangster, Howie Smith, and others.
Reinberger Chamber Hall, Severence Hall
8:00-11:30 pm, Friday, March 4

Bill Gordh and John Malpede

Dead Dog and Lonely Horse
Cleveland Public Theatre
8:00-9:00 pm, Friday, March 18
8:00-9:00 pm, Sunday, March 20

Guillermo Gómez-Peña

New World (B)Order
Guillermo Gómez-Peña, with Roberto Sifuentes and Salvador Gonzales
The Cleveland Museum of Art
8:00-9:30 pm, Wednesday, March 23

Suzanne Lacy and Carol Kumata

Auto: On the Edge of Time
Idea Garage
2:00-6:30 pm, by appointment, Saturday, April 2

John Fleck
All for You
Cleveland Public Theatre
8:00-9:30 pm, Sunday, April 3

Performance Art Films, Part 1
Cleveland International Film Festival
Hoyts Tower City Cinemas
9:15-11:15 pm, Monday, April 11

Number 4, 1966 (6 mins)
Yoko Ono

Entr'acte, 1924 (14 mins)
Rene Clair and Francis Picabia

Snapshots of the City, 1961 (1 min)
Stan van der Beek

Mirror, 1969 (9 mins)
Robert Morris

Song Delay, 1973 (18 mins)
Joan Jonas

Scotty and Stuart, 1977 (3 mins)
Skating, 1977 (3 mins)
Edwin Denby, 1978 1 min)
Hand/Water, 1978 3 (mins)
Rock/String, 1979 (2 mins)
Flying, 1979 (1 min)
Fish Story, 1979 (1 min)
Seven Short Films by **Stuart Sherman**

Foots, 1979 (5 mins)
Pat Oleszko

Where Fools Russian, 1985 (5 mins)
Pat Oleszko

Ellis Island, 1981 (28 mins)
Meredith Monk

Performance Art Films, Part 2
Cleveland International Film Festival
Hoyts Tower City Cinemas
9:15-11:15 pm, Tuesday, April 12

Disappearing Face Music, 1966 (10 mins)
Chieko Shiomi

Homage to Jean Tinguely's Homage à New York, 1960 (10 mins)
Robert Breer

The Bitter Message of Hopeless Grief, 1988 (13 mins)
Jonathon Reiss

The Discovery of the Phonograph, 1985(6 mins)
Stuart Sherman

Hippodrome Hardware, 1973-1980 (26 mins)
Red Grooms and **Mimi Gross**

I Like America and America Likes Me, 1974/78 (35 mins)
Joseph Beuys

Lenders

Alley Theatre, Houston, TX

Laurie Anderson

Jacki Apple

Chris Burden

Eileen and Michael Cohen

Paula Cooper Gallery, New York

Des Moines Art Center, Des Moines, IA

Jimmie Durham

Gretchen Faust, Kevin Warren, and Pat Hearn Gallery, New York

Ronald Feldman Fine Arts, Inc., New York

Terry Fox

Coco Fusco and Guillermo Gomez-Peña

Coco Fusco and Pepon Osorio

Barbara Gladstone Gallery, New York

Frank O. Gehry

The Resource Collections of the Getty Center for the History of Art and the Humanities

Matt Heckert

Geoffrey Hendricks

Anna Homler

The Institute for Contemporary Art/P.S. 1 Museum and The Plaster Foundation, New York

Joan Jonas

Sean Kelly, Inc., New York

Alison Knowles

Suzanne Lacy and Carol Kumata

Galerie Lelong, New York, and the Estate of Ana Mendieta

Luhring Augustine, New York

Meredith Monk

Linda Montano

Estate of Peter Moore; Barbara Moore, administrator

Bruce Nauman

Nirlilach

Lorraine O'Grady

Museum of Contemporary Art, Chicago

Claes Oldenburg and Coosje van Bruggen

Pat Oleszko

Yoko Ono

Raphael Montanez Ortiz

Nam June Paik

C.F. Peters Corporation

William Pope.L and Horodner Romley Gallery, New York

Liz Prince

Rubell Family Collections

Carolee Schneemann

Peter Schumann/Bread and Puppet

Joyce Scott

Stuart Sherman

Harry Shunk

Gilbert and Lila Silverman/Fluxus Collection Foundation

Stanley T. Stairs

John L. Stewart

Rirkrit Tiravanija

Video Data Bank, Chicago, IL

Wexner Center for the Arts, The Ohio State University

Sheila and Wally Weisman, Beverly Hills, California

Michael Werner Gallery, New York and Cologne

John White

Robert Whitman

Estate of Hannah Wilke and Ronald Feldman Fine Arts, New York

Acknowledgments

Cleveland Center for Contemporary Art wishes to thank and acknowledge the following individuals and organizations for their generous support and assistance, or for significant contributions to the research and presentation of *Outside the Frame*.

Josephine Abady

Marty Ackerly

Alley Theater

Maureen Sagan Alvim

Donald Anderle

arts alive! productions

Laura Aswad

B&B Appliance

Cindy Barber

Dennis Barrie

Lisa Bellanboyer

Susan Benish

Charles Bergengren

Robert Bergman

Michelle Bernatz

Camille Billops

Gwen Bitz

Jeff Blumenthal

Ross Bochnek

John Boone

Robert Breer

Eric Broder

Tami Brown

Charles Calmer

Eva Capobianco

Michael A. Capotosto

Arlene Carmine

Carrollgraphics

The Center for the Prevention of
Domestic Violence

Kathleen Cerveny

Jocelyn Chang

Susan Channing

Jeff Chiplis

Nina Chwast

The Cleveland Foundation

Cleveland International Film Festival

The Cleveland Museum of Art

Cleveland Performance Art Festival

The Cleveland Playhouse

Cleveland Public Theatre

Susanne Cockrell

Allison Cohen

Commercial Plastics

Stephanie Conforti

Sarah Cook

Roger Copeland

Doug Cox, Photographer

Joe Cronauer

Cunningham Dance Productions

Cynthia Cupach

Donna David

Dean Supply

Denajua

Justin Dennis

Mark Dent

Susan dePasquale

Dee Dietsche

Nancy Dine

Lorrie Dirkse

Greg Donley

Dennis Dooley

Charlotte Douglass

Lynn Dufenetz

Joe Dwyer

Nadine Dwyer

Chip Edelsberg

Shannah M. Ehrhart

Empirical Sound

Dr. Kenneth Ender

Deena Epstein

Julie Fehrenbach

Patti Fields

Brynna Fish

Margaret Ford-Taylor

Forge Recording Studios, Inc.

Brian Fowler

The Free Times

Sandra Gering

Danielle Gherardi

Vic Gideon

Rich Gilfert

Don Gillespie

Sally Glover

Roselee Goldberg

Ron Goldfarb

Salvador Gonzalez

Frank Green

Joseph Gresser

Gail Grubb

Tiffany Grubb

Ron Grundel

Jeff Gruszewski

The George Gund Foundation

Hall Auditorium, Oberlin College

Don Harvey

Richard Harvey

Christina Hejtmanek

Jon Hendricks

Lynn Hershman

Ryan Hill

Tom Hinson

Lin Hixson

Martha Holmes

Daniel Horning

Kate Horsfield

House of Plastics

Hoyts Tower City Cinemas

Hughie's Film and Flower

Carol Hunt

Dr. John Hunter

The Idea Gararge

Industrial Video

Betty Jackson

Jill Jacobson

Jensara Industries

Kathryn Jensen

Bev Jones

Judson Memorial Chruch

Andrew Kaletta

Kap Piano Co.

Allan Kaprow

Karamu House

Beth Kassabri

Maria Keckan

Sean Kelly

Marion Kessel

Lilian Kiesler

John Killacky

Ben Kinmont

Michael Kirby

Nicole Klagsbrun

Debby Klein

Mark Korneitchouk

Cheryl Kushner

Daniel Landau

Landscapers Wholesale

Wayne Lawson

Leff Electric

Kathy Leonard

James Levin

Deborah Leviton

Wayne Lewis

Sara Lieberth

The Little Warehouse Inc.

David Litz

Edwin London

Jana Loosli-Valtrakis

Irene Lotspeich-Phillips

David Low

Justin Lucas

Nola Mariano

David Marshall

Sarah May

Nancy McAfee

Mindy Meinders

Monique Meloche

Merrill David

The Metal Store of Cleveland, Inc.

Ed Mieczkowski

Sally Miklowski

Thea Miklowski

Burt Milter

Alan Moore

Barbara Moore

Jennifer Morin

Holly Morrison

Leslie Moynihan

Alice Mulready

Thomas Mulready, Jr.

Thomas Mulready, Sr

Susan Murray

Musical Arts Association

Bill Nagode

National Endowment for the Arts

Marc Nochella

Ohio Arts Council

Bob Olive

Ken O'Rourke

Michael Overn

Debbie Palen

Patrick Pardo

Young Park

Tim Parkinson

Kathy Peart

Kahlil Pedizisai

Performance Studies Department,
New York University

C.F. Peters Corporation

Carla Peterson

Ruth Phaneuf

Philip Morris Companies Inc.

Michael Pisano

David Platzger

Sean Rapacki

Kay Raplenovich

Jennifer Ratcliff

Thomas Reardon

Susan Reddish

Dennis Redmond

Ollie Reeves

Maris Rence

The Rockefeller Foundation

Don Roe

Sarah Rogers

Rose Brand

Lee Rosenberg

Mark Rosenberger

ACKNOWLEDGMENTS

Moira Roth

Mark Russell

Michael Ryncavage

Mary Sabbatino

Vic Sabula

Rich Sarian

Sue Ellen Saunders

Severance Hall, Reinberger Chamber Hall

Amanda Shaffer

Lynn Sharpless

Lauren Shaw

Sherman & Sons, Inc.

Sherwin Williams

Harry Shunk

Natasha Sigmund

Scott Simmerly

Stacey Sims

Robert Sirovica

Ron Skully

James Slowiak

Howie Smith

Snug Harbor Cultural Center

Katherine Solender

SPACES

Amy Sparks

Hank Stabler

Laurie Steelink

Kristine Stiles

Mike Subcek

Margaret Sundell

Nina Sundell

Sutton Industrial Hardware

Michou Szabo

Christine Szalay

Sandra Szemplak

Sarah Cooke Taggert

Teri Taylor

Blair Thurman

Robert Thurmer

Manfred Troibner

Barbara Tsumagari

United Packaging Supply

David Vaughn

Gordon Veneklasen

Vincent Lighting

Laila Voss

WCPN-FM 90.3

WENZ-FM 107.9

Lynne Warden

The Warhol Foundation for the Visual Arts

Julie Warren

Elizabeth Warson

Stephanie Weiseman

Andreas Weiss

Ira Weiss

Karen Wellman

West End Lumber

Westfall Framing Supply

David White

Sylvia White

Jesse Bryant Wilder

Maggie Willard

Kevin Williams

Martha Wilson

Elan Wingate

Lauren Wittels

David Wittkowsky

Chris Wrabel

Rene Yanez

Ted Zbozien

Z'ev

Barry Lee Zucker

Docent Council

Lorrie Anderson

Ruth Dancyger[†]

Joan Dowling

Becky Dunn[†]

Harriet Goldberg[†]

Florence Goodman

Brenda Gordon[†]

Marilyn Harris

Mary Ann Katzenmeyer

Nancy Marotta

Avis Max[†]

Helga Miller

Francine Pilloff

Sandra Pirouz

Phyllis Ross[†]

Marian Sells

Eunice Wertheim

† Docents presenting guided tours of *Outside the Frame*

Staff and Staff Volunteers

Lindy Barnett
Director of Artspace and Sales and Rental

Ginna Brand
Director of School Programs

Jennifer Breckner
Curatorial Intern [Youngstown State University]

Scott Cataffa
Curatorial Intern [Kent State University]

Kathy Charlton
Assistant Director of Development

Andrea Cipriani
Receptionist

Rosalie Cohen
Director of Sales and Rental

Pamela R. Esch
Director of Education

Char Fowler
Volunteer Coordinator

Grace Garver
Director of Finance and Human Resources

Erma Gillespie
Receptionist

Ray Juaire
Preparator and Facilities Coordinator

Michelle Knapik
Education Intern (Baldwin-Wallace College)

Pat Kramer
Director of Development

Heather Mackey
Marketing and Membership Coordinator

Julie Manke
Curatorial Intern [John Carroll University]

Michelle McCarthy
Artspace Assistant

Pat Neville
Accountant

Sue Nuremburg
Receptionist

Mary Previte
Office Manager, Director of Artspace

Pam Ratliff
Bookkeeper and Clerical Assistant

David S. Rubin
Associate Director/Chief Curator

Gary Sangster
Executive Director

Anna Spangler
Executive Assistant

Mark Stupi
Security/Staff Assistant

Teri Taylor
Staff Assistant

Toni J. White
Receptionist/Secretary

Dann Witczak
Registrar/Chief Preparator